Pronunciation
Dictionary of
Artists' Names

Pronunciation Dictionary of

Artists' Names

The Art Institute of Chicago

Third Revised Edition

Revised and Edited by
Debra Edelstein

A Bulfinch Press Book
Little, Brown and Company
Boston • New York • Toronto • London

Third Revised Edition

Designed by John Kane, Sametz Blackstone Associates

Edelstein, Debra
 Pronunciation dictionary of artists' names / Art Institute of
Chicago. — 3rd rev. ed. / revised and edited by Debra
Edelstein.
 p. cm.
 Rev. ed. of : Dictionary of pronunciation of artists'
names / G. E. Kaltenbach. 1989.
 "A Bulfinch Press book."
 ISBN 0-8212-2025-X
 1. Artists—Registers. 2. Names, Personal—
Pronunciation—Dictionaries. I. Art Institute of Chicago. II.
Kaltenbach, G. E. Dictionary of pronunciation of artists'
names. III. Title. IV. Title: Artists' names.
N40.K3 1993
709'.02'2—dc20 93–6130

Bulfinch Press is an imprint and trademark of
Little, Brown and Company (Inc.)

Published simultaneously in Canada by
Little, Brown & Company (Canada) Limited

PRINTED IN THE UNITED STATES OF AMERICA

Preface

This book is a revision of a work published by The Art Institute of Chicago in 1935 and reprinted in the 1960s. Although much within the book has changed, its purpose remains the same: to provide students, museum personnel, broadcasters, and people just interested in art with reliable pronunciations for names they may encounter only in print.

Changes in this edition include a new pronunciation scheme devised and executed by Holly Mitchell; the addition of gender and primary artistic medium to the basic entries containing each artist's nationality and dates; and the inclusion of photographers and printmakers as well as painters, sculptors, and draughtsmen. Of the original 1500 artists, approximately half appear in this edition; those deleted either are no longer considered art historically significant or were contemporary artists fashionable in 1935 but unknown today. Added to the volume are approximately 3500 new names reflecting changing art historical assessments, a broader geographic distribution, and a recognition that names native English speakers intuitively pronounce may present difficulties to speakers of other languages.

This volume focuses on Western Europe, North America, South America, and Australia and includes both significant historical and prominent contemporary artists whom people are likely to encounter in classes, American and European museums, galleries, and the general art press. Also included are the leading Russian artists of the nineteenth and early twentieth centuries and a small number of Japanese and Eastern European artists who have gained attention in the international arena. Though we expect to take some heat, the publisher and I decided that the rich traditions and emerging

trends in the arts of Asia, Africa, and Eastern Europe would be better served in a volume prepared by specialists in both the art and the languages. We also realize that "prominent contemporary artists" is a lightning rod: who's in and who's out will make for interesting revisions in about five years.

I am grateful to Brian Hotchkiss of Bulfinch Press for asking me to undertake this project and to my colleague Holly Mitchell, whose exceptional ear and impressive language skills made it possible. For their gracious assistance I would like to thank Margaret Archuleta, The Heard Museum, Phoenix; Jacqueline Doughty, Art Institute of Chicago; Lucinda Gideon, Neuberger Museum, SUNY Purchase; Musya Glants, Russian Institute, Harvard University; Adam Jolles, Art Institute of Chicago; Katerina Krivinkova, Department of Slavic Languages and Literatures, Harvard University; and Maria del Rosario Marroquin, Art Museum of the Americas, Washington, D.C. A special thanks goes to my friend Bill, for enduring with good humor months of mumbled names.

Debra Edelstein

Pronunciation Guide

The pronunciation scheme is based on that in Webster's *Third New International Dictionary*. In the chart below, we give examples of each vowel and consonant sound in American English, French, German, Italian, and Spanish; where there is no example, the language in question does not employ that particular sound.

The scheme, however, does somewhat simplify the European languages. For instance, the one symbol **ä** is used here to represent what is actually a range of vowel sounds: those found in the various pronunciations of the letter **a** in the English word **calm**; the French words **âge**, **gaz**, **passer**, **pâte**; the German **Jahr**, **Mann**, **Hatte**; the Italian **amo**; and the Spanish **año**. The single symbol **ā** here includes both the diphthong found in the English word **they** and the tighter vowel sound found in the French **été** and the German **Weh**.

The French nasal vowels are represented by the appropriate simple vowels followed by the superscript **n**. The vowel in **blanc** is a nasal rendition of the **a** in **father**; that in **un** may be approximated by nasally pronouncing the schwa sound in the English **about**. The vowel in **vin** is a nasal rendition of the short **a** in the English **hat**. The vowel in **bon** is a nasally produced long **o**, as in the English **bone**. To produce the sound represented by **œ**, pronounce the **e** in **bet** while rounding the lips for the **ü** in **rule**. To produce the sound represented by **ue**, pronounce the **ē** in **feet** while rounding the lips as for the **ü** in **rule**.

We have made no attempt to distinguish among the various **l** and **r** sounds across European languages and have simplified other consonants. Although, for instance,

the German words **ich** and **Bach** end in two somewhat differ-
ent aspirated sounds—the first made in the front of the mouth,
the second in the back—they are treated as the same sound,
represented by <u>**k**</u>; the final sound in the Scots word **loch** and
the initial sound in the Spanish **giro** are represented the same
way, although there are differences across the languages.

For ancient Greek names we have given the
customary American English pronunciation. Where we give
alternative pronunciations, as for Van Gogh, the first is the
pronunciation in the native language and the second that gen-
erally used by art historians in the United States.

Finally, syllables printed in boldface are to be
stressed. Note that French, Japanese, and aboriginal
Australian names contain no syllables thus marked: in French,
syllables receive equal emphasis; in Japanese emphasis is
through pitch rather than stress; and the aboriginal names are
simply English approximations.

Holly Mitchell

Vowels

	English	French	German	Italian	Spanish
ə	about, up, collapse	le, premier	Ehre, beantworten	—	—
$ə^n$	—	un	—	—	—
ər	further, third, word	—	Wasser	—	—
a	hat	femme, tabac	—	—	—
a^n	—	vin	—	—	—
ā	fade, they	été	Weh	pietà	peinar, rey
ä	calm, bother	gaz, pâte	Jahr	bagno	año, pata
$ä^n$	—	blanc	—	—	—
aù	crowd, loud	—	Frau	càusa	causa
e	bet	bête, bibliothèque	Bett, Händen	verde	denso, espada
ē	bleed, easy	dire, finir	Liebe	vino	vino
i	sip	—	mit	finestra	—
ī	abide	paille	bei	mai	baile, vaya
ō	bone	côté	Boot	molto	lodo, ocupar
$ō^n$	—	bon	—	—	—
ȯ	saw	fort	Gott	orzo	sordo, toldo

	English	French	German	Italian	Spanish
œ	—	b**œ**uf, fe**u**	H**ö**lle, sch**ö**n	—	—
œē	—	fe**ui**lle	—	—	—
ȯi	b**oy**	—	n**eu**, B**äu**me	v**ói**	**oi**go, v**oy**
ü	r**u**le, f**oo**l	t**ou**t	g**u**t	**u**mido	l**u**to, **u**til
u̇	p**u**ll, b**oo**k	—	F**u**tter	b**u**sto	b**u**sto
ue	—	r**ue**	f**ü**hlen, f**ü**llen	—	—
ueē	—	br**ui**t	—	—	—

Consonants

The sounds represented by the symbols *f, m, p,* and *t* are nearly identical across the five languages. Pronunciation of *l* and *r* vary considerably; but we have made no attempt here to represent the variations symbolically.

	English	French	German	Italian	Spanish
b	**b**a**b**y	**b**on**b**on	**B**ahn	**b**agno	**b**oca, em**b**argo[1]
ch	**ch**in	—	Put**sch**	**c**ena	mu**ch**a**ch**o
d	**d**ine	**d**iner	**D**ichter	mo**d**a	**d**ar, an**d**ar, fal**d**a[2]
g	**g**o, bi**g**	**g**amin	**G**arten	**g**ara	**g**oma
h	**h**at	—	**H**err	—	—
hw	**wh**ale	—	—	—	—
j	**j**ob, **g**em	—	—	ò**gg**i, **g**iro	—
k	coo**k**	co**q**	**K**arte	**c**aro	**c**asa, **qu**into
<u>k</u>	lo**ch**	—	Ba**ch**, i**ch**	—	**g**ente, **g**iro, **j**aleo
n	**n**oo**n**	**n**iveau	**n**ei**n**	**n**ome	**n**ada
ng	so**ng**, si**ng**er	—	Sa**ng**, Si**ng**en	ve**ng**o	fa**ng**o, re**nc**or
ny	ca**ny**on	a**gn**eau	—	ba**gn**o	ri**ñ**a
s	**c**ea**s**e	**c**e**ss**e	Ka**ss**e	**s**era	**c**o**s**a, mi**x**ta, **s**ino[3]
sh	o**c**ean, mi**ss**ion, ma**ch**ine	en**ch**anté	Ma**sch**e, **Sch**ein	**sc**ena	—

	English	French	German	Italian	Spanish
th	**th**in	—	—	—	**c**epo, vo**c**es, **z**ona, tra**z**ar[4]
t̲h̲	**th**is	—	—	—	lo**d**o, pa**d**re
v	o**f**, sa**v**e	**v**i**v**re	**W**elt, e**w**ig	**v**òlta	la**b**io, ta**b**la[5]
w	a**w**ay, dou**gh**y, pers**u**ade	**ou**ate	—	—	ag**ü**ero, b**u**eno
y	**y**ard, opin**i**on	révei**ll**er	**j**a	coia**i**o	b**i**en, o**ll**a[6]
z	o**z**one, hi**s**	ra**s**er	**S**onne, rei**s**en	**s**volta	—
zh	vi**s**ion, a**z**ure	**g**enou, **j**amais	**G**enie, **J**ournal	—	—

' An apostrophe following a consonant at the end of a word—as in the French name Alexandre, phonetically rendered ä-leg-zän-dr'— signifies that the final sound is something less than a syllable. Pronounce the consonant(s) in this final part of the word with as little vocalization as possible.

1. Initial or following *m*.
2. Initial or following *l* or *n*.
3. And, in southern Spain and most of Spanish America, **c**epo, vo**c**es, **z**ona, tra**z**ar; in most of Spain, however, the sound given these c's and z's is *th*.
4. Except in southern Spain and most of Spanish America, where these c's and z's are pronounced as *s*.
5. Between vowels or before *l* or *r*.
6. The *ll* is pronounced more like the *j* in *jar* in southern Spain and most of Spanish America and like *zh* in Argentina and Uruguay.

Artists'
Names

AA, DIRCK VAN DER
m. Dutch painter, 1731–1809
ä, dērk fən dər

AACHEN, HANS VON
m. German painter, 1552–1615
ä-ḵen, häns fȯn

AALTO, ALVAR
m. Finnish sculptor, architect, designer, 1898–1976
äl-tō, **äl**-vär

ABAKANOWICZ, MAGDALENA
f. Polish sculptor, 1930–
ä-bä-kä-**nō**-vits, mäg-dä-**lä**-nä

ABBATE, NICCOLÒ DELL'
m. Italian painter, c. 1512–71
äb-**bät**-tā, nēk-kō-**lō** del

ABBOT, LEMUEL FRANCIS
m. British painter, c. 1760–1802
ab-bət, **lem**-yü-əl **fran**-sis

ABBOTT, BERENICE
f. American photographer, 1898–1991
ab-bət, **ber**-ə-nēs

ABILDGAARD, NICOLAI ABRAHAM
m. Danish painter, 1743–1809
ä-bēl-gȯrd, ni-kō-**li ä**-brä-häm

ABT, ULRICH THE ELDER
m. German (Augsburg) painter, c. 1460–1532
äpt, **ül**-riḵ

ABULARACH, RODOLFO
m. Guatemalan painter, printmaker, 1933–
ä-bü-lä-**räsh**, rō-**dȯl**-fō

ACCONCI, VITO
m. American sculptor, installation artist, 1940–
ä-**kȯn**-chē, **vē**-tō

ACHILLES PAINTER
m. Greek vase painter, mid–5th c. BC
ə-**kil**-ēz

ADAM, HENRI-GEORGES ä-dän, än-rē–zhȯrzh
m. French sculptor, tapestry designer, printmaker, 1904–67

ADAMI, VALERIO ä-**dä**-mē, vä-**lä**-rē-ō
m. Italian painter, 1935–

ADAMS, ANSEL **ad**-əmz, **an**-səl
m. American photographer, 1902–84

ADAMS, EDDIE **ad**-əmz, **ed**-ē
m. American photographer, 1933–

ADLER, JANKEL **äd**-lər, **yäng**-kel
m. Polish painter, 1895–1949

AELST, WILLEM VAN älst, **vil**-əm fən
m. Dutch painter, 1625–c. 1683

AERTSEN, PIETER **ärt**-sən, **pē**-tər
m. Dutch painter, 1508–75

AFRICANO, NICHOLAS af-ri-**kä**-nō, **nik**-ə-ləs
m. American painter, sculptor, 1948–

AFRO (AFRO BASALDELLA) **äf**-rō (**äf**-rō bä-säl-**del**-lä)
m. Italian painter, 1912–76

AGAM, YAACOV (JACOB GIPSTEIN) ä-**gäm**, **yä**-kȯf (**yä**-kȯp **gip**-shtin)
m. Israeli sculptor, painter, 1928–

AGASSE, JACQUES-LAURENT ä-**gäs**, zhak–lō-rän
m. English (b. Switzerland) painter, printmaker, 1767–1849

AGATHARCUS OF SAMOS ag-ə-**thär**-kəs, **sä**-mȯs or **sā**-mäs
m. Greek painter, mid-late 5th c. BC

AGORACRITUS a-gȯ-**ra**-kri-təs
m. Greek sculptor, mid-late 5th c. BC

AGOSTINO DI DUCCIO ä-gō-**stē**-nō dē **dü**-chō
m. Florentine sculptor, 1418–81

AIZENBERG, ROBERTO **ī**-zən-berg, rō-**ver**-tō
m. Argentine painter, 1928–

AKEN, JOHANN VON **ä**-kən, **yō**-hän fȯn
m. German (Cologne) painter, 1552–1615

ALBANI, FRANCESCO　　　　　äl-**bä**-nē, frän-**ches**-kō
m. Bolognese painter, 1578–1660

ALBERS, JOSEF　　　　　**äl**-bərs or **al**-bərz, **yō**-zef or jō-zəf
m. American (b. Germany) painter, printmaker, 1888–1976

ALBERTI, LEON BATTISTA　　　　　äl-**ber**-tē, **lā**-ȯn bät-**tē**-stä
m. Italian sculptor, architect, 1404–72

ALBERTINELLI, MARIOTTO　　　　　äl-ber-tē-**nel**-lē, mä-rē-**ȯt**-tō
m. Florentine painter, 1474–1515

ALBIZU, OLGA　　　　　äl-**bē**-sü, **ōl**-gä
f. Puerto Rican painter, 1924–

ALBRIGHT, IVAN LE LORRAINE　　　　　**ȯl**-brīt, **ī**-vən lə lȯ-**rān**
m. American painter, 1897–1983

ALCAMENES　　　　　al-kə-**mē**-nēz
m. Greek sculptor, mid-late 5th c. BC

ALDEGREVER, HEINRICH　　　　　**äl**-də-grā-vər, **hin**-rik̲
m. German engraver, painter, 1502–c. 1560

ALECHINSKY, PIERRE　　　　　ä-le-**shin**-skē, pyer
m. Belgian painter, printmaker, 1927–

ALEJANDRO, RAMÓN　　　　　ä-lä-**kän**-drō, rä-**mōn**
m. Cuban (act. France) printmaker, draughtsman, 1943–

ALFONZO, CARLOS　　　　　äl-**fȯn**-sō, **kär**-lōs
m. Cuban (act. United States) painter, 1950–

ALGARDI, ALESSANDRO　　　　　äl-**gär**-dē, ä-les-**sänd**-rō
m. Bolognese sculptor, 1598–1654

ALICIA, JUANA　　　　　ä-**lē**-sē-ä, **kwä**-nä
f. American painter, 1953–

ALKEN, HENRY　　　　　**ȯl**-kən, **hen**-rē
m. English painter, printmaker, 1785–1851

ALLAN, DAVID　　　　　**al**-ən, **dā**-vid
m. Scottish painter, 1744–96

ALLAN, WILLIAM　　　　　**al**-ən, **wil**-yəm
m. Scottish painter, 1782–1850

ALLEN, DAVIDA **al**-ən, da-**vē**-də
f. Australian painter, 1951–

ALLORI, ALESSANDRO äl-**lō**-rē, ä-les-**sänd**-rō
m. Florentine painter, 1535–1607

ALLORI, CRISTOFANO äl-**lō**-rē, krē-stō-**fä**-nō
m. Florentine painter, 1577–1621

ALLSTON, WASHINGTON **ȯl**-stən, **wȯ**-shing-tən
m. American painter, 1779–1843

ALMA-TADEMA, LAWRENCE **al**-mə–**tad**-ə-mə, **lȯ**-rəns
m. English (b. Holland) painter, 1836–1912

ALMAREZ, CARLOS äl-**mär**-es, **kär**-lōs
m. American painter, 1941–89

ALPUY, JULIO äl-**pwē**, **k̲ül**-yō
m. Uruguayan sculptor, 1919–

ALSLOOT, DENIS VAN **äls**-lōt, də-**nē** fən
m. Flemish painter, c. 1570–c. 1627

ALTDORFER, ALBRECHT **ält**-dȯrf-ər, **äl**-brek̲t
m. German (Regensburg) painter, printmaker, c. 1480–1538

ALTICHIERI, ALTICHIERO DA ZEVIO äl-tē-**kyer**-ē,
äl-tē-**kyer**-ō dä **tsä**-vyō
m. Veronese sculptor, c. 1330–c. 1395

ALVAREZ, CANDIDA **äl**-vä-res, kän-**dē**-t̲hä
f. Puerto Rican painter, 1955–

ALVAREZ BRAVO, LOLA **äl**-vä-res **brä**-vō, **lō**-lä
f. Mexican photographer, 1907–

ALVAREZ BRAVO, MANUEL **äl**-vä-res **brä**-vō, män-**wel**
m. Mexican photographer, 1902–

ALVAREZ MUÑOZ, CELIA: see MUÑOZ, CELIA ALVAREZ

ÁLVAREZ Y CUBERO, JOSÉ **äl**-vä-reth ē kü-**vā**-rō, k̲ō-**sä**
m. Spanish sculptor, 1768–1827

AMAN-JEAN, EDMOND a-män–zhän, ed-mōn
m. French painter, 1860–1935/6

AMARAL, ANTÔNIO HENRIQUE ä-mä-**räl**, än-**tōn**-yō en-**rē**-kā
m. Brazilian painter, 1935–

AMARAL, TARSILA DO ä-mä-**räl**, tär-**sē**-lä dō
f. Brazilian painter, 1886–1973

AMASON, ALVIN ELI **ā**-mä-sən, **al**-vin **ē**-lī
m. American (Aleut) painter, 1948–

AMBERGER, CHRISTOPH **äm**-ber-gər, **kris**-tòf
m. German (Augsburg) painter, c. 1505–62

AMIGONI, JACOPO ä-mē-**gō**-nē, **yä**-kō-pō
m. Venetian painter, 1682–1752

AMMAN, JOST **äm**-män, yōst
m. Swiss (act. Germany) engraver, painter, 1539–91

AMOS, EMMA **ā**-məs, **em**-ə
f. American painter, 1940?–

ANATJARI (TJAMPITJINPA) ä-nə-chär-ē (chəm-pi-chin-pä)
m. Australian (Pintupi) painter, c. 1929–

ANDERSON, LAURIE **an**-dər-sən, **lòr**-ē
f. American performance artist, video artist, 1947–

ANDRÉ, ALBERT äⁿ-drā, äl-ber
m. French painter, 1869–1954

ANDRE, CARL än-**drā**, kärl
m. American sculptor, 1935–

ANDREA DA FIRENZE än-**drā**-ä dä fē-**rent**-sā
m. Florentine painter, act. c. 1343–77

ANDREA DEL CASTAGNO än-**drā**-ä del kä-**stän**-yō
m. Florentine painter, c. 1421–57

ANDREA DEL SARTO än-**drā**-ä del **sär**-tō
m. Florentine painter, 1486–1530

ANDREA DI BARTOLO än-**drā**-ä dē **bär**-tō-lō
m. Sienese painter, c. 1370–1428

ANDREWS, BENNY **an**-drüz, **ben**-ē
m. American painter, 1930–

ANDRIESSEN, JURRIAEN
m. Dutch painter, 1742–1819
än-drē-sən, **yü**-rē-än

ANGELICO, FRA
m. Florentine painter, 1387–1455
än-**jä**-lē-kō, frä

ANGLADA-CAMARASA, ERMENGILDO
än-**glä**-dä–kä-mä-**rä**-sä,
er-men-**kēl**-dō
m. Spanish painter, 1871–1959

ANGUIER, FRANÇOIS
m. French sculptor, c. 1604–69
än-gyä, frän-swä

ANGUIER, MICHEL
m. French sculptor, c. 1613–86
än-gyä, mē-shel

ANGUISSOLA, SOFONISBA
f. Cremonese painter, 1527–1625
än-**gwēs**-sō-lä, sō-fō-**nis**-bä

ANKER, ALBERT
m. Swiss painter, 1831–1910
äng-kər, **äl**-bert

ANNIGONI, PIETRO
m. Italian painter, 1910–88
än-nē-**gō**-nē, **pyä**-trō

ANQUETIN, LOUIS
m. French painter, printmaker, 1861–1932
än-kə-tan, lü-ē

ANSELMO, GIOVANNI
m. Italian sculptor, 1934–
än-**sel**-mō, jō-**vän**-nē

ANTELAMI, BENEDETTO
m. Italian sculptor, act. 1177–1233
än-tä-**lä**-mē, bā-nä-**det**-tō

ANTENOR
m. Greek sculptor, late 6th c. BC
an-**tē**-nȯr

ANTICO (PIER JACOPO ALARI BONACOLSI)
än-**tē**-kō (pyer **yä**-kō-pō
ä-**lä**-rē bō-nä-**kōl**-sē)
m. Mantuan sculptor, c. 1460–1528

ANTOKOLSKY, MARK
m. Russian sculptor, 1842–1902
än-tō-**kōl**-skē, märk

ANTOLÍNEZ, JOSÉ
m. Spanish painter, 1635–75
än-tō-**lē**-neth, kō-**sā**

ANTONELLO DA MESSINA
än-tō-**nel**-lō dä mes-**sē**-nä
m. Sicilian painter, c. 1430–79

ANTÚNEZ, NEMESIO
än-**tü**-nes, nā-**mās**-yō
m. Chilean printmaker, painter, 1918–

ANUSKIEWICZ, RICHARD
a-nü-**skā**-vich, **rich**-ərd
m. American painter, 1930–

APELLES
ə-**pel**-ēz
m. Greek painter, 4th c. BC

APOLLODORUS
ə-päl-ō-**do**-rəs
m. Greek painter, 5th c. BC

APPEL, KAREL
äp-əl, **kä**-rəl
m. Dutch painter, sculptor, 1921–

APPELT, DIETER
äp-pelt, **dē**-tər
m. German photographer, sculptor, 1935–

APPIANI, ANDREA THE ELDER
äp-**pyä**-nē, än-**drā**-ä
m. Italian painter, 1754–1817

APPLEBROOG, IDA
ap-əl-brüg, **ī**-də
f. American painter, 1929–

ARAKAWA, SHUSAKU
ä-rä-kä-wä, shü-sä-kü
m. Japanese painter, draughtsman, 1936–

ARBUS, DIANE NEMEROV
är-bəs, dī-**an nem**-ə-ròf
f. American photographer, 1923–71

ARCHIPENKO, ALEXANDER
är-ki-**peng**-kō, a-leg-**zan**-dər
m. American (b. Russia) sculptor, 1887–1964

ARCIMBOLDO, GIUSEPPE
är-chēm-**bōl**-dō, jü-**zep**-pā
m. Milanese painter, 1527–93

ARENTSZ., ARENT (ARENT VAN DER CABEL)
ä-rents, **ä**-rent (**ä**-rent fən der **kä**-bel)
m. Dutch painter, c. 1585–1635

ARKLEY, HOWARD
ärk-lē, **haù**-ərd
m. Australian painter, 1951–

ARMAJANI, SIAH
är-mä-**jä**-nē, **sē**-ä
m. Iranian (act. United States) sculptor, 1939–

ARMAN (ARMAND FERNANDEZ) är-**män** (är-män fer-**nän**-des)
m. American (b. France) sculptor, 1928–

ARMITAGE, KENNETH **är**-mi-təj, **ken**-əth
m. English sculptor, 1916–

ARNOLFO DI CAMBIO är-**nòl**-fō dē **käm**-byō
m. Italian sculptor, architect, c. 1245–c. 1302

ARP, HANS (JEAN) ärp, häns (zhän)
m. French (b. Germany) sculptor, painter, printmaker, 1887–1966

ARRIETA, JOSÉ AGUSTÍN är-**yā**-tä, k̄ō-**sä** ä-gü-**stēn**
m. Mexican painter, 1802–74

ARTHOIS, JACQUES D' där-twä, zhak
m. Flemish painter, 1613–86

ARTSCHWAGER, RICHARD **ärt**-shwä-gər, **rich**-ərd
m. American sculptor, painter, 1924–

ASAM, COSMAS DAMIAN **ä**-zäm, **kòs**-mäs **dä**-mē-än
m. German (Bavaria) painter, 1686–1739

ASAM, EGID QUIRIN **ä**-zäm, **ā**-git **kvē**-rin
m. German (Bavaria) sculptor, 1692–1750

ASPERTINI, AMICO äs-per-**tē**-nē, ä-**mē**-kō
m. Bolognese painter, c. 1475–1552

ASSELYN, JAN **äs**-sə-lin, yän
m. Dutch painter, c. 1615–52

AST, BALTHASAR VAN DER äst, bäl-**tä**-zär fən dər
m. Dutch painter, 1593/4–1657

ATGET, EUGÈNE ät-zhe, œ-zhen
m. French photographer, 1857–1927

ATL, DR. (GERARDO MURILLO CORNADO)
 ät-l' (kā-**rär**-t̲h̲ō mü-**rē**-yō kòr-**nä**-t̲h̲ō)
m. Mexican painter, 1875–1964

ATLAN, JEAN-MICHEL ät-län, zhän–mē-shel
m. French (b. Algeria) painter, 1913–60

ATTIE, DOTTY **at**-tē, **dät**-tē
f. American painter, 1938–

AUDRAN, CLAUDE III ō-dräⁿ, klōd
m. French painter, 1658–1734

AUDUBON, JOHN JAMES ȯ-də-bən, jän jāmz
m. American (b. Haiti) painter, 1785–1851

AUERBACH, FRANK aů-ər-bäk, frangk
m. British (b. Germany) painter, 1931–

AVALOS, DAVID ä-vä-lōs, **dā**-vid
m. American mixed-media artist, 1947–

AVED, JACQUES ä-ved, zhak
m. French painter, 1702–66

AVEDON, RICHARD **av**-ə-dän, **rich**-ərd
m. American photographer, 1923–

AVERCAMP, HENDRIK ä-vər-kämp, **hen**-drik
m. Dutch painter, 1585–1634

AVERY, MILTON ā-və-rē, **mil**-tən
m. American painter, 1885–1965

AYCOCK, ALICE ā-käk, **a**-lis
f. American sculptor, 1946–

AYRTON, MICHAEL **ār**-tən, **mi**-kəl
m. English painter, sculptor, 1921–75

AZACETA, LUÍS CRUZ ä-sä-**sā**-tä, lü-**ēs** krüs
m. American (b. Cuba) painter, 1942–

AZUMA, NORIO ä-zü-mä, nō-rē-ō
m. Japanese (act. United States) printmaker, 1928–

B

BACA, JUDITH FRANCISCA **bä**-kä, **jü**-dith frän-**sēs**-kä
f. American painter, 1946–

BACKER, JACOB ADRIAENSZ. **bäk**-ər, **yä**-kȯp **ä**-drē-äns
m. Dutch painter, printmaker, 1608–51

BACON, FRANCIS **bā**-kən, **fran**-sis
m. English painter, 1909–92

BACON, JOHN I **bā**-kən, jän
m. English sculptor, 1740–99

BAEDER, JOHN **bā**-dər, jän
m. American painter, 1938–

BAEN, JAN DE bän, yän də
m. Dutch painter, 1633–1702

BÁEZ, MYRNA **bä**-es, **mir**-nä
f. Puerto Rican printmaker, painter, 1931–

BAGNOLI, MARCO bä-**nyōl**-lē, **mär**-kō
m. Italian installation artist, 1949–

BAILEY, WILLIAM **bā**-lē, **wil**-yəm
m. American painter, 1930–

BAILLAIRGÉ, FRANÇOIS bī-yer-zhā, frän-swä
m. Canadian sculptor, 1759–1830

BAILLAIRGÉ, JEAN bī-yer-zhā, zhän
m. Canadian sculptor, 1726–1805

BAILLAIRGÉ, THOMAS bī-yer-zhā, tō-mä
m. Canadian sculptor, 1791–1859

BAILLY, ALICE bī-yē, ä-lēs
f. Swiss painter, printmaker, 1872–1938

BAILY, EDWARD HODGES **bā**-lē, **ed**-wərd **häj**-ez
m. English sculptor, 1788–1867

BAJ, ENRICO bī, en-**rē**-kō
m. Italian painter, 1924–

BAKHUYZEN, LUDOLF **bäk**-hœ-y'-zən or
 bäk-hȯi-zən, **lü**-dȯlf
m. Dutch painter, printmaker, 1631–1708

BAKST, LÉON (LEV SAMOYLOVICH ROZENBERG)
 bäkst, lā-ȯn (lef səm-ə-**ēl**-ə-vich
 rō-**zən**-bərg)
m. Russian painter, designer 1866–1925

BALDESSARI, JOHN bal-də-**sä**-rē, jän
m. American photographer, conceptual artist, 1931–

BALDESSIN, GEORGE **bȯld**-ə-sin, jȯrj
m. Australian (b. Italy) sculptor, printmaker, 1939–78

BALDOVINETTI, ALESSIO bäl-dō-vē-**net**-tē, ä-**les**-sē-ō
m. Florentine painter, 1426–99

BALDUCCI, GIOVANNI DI bäl-**dü**-chē, jō-**vän**-nē dē
m. Pisan sculptor, act. 1315–49

BALDUCCIO, MATTEO bäl-**dü**-chē-ō, mät-**tā**-ō
m. Umbrian/Sienese painter, late 15th c.–after 1554

BALDUNG (GRIEN), HANS **bäl**-düng (grœn), häns
m. German (Strasbourg) painter, c. 1484/5–1545

BALEN, HENDRIK VAN I **bä**-lən, **hen**-drik fən
m. Flemish painter, 1575–1632

BALLA, GIACOMO **bäl**-lä, **jä**-kō-mō
m. Italian painter, 1871–1958

BALTHUS (BALTHASAR KLOSSOWSKI DE ROLA)
 bäl-tœs
 (**bäl**-tä-sär klō-**sȯv**-skē də **rō**-lä)
m. French painter, 1908–

BALTZ, LEWIS bȯlts, **lü**-is
m. American photographer, 1945–

BANDINELLI, BACCIO bän-dē-**nel**-lē, **bät**-chō
m. Florentine sculptor, painter, 1493–1560

BANKS, THOMAS bangks, **täm**-əs
m. English sculptor, 1735–1805

BANNISTER, EDWARD MITCHELL **ban**-ə-stər, **ed**-wərd **mich**-əl
m. American painter, 1828–1901

BARBARI, JACOPO DE' **bär**-bä-rē, **yä**-kō-pō dā
m. Venetian painter, 1440/50–c. 1516

BARCELÓ, MIGUEL bär-thā-**lō**, mē-**gel**
m. Spanish painter, 1957–

BARENDSZ., DIRCK **bä**-rənts, dērk
m. Netherlandish painter, 1534–92

BARLACH, ERNST **bär**-läk, ernst
m. German sculptor, printmaker, 1870–1938

BARLOW, FRANCIS **bär**-lō, **fran**-sis
m. English painter, printmaker, 1626?–1704

BARNA DA SIENA **bär**-nä dä sē-**ä**-nä
m. Sienese painter, second half 14th c.

BARNEY, MATTHEW **bär**-nē, **math**-yü
m. American video artist, 1968–

BARNEY, TINA **bär**-nē, **tē**-nə
f. American photographer, 1945–

BAROCCI (BAROCCIO), FEDERICO bä-**ròt**-chē (bä-**ròt**-chō), fā-dā-**rē**-kō
m. Italian (Urbino) painter, printmaker, c. 1535–1612

BARRAZA, SANTA CONTRERAS bär-**rä**-sä, **sän**-tä kòn-**trä**-räs
f. American painter, 1951–

BARRET, GEORGE **ba**-rət, jòrj
m. Irish painter, 1732?–84

BARRIOS, ALVARO **bär**-yōs, äl-**vä**-rō
m. Colombian collagist, 1945–

BARRY, JAMES **ba**-rē, jāmz
m. Irish painter, 1741–1806

BARTLETT, JENNIFER **bärt**-lət, **jen**-ə-fər
f. American painter, photographer, sculptor, printmaker, 1941–

BARTOLO DI FREDI **bär**-tō-lō dē **frā**-dē
m. Sienese painter, 1330–1410

BARTOLOMMEO, FRA bär-tō-lō-**mā**-ō, frä
m. Florentine painter, 1472–1517

BARTOLOMMEO, VENETO bär-tō-lō-**mā**-ō, vā-**nā**-tō
m. Venetian painter, act. 1502–31

BARTOLOZZI, FRANCESCO bär-tō-**lòt**-sē, frän-**ches**-kō
m. Italian (act. England) painter, engraver, 1727–1815

BARYE, ANTOINE-LOUIS ba-rē, än-twän–lü-ē
m. French sculptor, painter, 1796–1875

BASELITZ, GEORG **bä**-zə-lēts, **gā**-òrg
m. German painter, printmaker, 1938–

BASKIN, LEONARD **bas**-kən, **len**-ərd
m. American printmaker, sculptor, 1922–

BASQUIAT, JEAN-MICHEL bäs-kē-ät, zhän–mē-shel
m. American painter, 1960–88

BASSA, FERRER **bäs**-sä, fer-**rer**
m. Aragonese painter, c. 1285/90–1348

BASSANO, JACOPO (DA PONTE) bäs-**sä**-nō, **yä**-kō-pō (dä **pòn**-tā)
m. Venetian painter, c. 1517/8–92

BASSANO, LEANDRO (DA PONTE) bäs-**sä**-nō, lā-**än**-drō (dä **pòn**-tā)
m. Venetian painter, 1557–1622

BASTIEN-LEPAGE, JULES bas-tyan–lə-päzh, zhuel
m. French painter, printmaker, sculptor, 1848–84

BATLLE-PLANAS, JUAN **bät**-yā–**plä**-näs, <u>k</u>wän
m. Argentine painter, 1911–66

BATONI, POMPEO bä-**tō**-nē, pòm-**pā**-ō
m. Luccan painter, 1708–87

BAUCHANT, ANDRÉ bō-shän, än-drā
m. French painter, 1873–1958

BAUGIN, LUBIN bō-zhan, lue-ban
m. French painter, c. 1610–63

BAUMEISTER, WILLI **baú**-mĭ-stər, **vil**-lē
m. German painter, 1889–1955

BAUMGARTEN, LOTHAR **baúm**-gär-tən, **lō**-tär
m. German installation artist, 1944–

BAYARD, HIPPOLYTE bä-yär, ē-pō-lēt
m. French photographer, 1801–87

BAYER, HERBERT **bi**-ər, **hər**-bərt
m. American (b. Austria) painter, graphic artist, 1900–85

BAYEU Y SUBÍAS, FRANCISCO bä-**yœ** ē sü-**bē**-äs, frän-**thēs**-kō
m. Spanish painter, printmaker, 1734–95

BAZAINE, JEAN bä-zen, zhän
m. French painter, 1904–75

BAZILE, CASTERA bä-zēl, kä-stā-rä
m. Haitian painter, 1923–65

BAZILLE, FRÉDÉRIC bä-zēl, frā-dā-rēk
m. French painter, 1841–70

BAZIOTES, WILLIAM ba-zē-**ō**-tēz, **wil**-yəm
m. American painter, 1912–63

BEAM, CARL bēm, kärl
m. Canadian (Ojibwa) painter, 1943–

BEARDEN, ROMARE **bēr**-dən, rō-**mār**
m. American painter, 1912–88

BEARDSLEY, AUBREY **bērdz**-lē, **ȯ**-brē
m. English illustrator, 1872–98

BEARDY, JACKSON **bēr**-dē, **jak**-sən
m. Canadian (Ojibwa) printmaker, painter, 1944–

BEAUNEVEU, ANDRÉ bō-nə-vœ, än-drā
m. French sculptor, act. 1360–1403/13

BEAUX, CECILIA bō, sə-**sēl**-yə
f. American painter, 1855–1942

BEAVER, FRED **bē**-vər, fred
m. American (Creek/Seminole) painter, 1911–

BECCAFUMI, DOMENICO bek-ä-**fü**-mē, dō-**mä**-nē-kō
m. Sienese painter, sculptor, c. 1469–1551

BECERRA, GASPAR bā-**ther**-rä, **gäs**-pär
m. Spanish sculptor, painter, c. 1520–70

BECHER, BERND **bek**-ər, bernt
m. German photographer, painter, 1931–

BECHER, HILLA **bek**-ər, **hil**-lä
f. German photographer, painter, 1934–

BECKMANN, MAX **bek**-män, mäks
m. German painter, printmaker, sculptor, 1884–1950

BEERBOHM, MAX **bēr**-bōm, maks
m. English draughtsman, 1872–1956

BEERSTRATEN, JAN ABRAHAMSZ. **bär**-strät-ən, yän **ä**-brä-häms
m. Dutch painter, printmaker, 1622–66

BEGAY, HARRISON be-**gā**, **har**-i-sən
m. American (Navajo) painter, printmaker, 1917–

BEHAM, BARTHEL **bā**-häm, **bär**-təl
m. German (Nuremberg) engraver, 1502–40

BEHAM, HANS SEBALD **bā**-häm, häns **zā**-bält
m. German (Nuremberg) engraver, 1500–50

BELANGER, LANCE bā-läⁿ-zhā, lans
m. Canadian (Maliseet) sculptor, 1956–

BELL, GRAHAM bel, **grā**-əm
m. English painter, 1910–43

BELL, LARRY bel, **la**-rē
m. American sculptor, 1939–

BELL, VANESSA bel, və-**nes**-sə
f. English painter, designer, 1879–1961

BELLA, STEFANO DELLA **bel**-lä, **stā**-fä-nō **del**-lä
m. Florentine engraver, draughtsman, 1610–64

BELLANGE, JACQUES bel-än-zh, zhak
m. French painter, etcher, act. 1600–17

BELLEGAMBE, JEAN bel-gän-b', zhän
m. Flemish painter, c. 1470/80–c. 1535

BELLINI, GENTILE bel-**lē**-nē, jen-**tē**-lā
m. Venetian painter, c. 1429–1507

BELLINI, GIOVANNI bel-**lē**-nē, jō-**vän**-nē
m. Venetian painter, c. 1430–1516

BELLINI, JACOPO bel-**lē**-nē, **yä**-kō-pō
m. Venetian painter, c. 1400–70/1

BELLMER, HANS **bel**-mər, häns
m. French (b. Poland) painter, etcher, 1902–75

BELLOWS, GEORGE WESLEY **bel**-lōz, jȯrj **wes**-lē
m. American painter, lithographer, 1882–1925

BENEDETTO DA MAJANO bā-nā-**det**-tō dä mä-**yä**-nō
m. Florentine sculptor, 1442–97

BÉNÉDIT, LUIS FERNANDO bā-nā-**dēt**, lü-**ēs** fer-**nän**-dō
m. Argentine painter, sculptor, 1937–

BENGLIS, LYNDA **beng**-gləs, **lin**-də
f. American sculptor, 1941–

BENOIS, ALEXANDRE (ALEKSANDR) ben-wä, ä-leg-zän-dr'
(əl-yik-**sän**-dər)
m. Russian painter, 1870–1960

BENOIT, RIGAUD ben-wä, rē-gō
m. Haitian painter, 1911–

BENSON, AMBROSIUS **ben**-sən, äm-**brō**-zē-ues
m. Flemish painter, act. 1519–50

BENTON, THOMAS HART **bent**-ən, **täm**-əs härt
m. American painter, 1889–1975

BERCHEM, NICOLAES **ber**-kəm, **nē**-kō-läs
m. Dutch painter, 1620–83

BERCKHEYDE, GERRIT ADRIAENSZ. berk-hī-də, **ker**-rit or
ger-rit **ä**-drē-äns
m. Dutch painter, 1638–98

BERG, CLAUS berg, klaůs
m. German sculptor, before 1485–after 1532

BERGHE, FRITS VAN DEN **ber**-gə, frits fən den
m. Belgian painter, printmaker, 1883–1939

BERLINGHIERI, BERLINGHIERO ber-lin-**gyā**-rē, ber-lin-**gyā**-rō
m. Milanese painter, act. 1228

BERMAN, EUGENE **bər**-mən, yü-**jēn**
m. American (b. Russia) painter, 1899–1972

BERMEJO, BARTOLOMÉ ber-**me**-kō, bär-tō-lō-**mā**
m. Spanish painter, c. 1435–95

BERMÚDEZ, CUNDO ber-**mü**-thes, **kün**-dō
m. Cuban (act. Puerto Rico) painter, 1914–

BERMÚDEZ, JOSÉ ber-**mü**-thes, kō-**sā**
m. Cuban painter, sculptor, 1922–

BERNAL, LOUIS CARLOS **bər**-nal, **lü**-ē **kär**-los
m. American photographer, 1941–

BERNARD, ÉMILE ber-när, ā-mēl
m. French painter, printmaker, 1868–1941

BERNI, ANTONIO **ber**-nē, än-**tōn**-yō
m. Argentine painter, 1905–81

BERNINI, GIOVANNI LORENZO (GIANLORENZO)
 ber-**nē**-nē, jō-**vän**-nē lō-**rent**-sō
 (jän-lō-**rent**-sō)
m. Roman sculptor, draughtsman, architect, 1598–1680

BERRUGUETE, ALONSO ber-rü-**gwā**-tā, ä-**lón**-sō
m. Spanish sculptor, painter, c. 1488–1561

BERRUGUETE, PEDRO ber-rü-**gwā**-tā, **pe**-thrō
m. Spanish painter, d. 1504

BESNARD, ALBERT bā-när, äl-ber
m. French painter, printmaker, 1849–1934

BEUYS, JOSEPH bȯis, **yō**-zef
m. German draughtsman, sculptor, 1921–86

BEVAN, ROBERT **be**-vən, **räb**-ərt
m. English painter, 1865–1925

BEWICK, THOMAS **byü**-ik, **täm**-əs
m. English engraver, 1753–1828

BEYEREN, ABRAHAM HENDRICKSZ. VAN
bi-ər-ən, **ä**-brä-häm **hen**-dricks fən
m. Dutch painter, 1620/1–90

BIEDERMAN, CHARLES **bē**-dər-mən, chärlz
m. American painter, sculptor, 1906–

BIERSTADT, ALBERT **bēr**-stat, **al**-bərt
m. American (b. Germany) painter, 1830–1902

BIGAUD, WILSON bē-gō, **wil**-sən
m. Haitian painter, 1931–

BIGBEAR, FRANK JR. big-ber, frangk
m. American (Chippewa) draughtsman, 1953–

BIGGERS, JOHN **big**-ərz, jän
m. American painter, 1924–

BILL, MAX bil, mäks
m. Swiss painter, sculptor, 1908–

BING, ILSE bing, **ēl**-sə
f. American (b. Germany) photographer, 1899–

BINGHAM, GEORGE CALEB **bing**-əm, jȯrj **kā**-ləb
m. American painter, 1811–79

BIRCH, WILLY bərch, **wil**-ē
m. American sculptor, painter, 1942–

BIRD, FRANCIS bərd, **fran**-sis
m. English sculptor, 1667–1731

BIRD, LYNDSAY (MPETYANE) bərd, **lin**-zē (m-pe-chä-nē)
m. Australian (Anmatyerre) painter, c. 1935–

BIROLLI, RENATO bē-**rōl**-lē, rā-**nä**-tō
m. Italian painter, 1906–59

BISCHOF, WERNER **bē**-shȯf, **ver**-nər
m. Swiss photographer, 1916–54

BISHOP, ISABEL **bish**-əp, **iz**-ə-bel
f. American painter, printmaker, 1902–88

BISSCHOP, JAN **bēs**-shȯp, yän
m. Dutch draughtsman, 1628–71

BISSIÈRE, ROGER bēs-yer, rō-zhā
m. French painter, designer, 1888–1964

BLACKOWL, ARCHIE blak-aůl, **är**-chē
m. American (Cheyenne) painter, 1911–

BLAKE, PETER blāk, **pē**-tər
m. English painter, 1932–

BLAKE, WILLIAM blāk, **wil**-yəm
m. English engraver, painter, poet, 1757–1827

BLANCHARD, MARIA GUTIERRIEZ bläⁿ-shär, mä-**rē**-ä gü-**tyer**-yeth
f. Spanish (act. France) painter, 1881–1932

BLANCHE, JACQUES-ÉMILE bläⁿsh, zhak–ā-mēl
m. French painter, 1861–1942

BLECHEN, KARL **ble**-k̲ən, kärl
m. German painter, 1798–1840

BLECKNER, ROSS **blek**-nər, rȯs
m. American painter, 1949–

BLES, HERRI MET DE (CIVETTA) bles, **her**-rē met də (chē-**vet**-tä)
m. Netherlandish painter, c. 1500/10–after 1550

BLOEMAERT, ABRAHAM **blü**-märt, **ä**-brä-häm
m. Dutch painter, 1564–1651

BLONDEEL, LANCELOT blȯn-**dāl**, **län**-sā-lȯt
m. Flemish painter, 1496–1561

BOCCIONI, UMBERTO bȯt-**chō**-nē, üm-**ber**-tō
m. Italian painter, sculptor, 1882–1916

BÖCKLIN, ARNOLD **bœk**-lin, **är**-nȯlt
m. Swiss painter, 1827–1901

BOETHUS bō-**ē**-thəs
m. Greek sculptor, 2nd c. BC

BOILLY, LOUIS-LÉOPOLD bwä-yē, lü-ē–lā-ō-pōl
m. French painter, 1761–1845

BOIZOT, SIMON-LOUIS bwä-zō, sē-mōⁿ–lü-ē
m. French sculptor, 1743–1809

BOL, FERDINAND bȯl, **fer**-dē-nänt
m. Dutch painter, printmaker, 1616–80

BOLDINI, GIOVANNI bōl-**dē**-nē, jō-**vän**-nē
m. Italian painter, 1842–1931

BOLOGNA, GIOVANNI OR BOULOGNE, JEAN:
see GIAMBOLOGNA

BOLOTOWSKY, ILYA bȯ-lȯ-**tȯv**-skē, **ēl**-yä
m. American (b. Russia) painter, 1907–81

BOLTANSKI, CHRISTIAN bōl-**tän**-skē, krēs-tyän
m. French sculptor, conceptual artist, 1944–

BOLTRAFFIO, GIOVANNI ANTONIO bōl-**träf**-fē-ō, jō-**vän**-nē än-**tōn**-yō
m. Milanese painter, 1466/7–1516

BOMBOIS, CAMILLE bōm-bwä, kä-mē-y'
m. French painter, 1883–1970

BONEVARDI, MARCELO bō-nä-**vär**-dē, mär-**sä**-lō
m. Argentine painter, 1929–

BONHEUR, ROSA bōn-œr, rō-zä
f. French painter, 1822–99

BONIFAZIO VERONESE bō-nē-**fät**-sē-ō vā-rō-**nā**-zā
m. Venetian painter, 1487–1553

BONINGTON, RICHARD PARKES **bän**-ing-tən, **rich**-ərd pärks
m. English (act. France) painter, 1802–28

BONNARD, PIERRE bȯn-när, pyer
m. French painter, 1867–1947

BONNAT, LÉON bȯn-nä, lā-ōⁿ
m. French painter, 1833–1922

BONTECOU, LEE **bän**-tə-kü, lē
f. American sculptor, printmaker, 1931–

BONTEMPS, PIERRE bōⁿ-täⁿ, pyer
m. French sculptor, c. 1505/10–68

BOOTH, PETER büth, **pē**-tər
m. Australian (b. England) painter, 1940–

BORDONE, PARIS bȯr-**dō**-nā, **pä**-rēs
m. Venetian painter, 1500–71

BORDUAS, PAUL-ÉMILE bȯr-due-ä, pōl–ā-mēl
m. Canadian painter, 1905–60

BORGES, JACOBO **bȯr**-kes, yä-**kō**-vō
m. Venezuelan painter, 1931–

BORGLUM, GUTZON **bȯr**-gləm, **gət**-sən
m. American sculptor, 1867–1941

BORGOGNONE, AMBROGIO FOSSANO
 bȯr-gō-**nyō**-nā, äm-**brō**-jō fȯs-**sä**-nō
m. Milanese sculptor, act. c. 1481–1523

BORGOÑA, JUAN DE bȯr-**gōn**-yä, ḵwän dā
m. Spanish painter, act. c. 1494–1554

BORISOV-MUSATOV, VIKTOR bə-**rē**-sȯf–mü-**sä**-tȯf, **vēk**-tȯr
m. Russian painter, 1870–1905

BOROFSKY, JONATHAN bȯ-**rȯf**-skē, jän-ə-thən
m. American painter, sculptor, installation artist, 1942–

BORRASSÁ, LUÍS bȯr-räs-**sä**, lü-**ēs**
m. Catalan painter, d. c. 1425

BOSBOOM, JOHANNES **bȯs**-bōm, yō-**hän**-es
m. Dutch painter, 1817–91

BOSCH, HIERONYMUS bȯs or bäsh, hir-**ȯn**-i-məs or
 hir-**än**-i-mus
m. Dutch painter, c. 1450–1516

BOSIN, BLACKBEAR **bō**-sin, blak-ber
m. American (Kiowa) painter, 1921–80

BOSSCHAERT, AMBROSIUS THE ELDER **bȯs**-shärt, äm-**brō**-zē-ues
m. Flemish painter, 1573–1621

BOSSE, ABRAHAM bȯs, ä-brä-häm
m. French engraver, 1602–76

BOSTON, PAUL **bȯs**-tən, pȯl
m. Australian painter, 1952–

BOTERO, FERNANDO bō-**tä**-rō, fer-**nän**-dō
m. Colombian painter, 1932–

BOTH, JAN bōt, yän
m. Dutch painter, printmaker, c. 1618–52

BOTTICELLI, SANDRO bȯt-tē-**chel**-lē, **sänd**-rō
m. Florentine painter, 1445–1510

BOTTICINI, FRANCESCO bȯt-tē-**chē**-nē, frän-**ches**-kō
m. Florentine painter, 1446–97

BOUCHARDON, EDME bü-shär-dōn, ed-m'
m. French sculptor, 1698–1762

BOUCHER, FRANÇOIS bü-shā, frän-swä
m. French painter, 1703–70

BOUDIN, LOUIS-EUGÈNE bü-dan, lü-ē–œ-zhen
m. French painter, 1824–98

BOUGUEREAU, ADOLPHE-WILLIAM bü-gə-rō, a-dȯlf–vil-yäm
m. French painter, 1825–1905

BOUGUEREAU, ELIZABETH JANE GARDNER
 bü-gə-rō, ə-**liz**-ə-bəth jān **gärd**-nər
f. American painter, 1837–1922

BOURDELLE, ÉMILE-ANTOINE bür-del, ā-mēl–än-twän
m. French sculptor, 1861–1929

BOURDICHON, JEAN bür-dē-shōn, zhän
m. French painter, c. 1457–1521

BOURDON, SÉBASTIEN bür-dōn, sā-bas-tyan
m. French painter, 1616–71

BOURGEOIS, LOUISE bür-**zhwä**, lü-**ēz**
f. American (b. France) sculptor, 1911–

BOURGET, MARIE bür-zhā, ma-rē
f. French sculptor, 1952–

BOURKE-WHITE, MARGARET bərk–hwīt, **mär**-gə-rət
f. American photographer, 1904–71

BOUTS, DIRK THE ELDER baůts, dērk
m. Flemish painter, c. 1420–75

BOYD, ARTHUR bȯid, **är**-thər
m. Australian painter, ceramicist, 1920–

BOYER, BOB **bȯi**-yər, bäb
m. Canadian (Metis) installation artist, 1948–

BOYS, THOMAS SHOTTER bȯiz, **täm**-əs **shä**-tər
m. English painter, printmaker, 1803–74

BOZA, JUAN **bō**-sä, k̲wän
m. Cuban (act. United States) lithographer, installation artist, 1941–

BRACK, CECIL JOHN brak, **se**-səl jän
m. Australian painter, draughtsman, 1920–

BRACQUEMOND, FÉLIX brak-mōn, fā-lēks
m. French engraver, painter, 1833–1914

BRADY, CAROLYN **brā**-dē, **ka**-rō-lin
f. American painter, 1937–

BRADY, MATHEW B. **brā**-dē, **math**-yü
m. American photographer, 1823–96

BRAMANTINO (BARTOLOMMEO SUARDI)
 brä-män-**tē**-nō
 (bär-tō-lō-**mä**-ō sü-**är**-dē)
m. Milanese painter, c. 1460–1530

BRAMER, LEONAERT **brä**-mər, **lā**-ȯ-närt
m. Dutch painter, 1596–1674

BRANCUSI, CONSTANTIN **bräng**-küsh or brän-**kü**-zē,
 kȯn-stän-tēn
m. Rumanian sculptor, 1876–1957

BRANDT, BILL brant, bil
m. English photographer, 1904–83

BRANGWYN, FRANK **brang**-win, frangk
m. Welsh painter, printmaker, 1867–1956

BRAQUE, GEORGES bräk, zhȯrzh
m. French painter, 1882–1963

BRASSAÏ (GYULA HALÁSZ) brä-**sä**-ē (**jü**-lä **hä**-läsh)
m. French (b. Hungary) photographer, 1899–1984

BRATBY, JOHN **brat**-bē, jän
m. English painter, 1928–92

BRAVO, CLAUDIO **brä**-vō, **klaủ**-dē-ō
m. Chilean (act. Tangier) painter, draughtsman, 1936–

BREENBERGH, BARTOLOMEUS **brān**-berk̲ or **brān**-berg,
 bär-tō-lō-**mā**-ủs
m. Dutch painter, 1598/1600–1657

BREGNO, ANDREA **brā**-nyō, än-**drā**-ä
m. Roman sculptor, 1418–1506

BREHME, HUGO **brā**-mə, **hü**-gō
m. Mexican (b. Germany) photographer, 1882–1954

BREITNER, GEORGE HENDRIK **brit**-nər, **gā**-òrg **hen**-drik
m. Dutch painter, 1857–1923

BRESDIN, RODOLPHE brā-dan, rò-dòlf
m. French watercolorist, lithographer, 1822–85

BRETON, JULES brə-tōn, zhuel
m. French painter, 1827–1906

BRETT, JOHN bret, jän
m. English painter, 1830–1902

BREU, JÖRG THE ELDER bròi, yœrg
m. German (Augsburg) painter, 1475/6–1537

BREU, JÖRG THE YOUNGER bròi, yœrg
m. German (Augsburg) painter, c. 1510–47

BRIÈRRE, MURAT brē-er, mue-rä
m. Haitian sculptor, 1938–

BRIL, PAUL bril, paủl
m. Flemish painter, 1554–1626

BRIULLOV (BRYULLOV), KARL PAVLOVICH
 brü-**lòf**, kärl **päv**-lō-vich
m. Russian painter, 1799–1852

BRIZZI, ARY **brē**-sē, **ä**-rē
m. Argentine painter, 1930–

BROEDERLAM, MELCHIOR **brü**-dər-läm, **mel**-kē-ȯr
m. Flemish painter, act. 1381–1409

BRONCKHORST, JAN GERRITSZ. VAN **brȯngk**-hȯrst, yän **ker**-rits or
ger-rits fən
m. Dutch painter, 1603–61

BRONZINO, AGNOLO brȯn-**dzē**-nō, **än**-yō-lō
m. Florentine painter, 1503–72

BROODTHAERS, MARCEL **brōt**-härs, mär-sel
m. Belgian multimedia artist, 1924–76

BROOKS, ROMAINE brȯks, rō-**män**
f. American painter, 1874–1970

BROUWER, ADRIAEN **braů**-ər, **ä**-drē-än
m. Flemish painter, 1605/6–38

BROWN, FORD MADOX braůn, fȯrd **mad**-əks
m. English painter, 1821–93

BROWN, FREDERICK braůn, **fred**-rik
m. American painter, 1945–

BROWN, SAMUEL JOSEPH braůn, **sam**-yü-əl **jō**-zəf
m. American painter, 1907–

BROWNE, VIVIAN E. braůn, **viv**-ē-ən
f. American painter, collagist, 1929–

BROWNSCOMBE, JENNIE AUGUSTA **braůnz**-kəm, **jen**-nē ȯ-**gəs**-tə
f. American painter, 1850–1936

BRUEGEL, PIETER THE ELDER **brœ**-kəl or **brœ**-gəl or
brȯi-gəl, **pē**-tər
m. Flemish painter, c. 1525–69

BRUEGHEL, JAN THE ELDER **brœ**-kəl or **brœ**-gəl or
brȯi-gəl, yän
m. Flemish painter, 1568–1625

BRUGUIÈRE, FRANCIS **brü**-gē-**er**, **fran**-sis
m. American photographer, 1880–1945

BRUNELLESCHI, FILIPPO brü-ne-**les**-kē, fē-**lip**-pō
m. Florentine sculptor, architect, 1377–1446

BUFFET, BERNARD bœ-fä, ber-när
m. French painter, 1928–

BUITRÓN, ROBERT C. bwē-**trän**, **räb**-ərt
m. American photographer, 1953–

BUNNY, RUPERT **bən**-ē, **rü**-pərt
m. Australian painter, 1864–1947

BURCHFIELD, CHARLES **bərch**-fēld, chärlz
m. American painter, 1893–1967

BURDEN, CHRIS **bərd**-ən, kris
m. American conceptual artist, sculptor, 1946–

BUREN, DANIEL bue-rän, dän-yel
m. French painter, conceptual artist, 1938–

BURGKMAIR, HANS THE ELDER **bürk**-mir, häns
m. German (Augsburg) painter, 1473–1531

BURLIUK, DAVID DAVIDOVICH bür-**lük**, də-**vēd** də-**vēd**-ō-vich
m. American (b. Russia) painter, 1882–1967

BURLIUK, VLADIMIR DAVIDOVICH bür-**lük**, vlə-**dē**-mir də-**vēd**-ō-vich
m. Russian painter, 1886–1916

BURNE-JONES, EDWARD COLEY bərn–jōnz, **ed**-wərd **kō**-lē
m. English painter, 1833–98

BURRA, EDWARD **bər**-ə, **ed**-wərd
m. English painter, 1905–76

BURRI, ALBERTO **bür**-rē, äl-**ber**-tō
m. Italian painter, collagist, 1915–

BURRI, RENÉ **bür**-rē, rə-nā
m. Swiss photographer, 1933–

BURSON, NANCY **bər**-sən, **nan**-sē
f. American composite photographer, 1948–

BURY, POL bue-rē, pōl
m. Belgian sculptor, painter, 1922–

BUSH, JACK HAMILTON bush, jak **ham**-əl-tən
m. Canadian painter, 1909–77

BUSHNELL, JOHN **bush**-nəl, jän
m. English sculptor, c. 1630–1701

BUSTELLI, FRANZ ANTON bü-**stel**-lē, fräns **än**-tòn
m. Swiss sculptor, ceramicist, 1723–63

BUTLER, REG **bət**-lər, rej
m. English sculptor, 1913–81

BUTTERFIELD, DEBORAH **bət**-ər-fēld, **deb**-ə-rə
f. American sculptor, 1949–

BUYTEWECH, WILLEM PIETERSZ. **bœē**-tə-vek or
 bòi-tə-vek, **vil**-əm **pē**-tərs
m. Dutch painter, engraver, 1591/2–1624

BYARD, CAROLE MARIE **bi**-ərd, **ka**-rəl mə-**rē**
f. American sculptor, draughtsman, 1941–

CABANEL, ALEXANDRE kä-bä-nel, ä-leg-zän-dr'
m. French painter, 1823–89

CABELLERO, LUIS kä-vä-**yä**-rō, lü-**ēs**
m. Colombian (act. France) painter, draughtsman, 1943–

CABRERA, MIGUEL kä-**vrä**-rä, mē-**gel**
m. Mexican painter, 1695–1768

CADMUS, PAUL **kad**-məs, pȯl
m. American painter, printmaker, 1904–

CAILLEBOTTE, GUSTAVE kī-yə-bȯt, gᵿes-täv
m. French painter, 1848–94

CALAME, ALEXANDRE kä-läm, ä-leg-zän-dr'
m. Swiss painter, printmaker, 1810–64

CALATRAVA, SANTIAGO kä-lä-**trä**-vä, sän-**tyä**-gō
m. Spanish sculptor, architect, 1951–

CALDER, ALEXANDER **kȯl**-dər, a-leg-**zan**-dər
m. American sculptor, 1898–1976

CALLAHAN, HARRY **kal**-ə-han, **har**-ē
m. American photographer, 1912–

CALLCOTT, AUGUSTUS WALL **kȯl**-kət, ȯ-**gəs**-təs wȯl
m. English painter, 1779–1844

CALLE, SOPHIE käl, sō-fē
f. French photographer, 1953–

CALLIMACHUS kə-**lim**-ə-kəs
m. Greek sculptor, late 5th c. BC

CALLIS, JO ANN **kal**-əs, jō an
f. American photographer, 1940–

CALLOT, JACQUES kal-lō, zhak
m. French engraver, draughtsman, 1592–1635

CALVAERT, DENYS **käl**-värt, də-**nē**
m. Flemish (act. Italy) painter, c. 1540–1619

CALVERT , EDWARD **kal**-vərt, **ed**-wərd
m. English painter, 1799–1883

CAMACHO, JORGE kä-**mä**-chō, **kȯr**-k̠ä
m. Cuban (act. France) painter, 1934–

CAMBIASO, LUCA käm-bē-**ä**-zō, **lü**-kä
m. Genoese painter, 1527–85

CAMERON, JULIA MARGARET **kam**-ə-rən, **jül**-yə **mär**-gə-rət
f. English photographer, 1815–79

CAMNITZER, LUIS **käm**-nit-sər, lü-**ēs**
m. Uruguayan (b. Germany) mixed-media artist, 1937–

CAMPAGNOLA, DOMENICO käm-pän-**yō**-lä, dō-**mä**-nē-kō
m. Paduan painter, printmaker, c. 1484–1562

CAMPANIA, PEDRO DE (PIETER DE KEMPENEER)
 käm-**pä**-nyä, **pā**-t̠hrō dä
 (**pē**-tər də **kem**-pə-nār)
m. Flemish (act. Spain) painter, 1503–80

CAMPENDONK, HEINRICH **käm**-pen-do̅ngk, **hin**-rik̠
m. German painter, draughtsman, 1889–1957

CAMPHUIJSEN, GOVERT DIRCKSZ. **kämp**-hœē-zən or **kämp**-ho̅i-zən,
 k̠ō-vərt or **gō**-vərt dērks
m. Dutch painter, 1623/4–72

CAMPIGLI, MASSIMO käm-**pēl**-yē, **mäs**-sē-mō
m. Italian painter, 1895–1971

CAMPUS, PETER **kam**-pəs, **pē**-tər
m. American photographer, video artist, 1937–

CANALETTO (BERNARDO BELLOTTO) kä-nä-**let**-tō (ber-**när**-dō bel-**lòt**-tō)
m. Venetian painter, 1720–80

CANALETTO (GIOVANNI ANTONIO CANAL)
 kä-nä-**let**-tō
 (jō-**vän**-nē än-**tōn**-yō kä-**näl**)
m. Venetian painter, 1697–1768

CANNON, T. C. **kan**-ən
m. American (Caddo/Kiowa) painter, 1946–78

CANO, ALONSO **kä**-nō, ä-**lón**-thō
m. Spanish sculptor, painter, 1601–67

CANOVA, ANTONIO kä-**nō**-vä, än-**tōn**-yō
m. Roman sculptor, 1757–1822

CAPA, ROBERT **kap**-ə, **räb**-ert
m. American photographer, 1913–54

ČAPEK, JOSEF **chä**-pek, **yō**-zef
m. Czech painter, 1887–1945

CAPONIGRO, PAUL ka-pə-**nē**-grō, pòl
m. American photographer, 1932–

CAPPELLE, JAN VAN DE käp-**pel**-lə, yän fən də
m. Dutch painter, 1624–79

CARACCIOLO, GIOVANNI BATTISTA kä-rä-**chō**-lō, jō-**vän**-nē bät-**tē**-stä
m. Neapolitan painter, 1578–1635

CARAVAGGIO, MICHELANGELO kä-rä-**väj**-ō, mē-kel-**än**-jä-lō
m. Roman painter, 1571–1610

CÁRDENAS, AGUSTÍN **kär**-dā-näs, ä-gü-**stēn**
m. Cuban (act. France) sculptor, 1927–

CÁRDENAS, SANTIAGO **kär**-dā-näs, sänt-**yä**-gō
m. Colombian painter, 1937–

CARDILLO, RIMER kär-**dē**-yō, **rē**-mer
m. Uruguayan (act. United States) painter, 1944–

CARDINAL-SCHUBERT, JOANE **kär**-də-nəl–**shü**-bert, jōn
f. Canadian (Metis) installation artist, 1942–

CARLEVARIS, LUCA kär-lä-**vä**-rēs, **lü**-kä
m. Venetian painter, 1663–1730

CARLSTEDT, JOHN BIRGER JARL **kärl**-shtet, yòn **bēr**-gər yärl
m. Finnish painter, 1907–75

CARMICHAEL, FRANKLIN **kär**-mī-kəl, **frangk**-lin
m. Canadian painter, printmaker, 1890–1945

CARO, ANTHONY **kä**-rō, **an**-tə-nē
m. English sculptor, 1924–

CAROLUS-DURAN, CHARLES-ÉMILE-AUGUSTE
 kä-rō-lues–due-rän,
 shärl–ā–mēl–ō-guest
m. French painter, 1838–1917

CARON, ANTOINE ka-rōn, än-twän
m. French painter, c. 1520–c. 1600

CAROSELLI, ANGELO kä-rō-**sel**-lē, **än**-jā-lō
m. Italian painter, 1585–1653

CAROTO, GIOVANNI FRANCESCO kä-**rò**-tō, jō-**vän**-nē frän-**ches**-kō
m. Veronese painter, c. 1480–1555

CARPACCIO, VITTORE kär-**päch**-ō, vit-**tō**-rā
m. Venetian painter, c. 1450/60–1525/6

CARPEAUX, JEAN-BAPTISTE kär-pō, zhän–bat-tēst
m. French sculptor, painter, printmaker, 1827–75

CARR, EMILY kär, **em**-ə-lē
f. Canadian painter, 1871–1945

CARRÀ, CARLO **kär**-rä, **kär**-lō
m. Italian painter, 1881–1966

CARRACCI, AGOSTINO kär-**räch**-ē, ä-gō-**stē**-nō
m. Bolognese painter, 1557–1602

CARRACCI, ANNIBALE kär-**räch**-ē, än-nē-**bäl**-lā
m. Bolognese painter, 1560–1609

CARRACCI, LUDOVICO kär-**räch**-ē, lü-**dō**-vē-kō
m. Bolognese painter, 1555–1619

CARRASCO, BARBARA kär-**räs**-kō, **bär**-bä-rä
f. American mixed-media artist, 1955–

CARREÑO, MARIO kär-**rān**-yō, **mär**-yō
m. Cuban (act. Chile) painter, 1913–

CARREÑO DE MIRANDA, JUAN kär-**rān**-yō dā mē-**rän**-dä, ḵwän
m. Spanish painter, 1614–85

CARRIERA, ROSALBA kär-**rē-ā**-rä, rōz-**äl**-bä
f. Venetian painter, 1675–1757

CARRIÈRE, EUGÈNE kär-yer, œ-zhen
m. French painter, 1849–1906

CARRILLO, EDUARDO kär-**rē**-yō, ō-**thwär**-thō
m. American painter, 1937–

CARRINGTON, LEONORA **ka**-ring-tən, lā-ə-**nȯ**-rə
f. British painter, 1917–

CARSTENS, ASMUS JACOB **kär**-stəns, **äs**-mu̇s **yä**-kȯb
m. German (b. Denmark) draughtsman, 1754–98

CASAS, MELESIO **kä**-säs, mā-**lās**-yō
m. American painter, 1929–

CASASOLA, VICTOR kä-sä-**sō**-lä, vēk-**tȯr**
m. Mexican photographer, 1874–1938

CASEBERE, JAMES **kā**-sə-bēr, jāmz
m. American photographer, 1953–

CASSATT, MARY kə-**sat**, **mer**-ē
f. American painter, 1844–1926

CASTELLANI, ENRICO kä-stel-**lä**-nē, en-**rē**-kō
m. Italian painter, 1930–

CASTELLANOS, JULIO käs-tä-**yä**-nōs, **kül**-yō
m. Mexican painter, 1905–47

CASTEÑADA, ALFREDO kä-stä-**nyä**-thä, äl-**frä**-thō
m. Mexican painter, 1932–

CASTIGLIONE, GIOVANNI BENEDETTO kä-stēl-**yō**-nā,
jō-**vän**-nē bā-nā-**det**-tō
m. Genoese painter, printmaker, c. 1610–65

CASTILLO, JORGE kä-**stē**-yō, **kȯr**-kä
m. Spanish painter, 1933–

CASTRO-CID, ENRIQUE **käs**-trō–sēth, en-**rē**-kä
m. Chilean sculptor, installation artist, 1937–

CATENA, VINCENZO kä-**tä**-nä, vēn-**chen**-dzō
m. Venetian painter, c. 1470–1531

CATLETT, ELIZABETH **kat**-lət, ə-**liz**-ə-bəth
f. American (act. Mexico) sculptor, 1915–

CATLIN, GEORGE **kat**-lən, jȯrj
m. American painter, 1796–1872

CAULFIELD, PATRICK **kȯl**-fēld, **pat**-rik
m. English painter, printmaker, 1936–

CAVALCANTI, EMILIANO DI kä-väl-**kän**-tē, ā-mēl-**yä**-nō dē
m. Brazilian painter, 1897–1976

CAVALLINI, PIETRO kä-väl-**lē**-nē, **pyä**-trō
m. Roman painter, act. 1273–1308

CAVALLINO, BERNARDO kä-väl-**lē**-nō, ber-**när**-dō
m. Neapolitan painter, 1616–56?

CELLINI, BENVENUTO chel-**lē**-nē, ben-vā-**nü**-tō
m. Florentine sculptor, 1500–71

CELMINS, VIJA **sel**-minz, **vē**-yä
f. American (b. Latvia) sculptor, draughtsman, 1939–

CEPHISODOTUS se-fi-**sä**-də-təs
m. Greek (Athens) sculptor, early 4th c. BC

CERQUOZZI, MICHELANGELO cher-**kwȯt**-sē, mē-kel-**än**-jā-lō
m. Roman painter, 1602–60

CERVÁNTEZ, YREINA D. ser-**vän**-tes, ē-**rā**-nä
f. American painter, 1952–

CÉSAR (CÉSAR BALDACCINI) sā-zär (sā-zär bäl-dä-**chē**-nē)
m. French sculptor, 1921–

CESARE DA SESTO **chä**-zä-rā dä **ses**-tō
m. Milanese painter, 1477–1523

CESARI, GIUSEPPE **chä**-zä-rē, jü-**zep**-pā
m. Roman painter, 1560/8–1640

CÉZANNE, PAUL sā-zan, pōl
m. French painter, 1839–1906

CHADWICK, LYNN **chad**-wik, lin
m. English sculptor, 1914–

CHAGALL, MARC sha-gal, märk
m. French (b. Russia) painter, printmaker, 1887–1985

CHAMPAIGNE, PHILIPPE DE shäⁿ-pa-ny', fē-lēp de
m. French (b. Flanders) painter, 1602–74

CHANTREY, FRANCIS **chan**-trē, **fran**-sis
m. English sculptor, painter, 1781–1841

CHARDIN, JEAN-BAPTISTE-SIMÉON shar-daⁿ, zhäⁿ–bat-tēst–sē-mā-ōⁿ
m. French painter, 1699–1779

CHARLESWORTH, BRUCE **chärlz**-werth, brüs
m. American photographer, 1950–

CHARLESWORTH, SARAH **chärlz**-werth, **ser**-e
f. American photographer, 1947–

CHARLOT, JEAN **shär**-lō, zhäⁿ
m. Mexican (b. France) painter, 1898–1974

CHARONTON, ENGUERRAND sha-rōⁿ-tōⁿ, äⁿ-ger-räⁿ
m. French painter, c. 1410–61

CHASE, WILLIAM MERRITT chās, **wil**-yem **mer**-et
m. American painter, 1849–1916

CHASSÉRIAU, THÉODORE shas-sā-rē-ō, tā-ō-dòr
m. French painter, 1819–56

CHAVEZ, EDUARDO **chä**-ves, ā-**thwär**-<u>th</u>ō
m. American painter, 1917–

CHÁVEZ, HUMBERTO **chä**-ves, ùm-**ber**-tō
m. Cuban (act. United States) sculptor, 1937–

CHIA, SANDRO **kē**-ä, **sänd**-rō
m. Italian painter, sculptor, 1945–

CHICAGO, JUDY she-**kä**-gō, **jü**-dē
f. American painter, sculptor, 1939–

CHILLIDA, EDUARDO chē-**yē**-<u>th</u>ä, ā-**thwär**-<u>th</u>ō
m. Spanish sculptor, printmaker, 1924–

CHIN, MEL chin, mel
m. American sculptor, environmental artist, 1951–

CHINNERY, GEORGE **chin**-e-rē, jòrj
m. English painter, 1774–1852

CHIRICO, GIORGIO DE kē-rē-kō, jȯr-jō dā
m. Italian painter, 1888–1978

CHODOWIECKI, DANIEL NIKOLAUS kō-dō-**vyek**-ē, **dän**-yel **nē**-kō-laùs
m. German (b. Poland) painter, draughtsman, printmaker,
1726–1801

CHONG, ALBERT chȯng, **al**-bərt
m. Jamaican photographer, 1958–

CHRISTMAN, GUNTER **krist**-mən, **gùn**-tər
m. Australian (b. Germany) painter, 1936–

CHRISTO (CHRISTO VLADIMIROV JAVACHEFF)
 kris-tō
 (**kris**-tō vlə-dē-**mir**-ȯf **yä**-və-chef)
m. Bulgarian sculptor, environmental artist, 1935–

CHRISTUS, PETRUS **krē**-stuⁱs or
 kris-tùs, **pā**-truⁱs or **pet**-rùs
m. Flemish painter, c. 1410–72/3

CHRYSSA **krē**-sä
f. American (b. Greece) sculptor, 1933–

CHURCH, FREDERICK EDWIN chərch, **fred**-rik **ed**-win
m. American painter, 1826–1900

CIGNANI, CARLO chē-**nyä**-nē, **kär**-lō
m. Bolognese painter, 1628–1719

CIGNAROLI, GIANBETTINO chē-nyä-**rō**-lē, jän-bät-**tē**-nō
m. Veronese painter, 1706–70

CIGOLI, IL (LUDOVICO CARDI) **chē**-gō-lē, ēl (lü-**dō**-vē-kō **kär**-dē)
m. Florentine painter, 1559–1613

CIMA DA CONEGLIANO, GIOVANNI BATTISTA
 chē-mä dä kȯ-nāl-**yä**-nō,
 jō-**vän**-nē bät-**tē**-stä
m. Venetian painter, 1459/60–1517/8

CIMABUE (CENNI DI PEPE) chē-mä-**bü**-ā (**chen**-nē dē **pā**-pē)
m. Florentine painter, c. 1240–1302

CIMON OF CLEONAE **si**-mən, klē-**ō**-nē
m. Greek painter, late 6th c. BC

CIPRIANI, GIOVANNI BATTISTA chē-prē-**ä**-nē, jō-**vän**-nē bät-**tē**-stä
m. Florentine (act. England) painter, engraver, 1727–85

CLAESZ., PIETER kläs, **pē**-tər
m. Dutch painter, 1597/8–1661

CLARK, CLAUDE klärk, klȯd
m. American painter, 1915–

CLARK, LYGIA klärk, **lē**-jē-ä
f. Brazilian sculptor, 1920–88

CLARKE, GEOFFREY klärk, **jef**-rē
m. English sculptor, 1924–

CLAUDEL, CAMILLE klō-del, ka-mē-y'
f. French sculptor, 1864–1943

CLAVÉ, ANTONI klä-vä, än-tō-nē
m. French (b. Spain) painter, 1913–

CLEMENTE, FRANCESCO klä-**men**-tä, frän-**ches**-kō
m. Italian painter, 1952–

CLEMENTS, GABRIELLE DE VEAUX **klem**-ənts, **ga**-brē-**el** də vō
f. American painter, 1858–1948

CLERGUE, LUCIEN klerg, lᴜe-syan
m. French photographer, 1934–

CLODION (CLAUDE MICHEL) klōd-yōn (klōd mē-shel)
m. French sculptor, 1738–1814

CLOSE, CHUCK klōs, chək
m. American painter, photographer, 1940–

CLOUET, FRANÇOIS klü-ä, frän-swä
m. French painter, c. 1510–72

CLOUET, JEAN klü-ä, zhän
m. French painter, c. 1485–1540/1

CLOVIO, GIORGIO GIULIO (JULIJE KLOVIC)
 klōv-yō, **jȯr**-jō **jül**-yō
 (**yül**-yə **klō**-vich)
m. Roman (b. Croatia) painter, 1498–1578

COBURN, ALVIN LANGDON **kō**-bərn, **al**-vin **lang**-dən
m. American photographer, 1882–1966

COCHIN, CHARLES-NICOLAS THE YOUNGER
 kō-shan, shärl–nē-kō-lä
m. French engraver, 1715–90

COCK, JAN DE kȯk, yän də
m. Flemish painter, act. 1506–c. 1526

COCTEAU, JEAN kȯk-tō, zhän
m. French painter, photographer, filmmaker, author, 1889–1963

CODDE, PIETER (JACOBSZ.) **kȯd**-də, **pē**-tər (**yä**-kȯps)
m. Dutch painter, 1599–1678

COECKE VAN AELST, PIETER I kœk fən älst, **pē**-tər
m. Flemish painter, 1502–50

COELLO, CLAUDIO kō-**ä**-yō, **klau̇**-dyō
m. Spanish painter, 1642–93

COLDSTREAM, WILLIAM **kōld**-strēm, **wil**-yəm
m. English painter, 1908–87

COLE, THOMAS kōl, **täm**-əs
m. American painter, 1801–48

COLESCOTT, ROBERT **kōl**-skət, **räb**-ərt
m. American painter, 1925–

COLLA, ETTORE **kōl**-lä, **ät**-tō-rä
m. Italian sculptor, 1899–1968

COLLINS, LARRY **käl**-ənz, **la**-rē
m. American painter, 1945–

COLLYER, ROBIN **käl**-yər, **räb**-in
m. Canadian sculptor, 1951–

COLÓN-MORALES, RAFAEL kō-**lōn**–mō-**rä**-les, rä-fä-**el**
m. Puerto Rican painter, 1941–

COLQUHOUN, ROBERT kō-**hün**, **räb**-ərt
m. British painter, printmaker, 1914–62

COLUNGA, ALEJANDRO kō-**lüng**-gä, ä-lā-**kän**-drō
m. Mexican painter, 1948–

COLVILLE, ALEXANDER **kōl**-vil, a-leg-**zan**-dər
m. Canadian painter, 1920–

CONCA, SEBASTIANO **kōng**-kä, sä-bäst-**yä**-nō
m. Roman painter, 1680–1764

CONDO, GEORGE **kän**-dō, jȯrj
m. American painter, 1967–

CONINXLOO, GILLIS VAN **kō**-ningks-lō, **kil**-is or **gil**-is fən
m. Flemish painter, c. 1544–1607

CONNER, BRUCE **kän**-ər, brüs
m. American assemblage artist, sculptor, 1933–

CONSTABLE, JOHN **kän**-stə-bəl, jän
m. English painter, 1776–1837

CONWILL, HOUSTON **kän**-wil, **hyü**-stən
m. American sculptor, painter, 1947–

COODAY, JESSE kü-**dā**, **jes**-ē
m. American (Tlingit) photographer, 1954–

COOPER, SAMUEL **kü**-pər, **sam**-yü-əl
m. English painter, 1609–72

COORTE, ADRIAEN **kȯr**-tə, **ä**-drē-än
m. Dutch painter, act. 1683–1708

COPLEY, JOHN SINGLETON **käp**-lē, jän **sing**-gəl-tən
m. American painter, c. 1738–1815

COPPO DI MARCOVALDO **kȯp**-pō dē mär-kō-**väl**-dō
m. Sienese painter, c. 1225–c. 1274

COQUES, GONZALES kȯks, gȯn-**thä**-les
m. Flemish painter, 1614/8–84

CORINTH, LOVIS kȯ-**rint**, **lō**-vis
m. German painter, printmaker, 1858–1925

CORMON, FERNAND kȯr-mōⁿ, fer-näⁿ
m. French painter, 1845–1924

CORNEILLE (CORNELIS VAN BEVERLOO) kȯr-nä-y' (kȯr-**nä**-lis fən **bā**-vər-lō)
m. Dutch (b. Belgium, act. France) painter, 1922–

CORNEILLE DE LYON kòr-nā-y' də lyōn
m. French (b. The Hague) painter, c. 1500–74

CORNELISZ. VAN OOSTSANEN (VAN AMSTERDAM), JACOB
kòr-**nā**-lis fən **ōst**-sä-nən
(fən **äm**-stər-däm), **yä**-kòb
m. Dutch painter, printmaker, 1470–1533

CORNELIUS, PETER VON kòr-**nā**-lē-üs, **pā**-tər fòn
m. German painter, 1783–1867

CORNELL, JOSEPH kòr-**nel**, **jō**-zəf
m. American sculptor, 1903–73

CORONEL, PEDRO kò-rò-**nel**, **pā**-<u>th</u>rō
m. Mexican painter, 1923–

CORONEL, RAFAEL kò-rò-**nel**, rä-fä-**el**
m. Mexican painter, 1932–

COROT, JEAN-BAPTISTE CAMILLE kò-rō, zhän–bat-tēst ka-mē-y'
m. French painter, 1796–1875

CORREA, JUAN THE ELDER kòr-**rā**-ä, <u>k</u>wän
m. Mexican painter, 1645/50–1716

CORREGGIO (ANTONIO ALLEGRI DA) kòr-**rej**-ō (än-**tōn**-yō äl-**lā**-grē dä)
m. Northern Italian painter, c. 1489–1534

CORTONA, PIETRO DA kòr-**tō**-nä, **pyā**-trō dä
m. Roman painter, architect, 1596–1669

CORTOR, ELDZIER **kòr**-tər, **eld**-zï-ər
m. American painter, 1915–

COSSA, FRANCESCO DEL **kòs**-sä, frän-**ches**-kō del
m. Ferrarese painter, c. 1435–c. 1477

COSTA, LORENZO THE ELDER **kò**-stä, lō-**rent**-sō
m. Ferrarese painter, c. 1460–1535

COSTA, OLGA **kò**-stä, **òl**-gä
f. Mexican (b. Germany) painter, 1913–

COSWAY, RICHARD **käz**-wā, **rich**-ərd
m. English painter, 1742–1821

COTES, FRANCIS kōts, **fran**-sis
m. English painter, 1726–70

COTMAN, JOHN SELL **kät**-mən, jän sel
m. English painter, 1782–1842

COURBET, GUSTAVE kür-bā, gυes-täv
m. French painter, 1819–77

COURTOIS, JACQUES kür-twä, zhak
m. French painter, 1621–76

COUSIN, JEAN THE ELDER kü-zan, zhän
m. French painter, sculptor, printmaker, author, c. 1490–1560/61

COUSIN, JEAN THE YOUNGER kü-zan, zhän
m. French painter, c. 1522–c. 1594

COUTURE, THOMAS kü-tυer, tō-mä
m. French painter, 1815–79

COVARRUBIAS, MIGUEL kō-vär-**rüb**-yäs, mē-**gel**
m. Mexican painter, illustrator, 1902–57

COX, DAVID THE ELDER käks, **dā**-vid
m. English painter, 1783–1859

COYPEL, ANTOINE kwä-pel, än-twän
m. French painter, 1661–1722

COYPEL, CHARLES-ANTOINE kwä-pel, shärl–än-twän
m. French painter, printmaker, 1696–1751

COYSEVOX, ANTOINE kwä-zə-vō, än-twän
m. French sculptor, 1640–1720

COZENS, ALEXANDER **kəz**-ənz, a-leg-**zan**-dər
m. English draughtsman, 1717–86

COZENS, JOHN ROBERT **kəz**-ənz, jän **räb**-ərt
m. English painter, 1752–99

CRAGG, TONY krag, **tō**-nē
m. English sculptor, 1949–

CRANACH, LUCAS THE ELDER **krä**-näk̲, **lü**-käs
m. German painter, printmaker, 1472–1553

CRANE, WALTER krān, **wȯl**-tər
m. English illustrator, painter, designer, 1845–1915

CRAWFORD, THOMAS **krȯ**-fərd, **täm**-əs
m. American sculptor, 1814–57

CREDI, LORENZO DI **krā**-dē, lō-**rent**-sō dē
m. Florentine painter, c. 1458–1537

CRESPI, DANIELE **krās**-pē, dän-**yä**-lā
m. Milanese painter, c. 1598–1630

CRESPI, GIOVANNI BATTISTA (IL CERANO)
 krās-pē, jō-**vän**-nē bät-**tē**-stä
 (ēl chä-**rä**-nō)
m. Milanese painter, 1567/70–1632

CRESPI, GIUSEPPE MARIA (LO SPAGNUOLO)
 krās-pē, jü-**zep**-pā mä-**rē**-ä
 (lō spän-yü-**ō**-lō)
m. Bolognese painter, printmaker, 1665–1747

CRITE, ALLAN ROHAN krīt, **al**-ən rō-ən
m. American painter, printmaker, 1910–

CRITIUS **krit**-ē-ús or **krish**-əs
m. Greek (Athens) sculptor, early 5th c. BC

CRIVELLI, CARLO krē-**vel**-lē, **kär**-lō
m. Venetian painter, c. 1430–93

CROME, JOHN krōm, jän
m. English painter, 1768–1821

CROPSEY, JASPER FRANCIS **cräp**-zē, **jas**-pər **fran**-sis
m. American painter, 1823–1900

CROSS, HENRI-EDMOND krȯs, äⁿ-rē–ed-mōⁿ
m. French painter, 1856–1910

CRUIKSHANK, GEORGE **krủk**-shangk, jȯrj
m. English painter, illustrator, 1792–1878

CRUZ, EMILIO krüz, e-**mēl**-ē-ō
m. American painter, 1937–

CRUZ, LUIS HERNÁNDEZ: see HERNÁNDEZ CRUZ, LUIS

CRUZ AZACETA, LUÍS: see AZACETA, LUÍS CRUZ

CRUZ-DIEZ, CARLOS krüs–**dē**-es, **kär**-lōs
m. Venezuelan painter, kinetic artist, 1923–

CUCCHI, ENZO **kük**-kē, **ān**-zō
m. Italian installation artist, painter, 1950–

CUEVAS, JOSÉ LUIS **kwā**-väs, k̠ō-**sā** lü-**ēs**
m. Mexican draughtsman, painter, 1934–

CULLEN, MAURICE **kəl**-ən, mȯ-**rēs**
m. Canadian painter, 1866–1934

CUNNINGHAM, IMOGEN **kən**-ing-ham, **im**-ə-jən
f. American photographer, 1883–1976

CURRY, JOHN STEUART **kər**-ē, jän **stü**-ərt
m. American painter, 1897–1946

CUYP, AELBERT kœēp or kȯip, **äl**-bərt
m. Dutch painter, 1620–91

CUYP, JACOB GERRITSZ. kœēp or kȯip, **yä**-kȯb **ker**-rits or
ger-rits
m. Dutch painter, 1594–1651/2

DADD, RICHARD dad, **rich**-ərd
m. English painter, c. 1818–87

DADDI, BERNARDO **däd**-dē, ber-**när**-dō
m. Florentine painter, act. 1290–c. 1349

DAGUERRE, LOUIS-JACQUES-MANDÉ dä-ger, lü-ē–zhak–män-dā
m. French Daguerrotypist, 1787–1851

DAHL, JOHAN CHRISTIAN däl, **yō**-hän **kris**-tyän
m. Norwegian (act. Germany) painter, 1788–1857

DAHL, MICHAEL däl, **mī**-kəl
m. Swedish (act. England) painter, 1659?–1743

DAHL-WOLFE, LOUISE däl–wùlf, lü-**ēz**
f. American photographer, 1895–1989

DAHN, WALTER dän, **väl**-tər
m. German painter, 1954–

DALÍ, SALVADOR **dä**-lē, säl-vä-**thòr** or **säl**-vä-dòr
m. Spanish painter, 1904–89

DALMAU, LUIS däl-**maù**, lü-**ēs**
m. Valencian painter, act. 1428–60

DALOU, AIMÉ-JULES dä-lü, ā-mā–zhuel
m. French sculptor, 1838–1902

DAMOPHON **dam**-ə-fän
m. Greek (Messene) sculptor, early 2nd c. BC

DANBY, FRANCIS **dan**-bē, **fran**-sis
m. Irish painter, 1793–1861

DANIELE DA VOLTERRA (DANIELE RICCIARELLI)
dän-**yä**-lä dä vōl-**ter**-rä
(dän-**yä**-lä rē-chä-**rel**-lē)
m. Roman painter, sculptor, c. 1509–66

DANLOUX, HENRI-PIERRE dän-lü, än-rē–pyer
m. French painter, 1753–1809

DANTI, VINCENZO **dän**-tē, vēn-**chen**-zō
m. Perugian sculptor, painter, 1530–76

DANZIGER, YITZHAK **dän**-tsig-ər, yits-**kak**
m. Israeli (b. Germany) sculptor, 1923–77

DARBOVEN, HANNE där-**bō**-vən, **hän**-nə
f. German mixed-media artist, 1941–

DARET, JACQUES da-rä, zhak
m. Flemish painter, 1406–68

DAUBIGNY, CHARLES-FRANÇOIS dō-bēn-yē, shärl–frän-swä
m. French painter, printmaker, 1817–78

DAUMIER, HONORÉ dōm-yä, ō-nō-rä
m. French painter, printmaker, 1808–79

DAVID, GERARD **dä**-vit, **kä**-rärt or **gä**-rärt
m. Flemish painter, 1450/60–1523

DAVID, JACQUES-LOUIS dä-vēd, zhak-lü-ē
m. French painter, 1748–1825

DAVID, PIERRE-JEAN dä-vēd, pyer–zhän
m. French sculptor, 1788–1856

DAVIE, ALAN **dä**-vē, **al**-ən
m. Scottish painter, 1920–

DAVIES, ARTHUR BOWEN **dä**-vēz, **är**-thər **bō**-ən
m. American painter, printmaker, 1862–1928

DAVILA, JUAN **dä**-vē-lä, kwän
m. Australian (b. Chile) painter, 1946–

DAVIS, STUART **dä**-vəs, **stü**-ərt
m. American painter, 1894–1964

DEACON, RICHARD **dē**-kən, **rich**-ərd
m. Welsh sculptor, printmaker, 1949–

DE ANDREA, JOHN dē **an**-drē-ə, jän
m. American sculptor, 1941–

DEBUCOURT, PHILIBERT LOUIS də-bue-kür, fē-lē-ber lü-ē
m. French painter, printmaker, 1755–1832

DECAMPS, ALEXANDRE də-kän, ä-leg-zän-dr'
m. French painter, printmaker, 1803–60

DECARAVA, ROY də-kar-**ä**-və, rȯi
m. American photographer, 1919–

DEGAS, HILAIRE GERMAINE EDGAR də-gä, ē-ler zher-men ed-gär
m. French painter, sculptor, 1834–1917

DEHNER, DOROTHY dā-nər, dȯr-ə-thē
f. American sculptor, printmaker, 1908–

DEKKERS, ADRIAN **dek**-ərs, **ä**-drē-än
m. Dutch sculptor, 1938–74

DE KOONING, ELAINE də **kō**-ning or də **kü**-ning, e-**lān**
f. American painter, 1920–89

DE KOONING, WILLEM də **kō**-ning or də **kü**-ning, **vil**-əm
m. American (b. Netherlands) painter, 1904–

DELACROIX, EUGÈNE də-lä-krwä, œ-zhen
m. French painter, 1798–1863

DELANEY, BEAUFORD də-**lā**-nē, **bō**-fərd
m. American painter, 1910–79

DELANEY, JOSEPH də-**lā**-nē, **jō**-zəf
m. American painter, 1904–

DELANO, IRENE **del**-ə-nō, ī-**rēn**
f. American (act. Puerto Rico) printmaker, 1919–82

DELAROCHE, PAUL də-lä-rȯsh, pōl
m. French painter, 1797–1856

DELAUNAY, ROBERT də-lō-nā, rō-ber
m. French painter, 1885–1941

DELAUNAY, SONIA TERK də-lō-nā, **sȯn**-yä terk
f. Russian (act. France) painter, printmaker, designer, 1885–1979

DELAUNE, ÉTIENNE də-lōn, ā-tyen
m. French engraver, 1518/9–83

DELLA ROBBIA, LUCA **del**-lä **ròb**-bē-ä, **lü**-kä
m. Florentine sculptor, 1399–1482

DELVAUX, PAUL del-vō, pōl
m. Belgian painter, 1897–

DEMACHY, ROBERT də-mä-shē, rō-ber
m. French photographer, 1859–1937

DE MARIA, NICOLA **dā** mä-**rē**-ä, **nē**-kō-lä
m. Italian painter, 1954–

DE MARIA, WALTER dē mə-**rē**-ə, **wòl**-tər
m. American sculptor, conceptual artist, 1935–

DEMPSEY, RICHARD **demp**-sē, **rich**-ərd
m. American painter, 1909–

DEMUTH, CHARLES dā-müth, chärlz
m. American painter, 1883–1935

DENIS, MAURICE də-nē, mō-rēs
m. French painter, 1870–1943

DENNY, ROBYN **den**-ē, **rä**-bin
m. British painter, printmaker, 1930–

DENON, DOMINIQUE-VIVANT də-nōⁿ, dō-mē-nē-kə--vē-väⁿ
m. French engraver, draughtsman, 1747–1825

DEPILLARS, MURRAY də-**pil**-ərz, **mər**-ē
m. American draughtsman, 1938–

DERAIN, ANDRÉ də-raⁿ, äⁿ-drā
m. French painter, printmaker, sculptor, 1880–1954

DER KINDEREN, ANTONIUS JOHANNES (ANTON)
 dər **kin**-dər-ən,
 än-**tō**-nē-uəs yō-**hän**-əs (**än**-tòn)
m. Dutch painter, 1859–1925

DESIDERIO DA SETTIGNANO dā-zē-**dā**-rē-o dä set-tēn-**yä**-no
m. Florentine sculptor, 1428/31–64

DES JARLAIT, PATRICK dā zhär-lā, **pat**-rik
m. American (Chippewa) painter, 1921–72

DESPIAU, CHARLES des-pē-ō, shärl
m. French sculptor, 1874–1946

DEUTSCH, NIKLAUS MANUEL dòich, **nēk**-laủs **män**-wel
m. Swiss painter, c. 1484–1530

DE WINT, PETER də **wint, pē**-tər
m. English painter, 1784–1849

DIAO, DAVID dyaủ, **dā**-vid
m. American (b. China) painter, 1943–

DIAZ, JULES DUPRÉ dē-äs, zhuɐl duɐ-prä
m. French painter, 1811–89

DIAZ DE LA PEÑA, NARCISSE VIRGILE
 dē-äs də lä pā-nyä, när-sēs vēr-zhēl
m. French painter, 1807–76

DIBBETS, JAN **dib**-əts, yän
m. Dutch siteworks artist, draughtsman, photographer, conceptual
artist, 1941–

DIEBENKORN, RICHARD **dē**-bən-kòrn, **rich**-ərd
m. American painter, 1922–93

DILLER, BURGOYNE **dil**-ər, bər-**gòin**
m. American painter, sculptor, 1906–65

DINE, JIM dīn, jim
m. American painter, printmaker, sculptor, 1935–

DIRUBE, ROLANDO LÓPEZ dē-**rü**-vā, rō-**län**-dō **lō**-pes
m. Cuban (act. Puerto Rico) painter, sculptor, 1920–

DI SUVERO, MARK dē **sü**-və-rō, märk
m. American (b. China) sculptor, 1933–

DITTBORN, EUGENIO **dit**-bòrn, ā-ü-**kān**-yō
m. Chilean mixed-media artist, 1943–

DIX, OTTO diks, **òt**-tō
m. German painter, printmaker, 1891–1969

DOBELL, WILLIAM dō-**bel**, **wil**-yəm
m. Australian painter, 1899–1970

DOBSON, FRANK **däb**-sən, frangk
m. English sculptor, 1886–1963

DOBSON, WILLIAM **däb**-sən, **wil**-yəm
m. English painter, 1610–46

DOESBURG, THEO VAN (CHRISTIAN EMIL MARIES KÜPPER)
 düs-bùrg, **tā**-ō fən (**kris**-tyän
 ā-mēl **mä**-rēs **kuep**-pər)
m. Dutch painter, sculptor, 1883–1931

DOISNEAU, ROBERT dwä-nō, rō-ber
m. French photographer, 1912–

DOKOUPIL, JIŘÍ GEORG **daù**-kō-pil, **yi**-rē **gä**-òrg
m. Czech (act. Germany) painter, 1954–

DOLCI, CARLO **dōl**-chē, **kär**-lō
m. Florentine painter, 1616–86

DOMENICHINO (DOMENICO ZAMPIERI)
 dō-mä-nē-**kē**-nō
 (dō-**mä**-nē-kō dzäm-**pyä**-rē)
m. Bolognese/Roman painter, 1581–1641

DOMENICO VENEZIANO (DOMENICO DI BARTOLOMEO DI VENEZIA)
 dō-**mä**-nē-kō vä-nät-sē-**ä**-nō
 (dō-**mä**-nē-kō dē bär-tō-lō-**mä**-ō dē
 vä-**nät**-sē-ä)
m. Florentine painter, c. 1400–61

DOMINGUEZ, OSCAR dō-ming-**geth**, òs-**kär**
m. Spanish painter, 1906–58

DONATELLO (DONATO DI NICCOLO) dō-nä-**tel**-lō (dō-**nä**-tō dē nēk-**kō**-lō)
m. Florentine sculptor, 1386–1466

DONNER, GEORG-RAPHAEL **dòn**-nər, **gä**-òrg–**rä**-fä-el
m. Austrian sculptor, 1693–1741

DORAZIO, PIERO dō-**rät**-zyō, **pyä**-rō
m. Italian painter, collagist, 1927–

DORÉ, GUSTAVE dō-rā, gūes-täv
m. French illustrator, painter, sculptor, 1832–83

DOSAMANTES, FRANCISCO dō-sä-**män**-tes, frän-**sēs**-kō
m. Mexican printmaker, 1911–

DOSSI DOSSO (GIOVANNI DE LUTERO) **dȯs**-sē **dȯs**-sō
(jō-**vän**-nē dä lü-**tä**-rō)
m. Ferrarese painter, c. 1490–1542

DOU, GERARD daü, **kā**-rärt *or* **gā**-rärt
m. Dutch painter, 1613–75

DOUGHTY, THOMAS **daü**-tē, **täm**-əs
m. American painter, 1793–1856

DOUGLAS, AARON **dəg**-ləs, **a**-rən
m. American painter, 1899–1979

DOURIS **dü**-ris
m. Greek (Athens) vase painter, c. 500 BC

DOVE, ARTHUR dəv, **är**-thər
m. American painter, 1880–1946

DOWNEY, JUAN **daü**-nē, ḵwän
m. Chilean (act. United States) video artist, draughtsman, 1940–93

DROUAIS, FRANÇOIS-HUBERT drü-ā, frän-swä–ue-ber
m. French painter, 1727–75

DRTIKOL, FRANTIŠEK **dr**-tē-kōl, **frän**-tē-shek
m. Czech photographer, 1883–1961

DRURY, ALFRED **drü**-rē, **al**-frəd
m. English sculptor, 1856–1944

DRYSDALE, RUSSELL **driz**-dāl, **rəs**-əl
m. Australian painter, 1912–81

DUBOIS, AMBROISE due-bwä, än-brwäz
m. French (b. Flanders) painter, 1542/3–1614

DUBREUIL, TOUSSAINT due-brœē, tü-san
m. French painter, 1561–1602

DUBUFFET, JEAN due-bue-fā, zhän
m. French painter, sculptor, 1901–85

DUCCIO DI BUONINSEGNA **dü**-chē-ō dē bwōn-ēn-**sen**-yä
m. Sienese painter, c. 1255–1319

DUCHAMP, MARCEL due-shän, mär-sel
m. French painter, sculptor, 1887–1968

DUCHAMP-VILLON, RAYMOND du̇e-shän–vē-yōn, rä-mōn
m. French sculptor, 1876–1918

DUCK, JACOB du̇ek, **yä**-kȯb
m. Dutch painter, c. 1600–after 1660

DUFY, RAOUL du̇e-fē, rä-ül
m. French painter, designer, ceramicist, 1877–1953

DUJARDIN, KAREL **du̇e**-zhär-dan, **kär**-əl
m. Dutch painter, printmaker, c. 1622–78

DUNCANSON, ROBERT SCOTT **dəng**-kən-sən, **räb**-ərt skät
m. American painter, 1821–72

DUNOYER DE SEGONZAC, ANDRÉ du̇e-nwä-yä də sə-gōn-zäk, än-drä
m. French painter, 1884–1974

DUPRÉ, JULES du̇e-prä, zhu̇el
m. French painter, 1811–89

DUQUE CORNEJO, PEDRO **dü**-kä kȯr-**ne**-kō, pā-<u>th</u>rō
m. Spanish sculptor, 1678–1757

DUQUESNOY, FRANÇOIS du̇e-ken-wä, frän-swä
m. Flemish (act. Rome) sculptor, 1594–1643

DURAND, ASHER B. dyü-**rand, ash**-ər
m. American painter, engraver, 1796–1886

DÜRER, ALBRECHT **du̇e**-rər, **äl**-bre<u>k</u>t
m. German (Nuremberg) painter, engraver, 1471–1528

DURHAM, JIMMIE **dər**-əm, **jim**-ē
m. American (Cherokee) sculptor, installation artist, 1940–

DUVET, JEAN du̇e-vä, zhän
m. French engraver, 1485–1561/70

DYCE, WILLIAM dīs, **wil**-yəm
m. Scottish painter, 1806–64

DYCK, ANTON (ANTHONIE) VAN dīk, **än**-tōn (**än**-tō-nē) fen or van
m. Flemish painter, 1599–1641

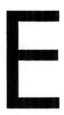

E

EAKINS, THOMAS ā-kənz, **täm**-əs
m. American painter, 1844–1916

EARL, RALPH ərl, ralf
m. American painter, 1751–1801

EARLOM, RICHARD ər-ləm, **rich**-ərd
m. English engraver, 1743–1822

EASTLAKE, CHARLES LOCK **ēst**-lāk, chärlz läk
m. English painter, 1793–1865

ECKERSBERG, CHRISTOFFER WILHELM **ek**-ərs-berk, kris-**töf**-ər **vil**-helm
m. Danish painter, 1783–1853

EDELFELT, ALBERT ā-dəl-felt, **äl**-bert
m. Finnish painter, 1854–1905

EDELINCK, GERARD ā-də-lank, zhā-rär
m. Flemish (act. France) engraver, 1640–1707

EDGERTON, HAROLD **ej**-ər-tən, **ha**-rəld
m. American photographer, 1903–90

EDMONDSON, WILLIAM **ed**-mən-sən, **wil**-yəm
m. American sculptor, c. 1870–1951

EDWARDS, MELVIN **ed**-wərdz, **mel**-vin
m. American sculptor, 1937–

EECKHOUT, GERBRANDT VAN DEN **āk**-haùt, **ker**-bränt or
 ger-bränt fən den
m. Dutch painter, 1621–74

EGG, AUGUSTUS eg, ȯ-**gəs**-təs
m. English painter, 1816–63

EIRIZ, ANTONIA ā-**rēs**, än-**tōn**-yä
f. Cuban painter, 1931–

ELSHEIMER, ADAM **els**-hī-mər, **ä**-däm
m. German (act. Italy) painter, 1578–1610

ENDO, TOSHIKATSU en-dō, tō-shi-kä-tsü
m. Japanese sculptor, 1952–

ENGEBRECHTSEN, CORNELIS **en**-ge-bre<u>k</u>t-sən, kȯr-**nā**-lis
m. Dutch painter, 1468–1533

ENRÍQUEZ, CARLOS en-**rē**-kes, **kär**-lōs
m. Cuban painter, 1901–57

ENSOR, JAMES **en**-sər, jāmz
m. Belgian painter, printmaker, 1860–1949

EPSTEIN, JACOB **ep**-stīn, **jā**-kəb
m. English (b. United States) sculptor, 1880–1959

ERNST, MAX ernst, mäks
m. German painter, sculptor, 1891–1976

ERWITT, ELLIOTT **ər**-wit, **el**-ē-ət
m. American (b. France) photographer, 1928–

ESCHER, MAURITS CORNELIS **esh**-ər, **maú**-rits kȯr-**nā**-lis
m. Dutch printmaker, 1898–1972

ESCOBEDO, HELEN es-kō-**vā**-<u>th</u>ō, ā-**len**
f. Mexican sculptor, environmental artist, 1936–

ESQUIVEL, ANTONIO MARIA es-kē-**vel**, än-**tōn**-yō mä-**rē**-ä
m. Spanish painter, 1806–57

ESTES, RICHARD **es**-tēz, **rich**-ərd
m. American painter, 1932–

ESTRADA, JOSÉ MARÍA es-**trä**-<u>th</u>ä, <u>k</u>ō-**sä** mä-**rē**-ä
m. Mexican painter, c. 1810–c. 1862

ETCHELLS, FREDERICK **et**-chəlz, **fred**-rik
m. English painter, architect, 1886–1973

ETTY, WILLIAM **et**-ē, **wil**-yəm
m. English painter, 1787–1849

EUPHRANOR OF CORINTH yü-**frā**-nər, **kȯ**-rinth
m. Greek (Athens) painter, sculptor, mid–4th c. BC

EUPHRONIOS yü-**frō**-nē-əs
m. Greek (Athens) vase painter, potter, act. c. 520–c. 500 BC

EUTHYMIDES yü-**thim**-ə-dēz
m. Greek (Athens) vase painter, act. c. 520–500 BC

EVANS, MINNIE **ev**-ənz, **min**-ē
f. American painter, 1890–1987

EVANS, WALKER **ev**-ənz, **wȯk**-ər
m. American photographer, 1903–75

EVENEPOEL, HENRI **ā**-və-nā-pül, äⁿ-rē
m. Belgian painter, 1872–99

EVERDINGEN, ALLART VAN **ā**-vər-ding-ən, äl-**lärt** fən
m. Dutch painter, printmaker, 1621–75

EVERDINGEN, CAESAR BOETIUS VAN **ā**-vər-ding-ən, **kä**-sər **bü**-tē-ʉes fən
m. Dutch painter, 1606–78

EVERGOOD, PHILIP **ev**-ər-gủd, **fil**-əp
m. American painter, printmaker, 1901–73

EXTER, ALEKSANDRA **eks**-tər, ä-lek-**sän**-drä
f. Russian painter, 1882–1949

EYCK, JAN VAN īk, yän fən
m. Flemish painter, c. 1390–1441

F

FABRITIUS, CAREL
m. Dutch painter, c. 1622–54

fä-**brēt**-sē-ues, **kär**-əl

FABRO, LUCIANO
m. Italian sculptor, 1936–

fäb-rō, lü-**chä**-nō

FAITHORNE, WILLIAM
m. English engraver, 1616–91

fā-thərn, **wil**-yəm

FALCONET, ÉTIENNE-MAURICE
m. French sculptor, 1716–91

fal-kō-nā, ā-tyen–mō-rēs

FALK, ROBERT RAFAILOVICH
m. Russian painter, 1886–1958

fälk, **räb**-ərt rä-fā-**ēl**-ō-vich

FANCELLI, DOMENICO DI ALESSANDRO

fän-**chel**-lē, dō-**mā**-nē-kō dē
ä-les-**sänd**-rō

m. Florentine sculptor, 1469–1519

FANTIN-LATOUR, HENRI
m. French painter, lithographer, 1836–1904

fäⁿ-taⁿ–lä-tür, äⁿ-rē

FATTORI, GIOVANNI
m. Italian painter, 1825–1908

fät-**tō**-rē, jō-**vän**-nē

FAUCON, BERNARD
m. French photographer, 1950–

fō-kōⁿ, ber-när

FAUSTIN, CELESTIN
m. Haitian painter, 1948–

fō-staⁿ, sā-les-taⁿ

FAUTRIER, JEAN
m. French painter, lithographer, sculptor, 1898–1964

fō-trē-ā, zhäⁿ

FEININGER, ANDREAS
m. American (b. France) photographer, 1906–

fi-ning-ər, än-**drä**-es

FEININGER, LYONEL **fī**-ning-ər, **lī**-ə-nəl
m. American painter, 1871–1956

FEKE, RICHARD fēk, **rich**-ərd
m. American painter, 1707–52

FELGUÉREZ, MANUEL fel-**gā**-res, män-**wel**
m. Mexican sculptor, painter, 1928–

FENTON, ROGER **fen**-tən, **räj**-ər
m. English photographer, 1819–69

FEODOTAV, PAVEL ANDREEVICH fē-ə-**dō**-täf, **pä**-vəl ən-**drē**-ə-vich
m. Russian painter, 1815–52

FERGUSSON, JOHN DUNCAN **fər**-gə-sən, jän **dəng**-kən
m. Scottish painter, 1874–1961

FERNÁNDEZ, AGUSTÍN fer-**nän**-des, ä-gü-**stēn**
m. Cuban (act. United States) painter, 1928–

FERNANDEZ, ALEJO fer-**nän**-deth, ä-**le**-ḵō
m. Spanish painter, c. 1470–1543

FERNANDEZ, GREGÓRIO fer-**nän**-deth, grä-**gòr**-yō
m. Spanish sculptor, c. 1576–1636

FERNÁNDEZ MURO, JOSÉ ANTONIO fer-**nän**-des **mü**-rō, ḵō-**sä** än-**tōn**-yō
m. Argentine (b. Spain) painter, 1938–

FERRARA, JACKIE fə-**rä**-rə, **jak**-ē
f. American sculptor, 1929–

FERRARI, GAUDENZIO fer-**rä**-rē, gaú-**dent**-sē-ō
m. Piedmontese painter, c. 1471/81–1546

FERRER, RAFAEL fä-**rer**, rä-fä-**el**
m. Puerto Rican sculptor, installation artist, 1933–

FETTI, DOMENICO **fet**-tē, dō-**mä**-nē-kō
m. Roman painter, c. 1589–1623

FETTI, LUCRINA **fet**-tē, lü-**krē**-nä
f. Mantuan painter, act. c. 1614–c. 1651

FEUCHTMAYER, JOSEPH ANTON **fòikt**-mī-ər, **yō**-zef **än**-tòn
m. German (Bavaria) sculptor, printmaker, 1696–1770

FEUERBACH, ANSELM **fói**-ər-bäk, **än**-selm
m. German painter, 1829–80

FIELDING, ANTHONY VANDYKE COPLEY
 fēl-ding, an-tə-nē van-**dik käp**-lē
m. English painter, 1787–1855

FIGARI, PEDRO fē-**gä**-rē, **pā**-<u>th</u>rō
m. Uruguayan painter, 1861–1938

FILARETE (ANTONIO AVERLINO) fē-lä-**rä**-tā (än-**tōn**-yō ä-ver-**lē**-nō)
m. Florentine sculptor, c. 1400–c. 1469

FILLA, EMIL **fil**-lä, **em**-il
m. Czech (b. Bohemia) painter, sculptor, 1882–1953

FILONOV, PAVEL NIKOLAIEVICH fē-**lō**-nòf, **pä**-vəl nēk-ə-**li**-ə-vich
m. Russian painter, 1883–1941

FINCH, ALFRED WILLIAM finch, **al**-frəd **wil**-yəm
m. Finnish (b. Belgium) painter, ceramicist, printmaker, 1854–1930

FINI, LEONOR fē-nē, lā-ō-nòr
f. French (b. Italy) painter, 1908–

FINIGUERRA, MASO fē-nē-**gwer**-rä, **mä**-zō
m. Florentine engraver, sculptor, 1426–64

FISCHL, ERIC **fish**-əl, **e**-rik
m. American painter, 1948–

FISH, JANET fish, **jan**-ət
f. American painter, 1938–

FLACK, AUDREY flak, **ò**-drē
f. American painter, 1931–

FLANDRIN, HIPPOLYTE flän-dran, ē-pō-lēt
m. French painter, 1809–64

FLAVIN, DAN **flā**-vin, dan
m. American sculptor, 1933–

FLAXMAN, JOHN **flaks**-mən, jän
m. English sculptor, draughtsman, 1755–1826

FLEGEL, GEORG **flā**-gəl, **gā**-òrg
m. German (Moravia) painter, 1563–1638

FLINCK, GOVAERT flingk, **kō**-värt *or* **gō**-värt
m. Dutch painter, 1615–60

FLINT, WILLIAM RUSSELL flint, **wil**-yəm **res**-əl
m. English painter, printmaker, 1880–1969

FLORIS, FRANS I **flō**-ris, fräns
m. Flemish painter, c. 1516–70

FLÖTNER, PETER **flœt**-nər, **pā**-tər
m. German (Nuremberg) sculptor, c. 1485–1546

FOLEY, FIONA **fō**-lē, fē-**ō**-nə
f. Australian (Butchulla) painter, 1964–

FONESCA, GONZALO fō-**nes**-kä, gōn-**sä**-lō
m. Uruguayan sculptor, 1922–

FONESCA, HARRY fō-**nes**-kä, **har**-ē
m. American (Nisenan Maidu) painter, 1946–

FONTANA, LAVINIA fōn-**tä**-nä, lä-**vēn**-yä
f. Bolognese painter, 1552–1614

FONTANA, LUCIO fōn-**tä**-nä, **lü**-chō
m. Italian (b. Argentina) painter, sculptor, 1899–1968

FONTANA, PROSPERO fōn-**tä**-nä, **prȯ**-spā-rō
m. Bolognese painter, 1512–97

FOPPA, VINCENZO **fȯp**-pä, vin-**chent**-sō
m. Milanese painter, c. 1427–1515

FORAIN, JEAN-LOUIS fȯ-ran, zhän–lü-ē
m. French painter, 1852–1931

FÖRG, GÜNTHER fœrk, **guen**-tər
m. German painter, draughtsman, installation artist, 1952–

FORNER, RAQUEL **fȯr**-nər, rä-**kel**
f. Argentine painter, 1902–

FORTUNY Y CARBO, MARIANO fȯr-**tü**-nē ē **kär**-bō, mä-rē-**ä**-nō
m. Spanish painter, 1838–74

FORTUNY Y MADRAZO, MARIANO fȯr-**tü**-nē ē mä-**thrä**-thō, mä-rē-**ä**-nō
m. Spanish (act. Italy) painter, photographer, 1871–1949

FOUJITA, TSUGUHARU (LÉONARD) fü-jē-tä, tsü-gü-hä-rü (lā-ō-när)
m. French (b. Japan) painter, 1886–1968

FOUQUET (FOUCQUET), JEAN fü-kā, zhän
m. French painter, illuminator, c. 1420–c. 1481

FOUQUIÈRES, JACQUES fü-kē-yer, zhak
m. Flemish (act. France) painter, c. 1580/90–1659

FOX TALBOT, WILLIAM HENRY fäks **tȯl**-bət, **wil**-yəm **hen**-rē
m. English photographer, 1800–77

FRAGONARD, JEAN-HONORÉ frä-gō-när, zhän–ō-nō-rā
m. French painter, 1732–1806

FRAMPTON, GEORGE **framp**-tən, jȯrj
m. English sculptor, 1860–1928

FRAMPTON, MEREDITH **framp**-tən, **mer**-ə-dəth
m. English painter, 1894–1984

FRANCESCO DI GIORGIO frän-**ches**-kō dē **jȯr**-jo
m. Sienese painter, sculptor, 1439–1500/2

FRANCIA, FRANCESCO (FRANCESCO RAIBOLINI)
 frän-chē-ä frän-**ches**-kō
 (frän-**ches**-kō rī-bō-**lē**-nē)
m. Bolognese painter, 1450–1517/8

FRANCIABIGIO (FRANCESCO DI CRISTOFANO)
 frän-chē-ä-**bē**-jō
 (frän-**ches**-kō dē kris-**tȯf**-ä-nō)
m. Florentine painter, 1482–1525

FRANCIS, SAM **fran**-sis, sam
m. American painter, 1923–

FRANCKEN, FRANS I **frän**-kən, fräns
m. Flemish painter, 1542–1616

FRANCKEN, FRANS II **frän**-kən, fräns
m. Flemish painter, 1581–1642

FRANCO, SIRON **fräng**-kō, sē-**rōn**
m. Brazilian painter, 1947–

FRANK, ROBERT frangk, **räb**-ərt
m. American photographer, 1924–

FRANKENTHALER, HELEN **frang**-kən-thä-lər, **hel**-ən
f. American painter, 1928–

FRANQUEVILLE, PIERRE DE frän-k'-vēl, pyer də
m. French (b. Netherlands) sculptor, painter, 1548–1615

FRASCONI, ANTONIO fräs-**kō**-nē, än-**tōn**-yō
m. Uruguayan (b. Argentina) printmaker, 1919–

FRÉMINET, MARTIN frā-mē-nā, mär-tan
m. French painter, 1567–1619

FRENCH, DANIEL CHESTER french, **dan**-yəl **ches**-tər
m. American sculptor, 1850–1931

FREUD, LUCIAN froid, **lü**-shən
m. English (b. Germany) painter, 1922–

FREUND, GISÈLE froint, zhē-zel
f. French (b. Germany) photographer, 1912–

FREUNDLICH, OTTO **froint**-lik, **òt**-tō
m. German painter, sculptor, 1878–1943

FRIEDEBERG, PEDRO **frē**-də-berg, **pā**-thrō
m. Mexican (b. Italy) painter, 1937–

FRIEDLANDER, LEE **frēd**-lan-dər, lē
m. American photographer, 1934–

FRIEDRICH, CASPAR DAVID **frēd**-rik, **käs**-pär **dä**-fit
m. German painter, 1774–1840

FRIESZ, OTHON frēz, ō-tōn
m. French painter, 1879–1949

FRINK, ELISABETH fringk, ə-**liz**-ə-bəth
f. English sculptor, 1930–

FRITH, FRANCIS frith, **fran**-sis
m. English photographer, 1822–98

FRITH, WILLIAM POWELL frith, **wil**-yəm **paù**-əl
m. English painter, 1819–1909

FROMENT, NICOLAS frò-män, nē-kō-lä
m. French painter, c. 1435–83/84

FROMENTIN, EUGÈNE frȯ-mäⁿ-taⁿ, œ-zhen
m. French painter, 1820–76

FROST, TERRY frȯst, **ter**-ē
m. British painter, 1915–

FÜHRICH, JOSEF VON **fue**-ri̱k, **yō**-zef fȯn
m. Austrian painter, draughtsman, 1800–76

FUKAI, TAKASHI fü-kī, tä-kä-shē
m. Japanese sculptor, contemporary

FULLER, ISAAC **fu̇l**-ər, **ī**-zək
m. English painter, c. 1606–72

FULLER, META VAUX WARRICK **fu̇l**-ər, **met**-ə vō **wȯ**-rik
f. American sculptor, 1877–1968

FULTON, HAMISH **fu̇l**-tən, **hā**-mish
m. British conceptual artist, 1946–

FUNAKOSHI, KATSURA fü-nä-kō-shē, kä-tsü-rä
m. Japanese sculptor, contemporary

FUSELI, HENRY (JOHANN HEINRICH FÜSSLI)
 fyü-zə-lē, **hen**-rē
 (**yō**-hän **hin**-ri̱k **fu̇es**-lē)
m. Swiss (act. England) painter, 1741–1825

FYT, JAN fit, yän
m. Flemish painter, 1611–61

G

GABO, NAUM **gä**-bō, naům
m. American (b. Russia) sculptor, 1890–1977

GABRIEL, PAUL JOSEPH CONSTANTIN **gäb**-rē-əl, paůl **yō**-zef **kòn**-stän-tēn
m. Dutch painter, 1828–1903

GADDI, AGNOLO **gäd**-dē, **än**-yō-lō
m. Florentine painter, act. 1364–96

GADDI, TADDEO **gäd**-dē, täd-**dä**-ō
m. Florentine painter, c. 1300–c. 1366

GAGERN, VERENA VON **gä**-gərn, fe-**rä**-nä fòn
f. German photographer, 1946–

GAINSBOROUGH, THOMAS **gānz**-bər-ə, **täm**-əs
m. English painter, 1727–88

GALIZIA, FEDE gä-**lēt**-sē-ä, **fä**-dä
f. Milanese painter, 1578–1630

GALLEGO, FERNANDO gä-**yä**-gō, fer-**nän**-dō
m. Castilian painter, c. 1440–after 1507

GALLEN-KALLELA, AKSELI (GALLÉN, AXEL)
gä-**län**–**käl**-lā-lä, **äk**-sä-lē
(gä-**län**, **äk**-səl)
m. Finnish painter, 1865–1931

GALVÁN, JESÚS GUERRERO gäl-**vän**, ka̲-**süs** ger-**rä**-rō
m. Mexican painter, 1910–early 1970s

GALVEZ, DANIEL **gäl**-ves, dän-**yel**
m. American painter, 1953–

GALVEZ, JOSÉ **gäl**-ves, ko̲-**sä**
m. American photographer, 1949–

GAMARRA, JOSÉ gä-**mär**-rä, k̲ō-**sā**
m. Uruguayan painter, 1934–

GAMBOA, HARRY JR. gam-**bō**-ə, **ha**-rē
m. American photographer, 1951–

GARCÍA, ANTONIO gär-**sē̄**-ä, än-**tōn**-yō
m. American painter, 1901–

GARCÍA, ENRIQUE GAY gär-**sē̄**-ä, en-**rē**-kä gī
m. Cuban (act. United States) sculptor, 1928–

GARCÍA, JOAQUÍN TORRES: see TORRES GARCÍA, JOAQUÍN

GARCÍA, ROMUALDO gär-**sē̄**-ä, rōm-**wäl**-dō
m. Mexican photographer, 1852–1930

GARCÍA, RUPERT gär-**sē̄**-ä, **rü**-pərt
m. American painter, printmaker, 1941–

GARCÍA, VÍCTOR MANUEL gär-**sē̄**-ä, **vēk**-tòr män-**wel**
m. Cuban painter, 1897–1969

GARCÍA SEVILLA, FERRAN gär-**sē̄**-ä sä-**vē**-yä, fer-**rän**
m. Spanish painter, 1949–

GARDNER, ALEXANDER **gärd**-nər, a-leg-**zan**-dər
m. American (b. Scotland) photographer, 1821–82

GARGALLO, PABLO gär-**gi**-yō, **päv**-lō
m. Spanish sculptor, 1881–1934

GAROFALO (BENVENUTO TISI) gä-**rò**-fä-lō (ben-vä-**nü**-tō **tē**-zē)
m. Ferrarese painter, c. 1481–1559

GAROUSTE, GÉRARD gä-rü-st', zhā-rär
m. French painter, 1946–

GASCOIGNE, ROSALIE gas-**kòin**, **rō**-zə-lē
f. Australian assemblage artist, 1943–

GASPARD, LEON **gas**-pärd, **lē**-än
m. American (b. Russia) painter, 1882–1964

GASTINI, MARCO gäs-**tē**-nē, **mär**-kō
m. Italian painter, 1938–

GAUDIER-BRZESKA, HENRI gō-dē-ā-**bzhes**-kä, äⁿ-rē
m. French sculptor, 1891–1915

GAUGUIN, PAUL gō-gaⁿ, pōl
m. French painter, 1848–1903

GAULLI, GIOVANNI BATTISTA (IL BACICCIO)
 gaú-lē, jō-**vän**-nē bät-**tē**-stä
 (ēl bä-**chē**-chō)
m. Genoese painter, 1639–1709

GAVARNI, PAUL (SULPICE-GUILLAUME CHEVALIER)
 ga-vär-nē, pōl
 (suel-pēs–gē-ōm shə-val-yā)
m. French draughtsman, 1804–66

GAWBOY, CARL **gó**-bói, kärl
m. American (Bois Fort Chippewa) painter, 1942–

GE, NIKOLAI NIKOLAIEVICH geh, nēk-ə-**li** nēk-ə-**li**-ə-vich
m. Russian painter, sculptor, 1831–94

GEERTGEN TOT SINT JANS **kärt**-kən or **gärt**-gən tót sint yäns
m. Dutch painter, c. 1465–c. 1495

GELDER, AERT DE **kel**-dər or **gel**-dər, ärt də
m. Dutch painter, 1645–1727

GELLÉE, CLAUDE (LORRAIN) zhə-lā, klōd (lór-raⁿ)
m. French painter, 1600–82

GENOVÉS, JUAN k̲ā-nō-**ves**, k̲wän
m. Spanish painter, 1930–

GENTILE DA FABRIANO jen-**tē**-lā dä fä-brē-**ä**-nō
m. Sienese painter, c. 1370–1427

GENTILESCHI, ARTEMISIA jen-tē-**les**-kē, är-tā-**mē**-zē-ä
f. Roman painter, 1593–c. 1652

GENTILESCHI, ORAZIO jen-tē-**les**-kē, ō-**rät**-sē-ō
m. Roman painter, 1563–1639

GÉRARD, FRANÇOIS zhā-rär, fräⁿ-swä
m. French painter, 1770–1837

GÉRARD, MARGUERITE zhā-rär, mär-gə-rēt
f. French painter, 1761–1837

GERHAERT VAN LEYDEN, NICOLAUS **ker**-härt or **ger**-härt fən **li**-dən,
m. Dutch sculptor, act. 1462–73 **nē**-kō-laús

GÉRICAULT, THÉODORE zhā-rē-kō, tā-ō-dòr
m. French painter, 1791–1824

GÉRÔME, JEAN-LÉON zhā-rōm, zhän–lā-ōn
m. French painter, 1824–1904

GERSTL, RICHARD **ger**-stəl, **rik**-ärt
m. Austrian painter, 1883–1908

GERTLER, MARK **gert**-lər, märk
m. English painter, 1891–1939

GERZSO, GUNTHER **gers**-sō, **guen**-tər
m. Mexican painter, 1915–

GESSNER, SALOMON **ges**-nər, **sä**-lō-mòn
m. Swiss painter, 1730–88

GESTEL, LEO (LEENDERT) **kes**-təl or **ges**-təl, **lā**-ō (**lān**-dərt)
m. Dutch painter, printmaker, 1881–1941

GHEERAERTS, MARCUS THE YOUNGER **kā**-rärts or **gā**-rärts, **mär**-kᴜes
m. Flemish (act. England) painter, 1561–1636

GHEYN, JACOB DE, II kīn or gīn, **yä**-kòp də
m. Dutch draughtsman, 1565–1629

GHIBERTI, LORENZO gē-**ber**-tē, lō-**rent**-sō
m. Florentine sculptor, 1378–1455

GHIRLANDAIO, DOMENICO (DOMENICO BIGORDI)
 gēr-län-**dä**-yō, dō-**mä**-nē-kō
 (bē-**gòr**-dē)
m. Florentine painter, 1449–94

GHIRLANDAIO, RIDOLFO (RIDOLFO DI DOMENICO BIGORDI)
 gēr-län-**dä**-yō, rē-**dōl**-fō
 (dē dō-**mä**-nē-kō bē-**gòr**-dē)
m. Florentine painter, 1483–1561

GHIRRI, LUIGI **gir**-rē, lü-**ē**-jē
m. Italian photographer, 1943–

GIACOMETTI, ALBERTO jä-kō-**met**-tē, äl-**ber**-tō
m. Swiss sculptor, painter, 1901–66

GIACOMETTI, DIEGO jä-kō-**met**-tē, **dyā**-gō
m. Swiss sculptor, 1902–85

GIAMBOLOGNA (GIOVANNI BOLOGNA OR JEAN BOULOGNE)
 jäm-bō-**lō**-nyä (jō-**vän**-nē
 bō-lō-nyä *or* zhän bü-lò-ny')
m. Italian (b. Flanders) sculptor, 1529–1608

GIAQUINTO, CORRADO jä-**kwin**-tō, kòr-**rä**-dō
m. Neapolitan painter, c. 1703–65

GIBBONS, GRINLING **gib**-ənz, **grin**-ling
m. Dutch (act. England) sculptor, 1648–1721

GIBSON, JOHN **gib**-sən, jän
m. English sculptor, 1790–1866

GIERSING, HARALD **kēr**-sing *or* **gēr**-sing, **hä**-rəld
m. Danish painter, 1881–1927

GILBERT, ALFRED **gil**-bərt, **al**-frəd
m. English sculptor, 1854–1934

GILL, ERIC gil, **e**-rik
m. British sculptor, typographer, 1882–1940

GILLIAM, SAM **gil**-ē-əm, sam
m. American painter, 1933–

GILLOT, CLAUDE zhē-lō, klōd
m. French draughtsman, etcher, 1673–1722

GILLRAY, JAMES **gil**-rā, jāmz
m. English caricaturist, 1757–1815

GILMAN, HAROLD **gil**-mən, **ha**-rəld
m. English painter, 1876–1919

GILOT, FRANÇOISE zhē-lō, frän-swäz
f. French printmaker, 1921–

GILPIN, LAURA **gil**-pin, **lò**-rə
f. American photographer, 1891–1979

GILPIN, SAWREY **gil**-pin, **sò**-rē
m. English painter, 1733–1807

GINNER, CHARLES **jin**-ər, chärlz
m. English painter, 1879–1952

GIORDANO, LUCA jȯr-**dä**-nō, **lü**-kä
m. Neapolitan painter, 1634–1705

GIORGIONE (GIORGIO DEL CASTELFRANCO OR GIORGIO BARBARELLI)
jȯr-**jō**-nā (**jȯr**-jō del
kä-stel-**frän**-kō or bär-bä-**rel**-lē)
m. Venetian painter, 1476/8–1510

GIOTTO DI BONDONE **jȯt**-tō dē bȯn-**dō**-nā
m. Florentine painter, architect, c. 1267–1337

GIOVANNI DI PAOLO jō-**vän**-nē dē **paů**-lō
m. Sienese painter, act. 1420–82

GIRARDON, FRANÇOIS zhē-rär-**dōn**, frän-swä
m. French sculptor, 1628–1715

GIRKE, RAIMUND **gēr**-kə, **ri**-mů̇nt
m. German painter, 1930–

GIRODET-TRIOSON, ANNE LOUIS zhē-rō-dā–trē-ō-zōn, än lü-ē
m. French painter, 1767–1824

GIRONCOLI, BRUNO jē-rōn-**kō**-lē, **brü**-nō
m. Austrian sculptor, 1936–

GIRONELLA, ALBERTO k̲ē-rō-**nä**-zhä, äl-**ber**-tō
m. Mexican painter, 1929–

GIRTIN, THOMAS **gər**-tən, **täm**-əs
m. English painter, 1775–1802

GISLEBERTUS jis-əl-**ber**-təs
m. French sculptor, 12th c.

GIULIO ROMANO **jü**-lē-ō rō-**mä**-nō
m. Roman (act. Mantua) painter, architect, 1499–1546

GIUSTI, GIOVANNI (JEAN JUSTE) **jüs**-tē, jō-**vän**-nē (zhän zhuest)
m. Italian (act. France) sculptor, 1485–1549

GLACKENS, WILLIAM J. **glak**-ənz, **wil**-yəm
m. American painter, 1870–1938

GLEIZES, ALBERT glez, al-ber
m. French painter, 1881–1953

GLEYRE, CHARLES glār, shärl
m. Swiss (act. France) painter, 1808–74

GOBER, ROBERT **gō**-bər, **räb**-ərt
m. American sculptor, installation artist, 1954–

GODWIN, FAY **gäd**-win, fā
f. British photographer, 1931–

GOERITZ, MATHIAS **gœ**-rits, mä-**tē**-äs
m. Mexican (b. Poland) sculptor, 1915–

GOES, HUGO VAN DER küs or güs, **hue**-k̲ō or
hue-gō fən dər
m. Flemish painter, c. 1440–82

GOGH, VINCENT VAN k̲ók̲ or gók̲ or gō, **vin**-sent fən
m. Dutch painter, 1853–90

GOITA GARCÍA, FRANCISCO **gȯi**-tä gär-**sē**-ä, frän-**sēs**-kō
m. Mexican painter, 1882–1960

GOLDIN, NAN **gōl**-dən, nan
f. American photographer, 1953–

GOLTZIUS, HENDRICK **k̲ȯlt**-sē-ʉes or **gȯlt**-sē-ʉes, **hen**-drik
m. Dutch painter, 1558–1617

GOLUB, LEON **gä**-ləb, **lē**-än
m. American painter, printmaker, 1922–

GOLUBKINA, ANNA SEMIONOVNA gə-**lüb**-kin-ä, **ä**-nə sem-ē-**ō**-nōv-nə
f. Russian sculptor, 1864–1927

GÓMEZ JARAMILLO, IGNACIO: **see** JARAMILLO, IGNACIO GÓMEZ

GONCHAROVA, NATALIA SERGEEVNA gən-chə-**rōv**-ə,
nə-**täl**-yə ser-**gä**-ev-nə
f. Russian painter, 1881–1962

GONZÁLEZ, BEATRIZ gōn-**sä**-les, bā-ä-**trēs**
f. Colombian painter, 1936–

GONZÁLEZ, JUAN gōn-**sä**-les, k̲wän
m. Cuban (act. United States) painter, draughtsman, 1945–

GONZÁLEZ, JULIO gōn-**thä**-leth, **k̲ül**-yō
m. Spanish sculptor, 1876–1942

GONZÁLEZ AMÉZCUA, CONSUELO (CHELO)
gōn-**sä**-les ä-**mäs**-kwä,
kōn-**swä**-lō (**chä**-lō)
f. American draughtsman, 1903–75

GONZALEZ-TORRES, FELIX gōn-**sä**-les–**tȯr**-res, fā-**lēs**
m. Cuban (act. United States) installation artist, contemporary

GORDILLO, LUIS gȯr-**thē**-yō, lü-**ēs**
m. Spanish painter, 1934–

GORE, SPENCER gȯr, **spen**-sər
m. English painter, 1878–1914

GORKY, ARSHILE **gȯr**-kē, **är**-shēl
m. American (b. Turkish Armenia) painter, 1905–48

GORMAN, R. C. **gȯr**-mən
m. American (Navajo) painter, 1932–

GOSSAERT, JAN (MABUSE) kȯs-**särt** or gȯs-**särt**, yän (mä-buez)
m. Flemish painter, c. 1472–c. 1533

GOTTLIEB, ADOLPH **gät**-lēb, **ā**-dȯlf
m. American painter, 1903–74

GOUJON, JEAN gü-zhōn, zhän
m. French sculptor, c. 1510–68

GOURGUE, JACQUES ENGUÉRRAND gür-g', zhak än-gä-rän
m. Haitian painter, 1930–

GOWIN, EMMET **gau**-ən, **em**-ət
m. American photographer, 1944–

GOWING, LAWRENCE **gau**-ing, **lȯr**-ənts
m. English painter, 1918–91

GOYA Y LUCIENTES, FRANCISCO JOSÉ DE
gȯ-yä ē lü-thē-**än**-tās,
frän-**thēs**-kō k̲ō-**sä** dā
m. Spanish painter, engraver, 1746–1828

GOYEN, JAN VAN **kȯi**-ən or **gȯi**-ən, yän fən
m. Dutch painter, 1596–1656

GOZZOLI, BENOZZO **gȯt**-sō-lē, bā-**nȯt**-sō
m. Florentine painter, c. 1421–97

GRAF, URS gräf, ürs
m. Swiss draughtsman, printmaker, c. 1485–1527/8

GRAFF, ANTON gräf, **än**-tōn
m. Swiss (act. Germany) painter, 1736–1813

GRANACCI, FRANCESCO grä-**nät**-chē, frän-**ches**-kō
m. Florentine painter, 1477–1543

GRANDVILLE (JEAN-IGNACE-ISIDORE GÉRARD)
 gräⁿ-d'-vēl
 (zhäⁿ–ē-nyäs–ē-zē-dòr zhā-rär)
m. French caricaturist, illustrator, 1803–47

GRANET, FRANÇOIS-MARIUS grä-nā, fräⁿ-swä–mär-yues
m. French painter, 1775–1849

GRANT, DUNCAN grant, **deng**-kən
m. English painter, 1885–1978

GRANT, FRANCIS grant, **fran**-sis
m. Scottish painter, 1803–78

GRASSER, ERASMUS **gräs**-er, ā-**räs**-mùs
m. German sculptor, c. 1450–1518

GRAU, ENRIQUE graù, en-**rē**-kā
m. Colombian painter, 1920–

GRAVELOT, HUBERT-FRANÇOIS gra-v'-lō, ue-ber-fräⁿ-swä
m. French engraver, 1699–1773

GRAVES, NANCY grāvz, **nan**-sē
f. American sculptor, painter, 1940–

GRECO, EL (DOMÉNIKOS THEOTOKÓPOULOS)
 grek-ō, el (dō-**mā**-nē-kòs
 thā-ō-tō-**kō**-pü-lòs)
m. Spanish (b. Crete) painter, 1541–1614

GRECO, EMILIO **grā**-ko, ā-**mēl**-yō
m. Italian sculptor, 1913–

GREEN, VALENTINE grēn, **val**-ən-tin
m. English engraver, 1739–1813

GREENE, BALCOMB grēn, **bal**-kəm
m. American painter, 1904–90

GREENOUGH, HORATIO　　　　　**grē**-nō, hȯ-**rā**-shō
m. American sculptor, 1805–52

GREUZE, JEAN-BAPTISTE　　　　grœz, zhän–bat-tēst
m. French painter, 1725–1805

GRIEN (GRÜN): see BALDUNG, HANS

GRIFFIN, BRIAN　　　　　**grif**-in, **bri**-ən
m. British photographer, 1948–

GRIGORESCU, NICOLAE　　　　grē-gȯ-**res**-kü, **nē**-kȯ-lī
m. Rumanian painter, 1838–1907

GRILO, SARAH　　　　　**grē**-lō, **sä**-rä
f. Argentine painter, 1921–

GRIMALDI, GIOVANNI FRANCESCO (IL BOLOGNESE)
　　　　　grē-**mäl**-dē, jō-**vän**-nē frän-**ches**-kō
　　　　　(ēl bō-lō-**nyā**-zā)
m. Bolognese painter, 1606–80

GRIMM, SAMUEL HIERONYMUS　　　grim, **sam**-yü-əl hēr-**ä**-nə-məs
m. Swiss (act. England) painter, draughtsman, 1733–94

GRIMSHAW, ATKINSON　　　　**grim**-shȯ, **at**-kin-sən
m. English painter, 1836–93

GRIS, JUAN　　　　　grēs, \underline{k}wän
m. Spanish (act. France) painter, 1887–1927

GROMAIRE, MARCEL　　　　grō-mer, mär-sel
m. French painter, 1892–1971

GRONK (GLUGIO GRONK NICANDRO)
　　　　　grȯngk
　　　　　(**glü**-\underline{k}yō grȯngk nē-**kän**-drō)
m. American painter, 1954–

GROOMS, RED　　　　　grümz, red
m. American painter, sculptor, 1937–

GROOVER, JAN　　　　　**grü**-vər, jan
f. American photographer, 1943–

GROS, ANTOINE-JEAN　　　　grō, än-twän–zhän
m. French painter, 1771–1835

GROSZ, GEORGE　　　　　grōs, jȯrj
m. American (b. Germany) painter, draughtsman, 1893–1959

GRÜNEWALD, MATTHIAS **grue**-nə-vält, mä-**tē**-äs
m. German painter, c. 1470/80–1528

GUARDI, FRANCESCO **gwär**-dē, frän-**ches**-kō
m. Venetian painter, 1712–93

GUAYASAMÍN, OSWALDO gwä-yä-sä-**mēn**, ōs-**wäl**-dō
m. Ecuadoran painter, 1919–

GUERCINO, IL (GIOVANNI FRANCESCO BARBIERI)
 gwer-**chē**-nō, ēl (jō-**vän**-nē
 frän-**ches**-kō bärb-**yä**-rē)
m. Bolognese painter, 1591–1666

GUÉRIN, GILLES gā-ran, zhēl
m. French sculptor, 1606–78

GUÉRIN, PIERRE-NARCISSE gā-ran, pyer–när-sēs
m. French painter, 1774–1833

GUGLIELMO DELLA PORTA gül-**yel**-mō **del**-lä **pòr**-tä
m. Genoese/Roman sculptor, d. 1577

GUIDO DA SIENA **gwē**-dō dä sē-**ā**-nä
m. Sienese painter, act. 13th c.

GUILLAUMIN, ARMAND gē-yō-man, är-män
m. French painter, 1841–1927

GÜNTHER, IGNAZ **guen**-tər, **ē**-nyäts
m. Bavarian sculptor, 1725–75

GUSTON, PHILIP **gəs**-tən, **fil**-əp
m. American painter, 1913–80

GUTFREUND, OTTO **güt**-fròint, **òt**-tō
m. Czech sculptor, 1889–1927

GUTMAN, JOHN **gət**-mən, jän
m. American (b. Germany) photographer, 1905–

GUTTUSO, RENATO güt-**tü**-sō, rā-**nä**-tō
m. Italian painter, 1912–87

GUYS, CONSTANTIN gēs, kōn-stän-tan
m. French draughtsman, 1805–92

GWATHMEY, ROBERT **gwäth**-mē, **räb**-ərt
m. American painter, 1903–88

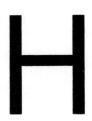

H

HAACKE, HANS **hä**-kə, häns
m. German (act. United States) installation artist, 1936–

HACKAERT, JAN **hak**-ərt, yän
m. Dutch painter, 1628–99

HAIJIMA, MASAO hä-ē-jē-mä, mä-sä-ō
m. Japanese (act. Paris) painter, contemporary

HALE, ELLEN DAY hāl, **el**-ən dā
f. American painter, 1855–1940

HALLEY, PETER **hal**-ē, pē-tər
m. American painter, 1953–

HALS, FRANS häls, fräns
m. Dutch painter, 1581/5–1666

HALVERSON, KAREN **hal**-vər-sən, **ker**-ən
f. American photographer, 1941–

HAMAYA, HIROSHI hä-mä-yä, hē-rō-shē
m. Japanese photographer, 1915–

HAMILTON, ANN **ham**-əl-tən, an
f. American installation artist, 1956–

HAMILTON, GAVIN **ham**-əl-tən, **gav**-ən
m. Scottish painter, 1723–98

HAMILTON, RICHARD **ham**-əl-tən, **rich**-ərd
m. English painter, 1922–

HAMMERSHØI, VILHELM **ham**-mers-hœē, **vil**-helm
m. Danish painter, 1864–1916

HAMMONS, DAVID **ham**-ənz, **dā**-vid
m. American mixed-media artist, 1943–

HAMPTON, JAMES **hamp**-tən, jāmz
m. American sculptor, 1909–64

HANNEMAN, ADRIAEN **hän**-nə-män, **ä**-drē-än
m. Dutch painter, c. 1601–71

HANSON, DUANE **han**-sən, dwān
m. American sculptor, 1925–

HAOZOUS, ROBERT **haú**-züs, **räb**-ərt
m. American (Chiricahua/Apache) sculptor, 1943–

HARDIN, HELEN **härd**-ən, **hel**-ən
f. American (Pueblo) painter, 1943–84

HARE, DAVID hār, **dā**-vid
m. American sculptor, 1917–

HARING, KEITH **her**-ing, kēth
m. American painter, 1958–90

HARLESTON, EDWIN A. **här**-les-tən, **ed**-win
m. American painter, 1882–1931

HARPIGNIES, HENRI är-pēn-yē, än-rē
m. French painter, 1819–1916

HARRIS, LAWREN STEWART **har**-əs, **lòr**-ən **stü**-ərt
m. Canadian painter, 1885–1970

HARRISON, HELEN MAYER **har**-ə-sən, **hel**-ən **mi**-ər
f. American environmental artist, 1929–

HARRISON, NEWTON **har**-ə-sən, **n(y)üt**-ən
m. American environmental artist, 1932–

HARTIGAN, GRACE **här**-tə-gən, grās
f. American painter, 1922–

HARTLEY, MARSDEN **härt**-lē, **märz**-dən
m. American painter, 1877–1943

HARTUNG, HANS **här**-tùng, häns
m. French (b. Germany) painter, 1904–89

HARVEY, BESSIE **här**-vē, **bes**-ē
f. American sculptor, 1928–

HA-SO-DE (NARCISCO ABEYTA) hä-sō-dā (när-**sēs**-kō ä-**bā**-tä)
m. American (Navajo) painter, 1918–

HASSAM, CHILDE **has**-əm, chīld
m. American painter, printmaker, 1859–1935

HASSINGER, MAREN **ha**-sing-ər, **mar**-ən
f. American sculptor, 1947–

HAUDEBOURT-LESCOT, ANTOINETTE CÉCILE HORTENSE
ō-də-bür–les-kō,
äⁿ-twä-net sā-sēl ȯr-täⁿs
f. French painter, 1784–1845

HAVARD, JAMES **hav**-ərd, jāmz
m. American (Chippewa/Choctaw) painter, 1937–

HAWKINS, WILLIAM **hȯ**-kənz, **wil**-yəm
m. American painter, 1895–1990

HAYDEN, PALMER **hā**-dən, **päm**-ər
m. American painter, 1890–1973

HAYEZ, FRANCESCO **ä**-yes, frän-**ches**-kō
m. Milanese painter, 1791–1881

HAYMAN, FRANCIS **hā**-mən, **fran**-sis
m. English painter, 1707/8–76

HAYTER, S. W. (STANLEY WILLIAM) **hā**-tər (**stan**-lē **wil**-yəm)
m. English engraver, painter, 1901–88

HEADE, MARTIN JOHNSON hēd, **mär**-tən **jän**-sən
m. American painter, 1819–1904

HEAP OF BIRDS, EDGAR hēp əv bərdz, **ed**-gər
m. American (Cherokee/Arapaho) painter, installation artist, 1954–

HEARNE, THOMAS hərn, **täm**-əs
m. English draughtsman, 1744–1817

HEARTFIELD, JOHN (HELMUT HERZFELDE)
härt-fēld, jän (**hel**-mủt **herts**-fel-də)
m. German photomontagist, filmmaker, 1891–1968

HECKEL, ERICH **hek**-əl, **ā**-ri<u>k</u>
m. German painter, 1883–1970

HEDA, WILLEM CLAESZ. **hā**-dä, **vil**-əm kläs
m. Dutch painter, 1593/4–1680/2

HEEM, JAN DAVIDSZ. DE häm, yän **dä**-vits də
m. Dutch painter, 1606–83/4

HEEMSKERCK, MAERTEN VAN **hāms**-kerk, **mär**-tən fən
m. Dutch painter, 1498–1574

HEINECKEN, ROBERT **hī**-nə-kən, **räb**-ərt
m. American photographer, 1931–

HELD, AL held, al
m. American painter, 1928–

HELLEU, PAUL el-lœ, pōl
m. French painter, draughtsman, 1859–1927

HELST, BARTHOLOMEUS VAN DER helst, bär-tō-lō-**mā**-ues fən dər
m. Dutch painter, 1613–70

HEMESSEN, CATERINA VAN **hā**-mes-sən, kä-te-**rē**-nä fən
f. Flemish painter, 1528–after 1587

HEMESSEN, JAN VAN **hā**-mes-sən, yän fən
m. Flemish painter, c. 1500–c. 1575

HENRI, ROBERT hen-rī, **räb**-ərt
m. American painter, 1865–1929

HEPWORTH, BARBARA **hep**-werth, **bär**-bə-rə
f. English sculptor, 1903–75

HERBIN, AUGUSTE er-ban, ō-guest
m. French painter, 1882–1960

HERKOMER, HUBERT VON **her**-kȯ-mer, **hü**-bert fȯn
m. English (b. Germany) painter, 1849–1914

HERLIN, FRIEDRICH **her**-lin, **frēd**-ri<u>k</u>
m. German painter, act. c. 1460–1500

HERNANDEZ, ESTER er-**nän**-des, **es**-tər
f. American printmaker, 1944–

HERNÁNDEZ CRUZ, LUIS er-**nän**-des krüs, lü-**ēs**
m. Puerto Rican painter, 1936–

HERRÁN, SATURNINO er-**rän**, sä-tür-**nē**-nō
m. Mexican painter, 1887–1918

HERRERA, CARMEN er-**rā**-rä, **kär**-men
f. Cuban (act. United States) painter, 1915–

HERRERA, FRANCISCO THE ELDER er-**rā**-rä, frän-**thēs**-kō
m. Spanish painter, c. 1576–1656

HERRERA, FRANCISCO THE YOUNGER er-**rā**-rä, frän-**thēs**-kō
m. Spanish painter, 1622–85

HERRÓN, WILLIE er-**rōn, wil**-ē
m. American painter, 1951–

HESSE, EVA **hes**-ə, **ā**-vä
f. American (b. Germany) sculptor, 1936–70

HEYDEN, JAN VAN DER **hi**-dən, yän fən dər
m. Dutch painter, printmaker, 1637–1712

HEYSEN, HANS **hi**-sən, häns
m. Australian (b. Germany) painter, 1877–1968

HICKEY, DALE **hik**-ē, dāl
m. Australian painter, 1937–

HICKS, EDWARD hiks, **ed**-wərd
m. American painter, 1780–1849

HILLIARD, NICHOLAS **hil**-yərd, **nik**-ə-ləs
m. English painter, 1547–1619

HILTON, ROGER **hil**-tən, **räj**-ər
m. English painter, 1911–75

HINE, LEWIS WICKES hīn, **lü**-is wiks
m. American photographer, 1874–1940

HINES, FELRATH hīnz, **fel**-rath
m. American painter, 1918–

HIRABAYASHI, KAORU hē-rä-bä-yä-shē, kä-ō-rü
f. Japanese painter, 1955–

HIRO (YASUHIRO WAKABAYASHI) hē-rō (yä-sue-hē-rō wä-kä-bä-yä-shē)
m. Japanese (b. China) photographer, 1930–

HIROSHIGE, ANDO hē-rō-shē-gā, än-dō
m. Japanese printmaker, 1797–1858

HOBBEMA, MEINDERT **hȯb**-bə-mä, **min**-dərt
m. Dutch painter, 1638–1709

HÖCH, HANNAH hœḵ, **hän**-nä
f. German collagist, 1889–1978

HOCKNEY, DAVID **häk**-nē, **dā**-vid
m. English painter, printmaker, photographer, 1937–

HODGKIN, HOWARD **häj**-kin, **haủ**-ərd
m. English painter, 1932–

HODLER, FERDINAND **hōd**-lər, **fer**-dē-nänt
m. Swiss painter, 1853–1918

HOFER, EVELYN **hō**-fər, **ev**-ə-lin
f. British (b. Germany) photographer, act. 1974–

HOFER, KARL **hō**-fər, kärl
m. German painter, 1878–1955

HOFFMAN, MALVINA **hȯf**-mən, mal-**vē**-nə
f. American sculptor, 1887–1966

HOFMANN, HANS **hȯf**-män, häns
m. American (b. Germany) painter, 1880–1966

HOGARTH, WILLIAM **hō**-gärth, **wil**-yəm
m. English painter, engraver, 1697–1764

HOKUSAI, KATSUSHIKA hō-k′-sī, kät-sü-shē-kä
m. Japanese printmaker, 1760–1849

HOLBEIN, HANS THE ELDER **hȯl**-bīn or **hōl**-bīn, häns
m. German painter, c. 1460–1524

HOLBEIN, HANS THE YOUNGER **hȯl**-bīn or **hōl**-bīn, häns
m. German painter, 1498–1543

HOLLAR, WENZEL (WENCESLAUS) **hȯl**-lär, **vent**-sel (**vent**-ses-läs)
m. Bohemian engraver, watercolorist, 1607–77

HOLLEY, LONNIE **häl**-ē, **län**-ē
m. American sculptor, 1950–

HOLMBERG, GUSTAF WERNER **hōlm**-berg, **gu̇s**-täf **ver**-nər
m. Finnish painter, 1830–60

HOLT, NANCY hōlt, **nan**-sē
f. American siteworks artist, sculptor, 1938–

HOLZER, JENNY **hōlt**-sər, **jen**-ē
f. American conceptual artist, 1950–

HOMAR, LORENZO ō-**mär**, lō-**ren**-sō
m. Puerto Rican printmaker, 1913–

HOMER, WINSLOW **hō**-mər, **winz**-lō
m. American painter, 1836–1910

HONDECOETER, MELCHIOR D' **hōn**-də-kü-tər, **mel**-k̲ē-òr d'
m. Dutch painter, c. 1636–91/5

HONTHORST, GERRIT VAN **hȯnt**-hȯrst, **k̲er**-rit or **ger**-rit fən
m. Dutch painter, 1590–1656

HOOCH, PIETER DE hōk̲, **pē**-tər də
m. Dutch painter, 1629–84

HOOGSTRATEN, SAMUEL VAN **hōk̲**-strät-ən or **hōg**-strät-ən,
sam-ü-el fən
m. Dutch painter, 1627–78

HOPPER, EDWARD **häp**-ər, **ed**-wərd
m. American painter, 1882–1967

HORN, REBECCA hȯrn, ri-**bek**-ə
f. German installation artist, 1944–

HOSOE, EIKOH hō-sō-e, e-ē-kō
m. Japanese photographer, 1933–

HOUDON, JEAN-ANTOINE ü-dōⁿ, zhäⁿ–äⁿ-twän
m. French sculptor, 1741–1828

HOUSER, ALLAN **hau̇**-zər, **al**-ən
m. American (Chiricahua/Apache) painter, sculptor, 1915–

HOWE, OSCAR hau̇, **äs**-kər
m. American (Yanktonai Sioux) painter, draughtsman, 1915–83

HOYOS, ANA MERCEDES **ôi**-ōs, **ä**-nä mer-**sä**-des
f. Colombian painter, 1942–

HUBER, WOLFGANG **hü**-bər, **vôlf**-gäng
m. German painter, printmaker, c. 1490–1553

HUGHES, ARTHUR hyüz, **är**-thər
m. English painter, 1830–1915

HUGUET, JAIME (JAUME) ü-**get**, **ki**-mä (**kaû**-mä)
m. Catalan painter, c. 1415–92

HUNT, RICHARD hənt, **rich**-ərd
m. American sculptor, 1935–

HUNT, WILLIAM HOLMAN hənt, **wil**-yəm **hōl**-mən
m. English painter, 1827–1910

HUNTER, CLEMENTINE hənt-ər, **klem**-ən-tīn
f. American painter, 1883–1988

HUNTINGTON, ANNA VAUGHN HYATT
 hənt-ing-tən, **an**-ə vôn **hi**-ət
f. American sculptor, 1876–1973

HÜTTE, AXEL **huet**-tə, **äk**-sel
m. German photographer, 1955–

HUYSUM, JAN VAN **hœē**-süm or **hôi**-süm, yän fən
m. Dutch painter, 1682–1749

HYDE, DOUG hīd, dəg
m. American (Nez Perce/Assiniboin) sculptor, 1946–

HYPPOLITE, HECTOR ē-pō-lēt, äk-tôr
m. Haitian painter, 1894–1948

I

IDA, SHOICHI ē-dä, shō-ē-chē
m. Japanese etcher, 1941–

IHARA, MICHIO ē-hä-ra, mē-chē-ō
m. Japanese (b. France) sculptor, 1928–

ILSTED, PETER VILHELM **il**-stəd, **pā**-tər **vil**-helm
m. Danish painter, 1861–1933

IMMENDORFF, JÖRG **im**-mən-dȯrf, yœrg
m. German painter, 1945–

INDIANA, ROBERT in-dē-**an**-ə, **räb**-ərt
m. American painter, sculptor, 1928–

INGRES, JEAN-AUGUSTE-DOMINIQUE a^n-gr', zhän–ō-guest–dȯ-mē-nē-k'
m. French painter, 1780–1867

INNES, JAMES DICKSON **in**-əs, jāmz **dik**-sən
m. Welsh painter, 1887–1914

INNESS, GEORGE **in**-əs, jȯrj
m. American painter, 1825–94

IPOUSTÉGUY, JEAN ē-pü-stä-gē, zhän
m. French sculptor, 1920–

IRIZARRY, CARLOS ē-rē-**sär**-rē, **kär**-lōs
m. Puerto Rican printmaker, 1938–

IRWIN, ROBERT **ər**-win, **räb**-ərt
m. American painter, sculptor, 1928–

ISABEY, EUGÈNE ē-zä-bā, œ-zhen
m. French painter, 1803–86

ISAKSON, KARL ē-säk-sȯn, kärl
m. Swedish painter, 1878–1922

ISENBRANT, ADRIAEN ē-zən-bränt, **ä**-drē-än
m. Flemish painter, c. 1490–1551

ISRAËLS, IZACK **is**-rä-els, ē-zäk
m. Dutch painter, 1865–1934

ISRAËLS, JOZEF **is**-rä-els, **yō**-zef
m. Dutch painter, 1824–1911

ITATANI, MICHIKO ē-tä-tä-nē, mē-chē-kō
f. Japanese (act. United States) painter, 1948–

ITTEN, JOHANNES **it**-tən, yō-**hän**-əs
m. Swiss painter, sculptor, 1888–1967

ITURBIDE, GRACIELA ē-tür-**bē**-_th_ā, grä-**syā**-lä
f. Mexican photographer, 1942–

IVANOV, ALEXANDER ē-**vä**-nȯf, əl-yik-**sän**-dər
m. Russian (act. Italy) painter, 1806–58

IZQUIERDO, MARÍA ēs-**kyer**-dō, mä-**rē**-ä
f. Mexican painter, 1906–55

JAAR, **A**LFREDO yär, äl-**frä**-dō
m. Chilean (act. United States) sculptor, installation artist, 1956–

JACKS, **R**OBERT jaks, **räb**-ərt
m. Australian painter, 1943–

JACKSON, **A**LEXANDER **Y**OUNG **jak**-sən, ə-leg-**zan**-dər yəng
m. Canadian painter, 1882–1974

JACKSON, **W**ILLIAM **H**ENRY **jak**-sən, **wil**-yəm **hen**-rə
m. American photographer, 1843–1942

JAMESONE, **G**EORGE **jām**-sən, jȯrj
m. Scottish painter, c. 1590–1644

JANSSENS, **A**BRAHAM **yän**-səns, **ä**-brä-häm
m. Flemish painter, c. 1575–1632

JARAMILLO, **I**GNACIO **G**ÓMEZ ḵä-rä-**mē**-yō, ē-**nyä**-syō **gō**-mes
m. Colombian painter, draughtsman, 1910–71

JAUDON, **V**ALERIE zhä-**dǝn**, **val**-ǝ-rē
f. American painter, 1945–

JAWLENSKY, **A**LEXEI VON yä-**vlen**-skē, ä-**leks**-yē fȯn
m. Russian painter, 1867–1941

JEAN **B**OULOGNE: **see** **G**IAMBOLOGNA

JEANNERET, **C**HARLES **É**DOUARD (**L**E **C**ORBUSIER)
 zhan-nǝ-**rä**, shärl ā-dwär
 (lǝ kȯr-bue-zyā)
m. Swiss painter, architect, 1887–1965

JENNEY, **N**EIL **jen**-ē, nēl
m. American painter, 1945–

JENSEN, ALFRED **jen**-sən, **al**-frəd
m. American (b. Guatemala) painter, 1903–81

JESSUP, GEORGIA MILLS **jes**-əp, **jȯr**-jə milz
f. American painter, 1926–

JIMÉNEZ, LUIS k̲ē̲-**mā**-nes, lü-**ēs**
m. American sculptor, 1940–

JODICE, MIMMO **yō**-dē-chā, **mēm**-mō
m. Italian photographer, 1934–

JOEST VAN CALCAR, JAN yüst fən **käl**-kär, yän
m. Dutch painter, c. 1450–1519

JOHN, AUGUSTUS jän, ȯ-**gəs**-təs
m. English painter, 1878–1961

JOHN, GWENDOLEN jän, **gwen**-də-lən
f. English painter, 1876–1939

JOHNS, JASPER jänz, **jas**-pər
m. American painter, sculptor, printmaker, 1930–

JOHNSON, JOSHUA **jän**-sən, **jäsh**-ü-ə
m. American painter, act. 1789–1832

JOHNSON, MALVIN GRAY **jän**-sən, **mal**-vin grā
m. American painter, 1896–1934

JOHNSON, SARGENT **jän**-sən, **sär**-jənt
m. American sculptor, 1887–1967

JOHNSON, WILLIAM H. **jän**-sən, **wil**-yəm
m. American painter, 1901–70

JOLIMEAU, SERGE zhō-lē-mō, serzh
m. Haitian sculptor, 1952–

JONES, ALLEN jōnz, **al**-ən
m. English painter, sculptor, 1937–

JONES, BEN jōnz, ben
m. American sculptor, painter, 1942–

JONES, FRANK jōnz, frangk
m. American draughtsman, 1900–69

JONES, LOIS MAILOU jōnz, **lō**-is **mi**-lü
f. American painter, designer, 1905–

JONES, THOMAS jōnz, **täm**-əs
m. Welsh painter, 1742–1803

JONGKIND, JOHAN BARTHOLD **yȯng**-kint, **yō**-hän **bär**-tȯlt
m. Dutch painter, 1819–91

JORDAENS, JACOB **yȯr**-däns, **yä**-kȯp
m. Flemish painter, 1593–1678

JOSEPH, ANTONIO zhō-zef, än-**tōn**-yō
m. Haitian (b. Dominican Republic) painter, 1921–

JOSEPHSON, ERNST **yō**-zef-sȯn, ernst
m. Swedish painter, 1851–1906

JOUVENET, JEAN zhü-və-nā, zhän
m. French painter, 1644–1717

JUAN DE JUANES (JUAN VICENTE MACIP)
 kwän dā **kwän**-es
 (kwän vē-**then**-tä mä-**thēp**)
m. Spanish painter, c. 1523–79

JUÁREZ, JOSÉ **kwä**-res, kō-**sā**
m. Mexican painter, c. 1615–c. 1665

JUDD, DONALD jəd, **dän**-əld
m. American sculptor, 1928–

JUNI, JUAN DE **kü**-nē, kwän dā
m. Spanish sculptor, c. 1507–77

JUSTUS VAN GHENT (JOOS VAN WASSENHOVE)
 yues-tues fən kent or gent
 (yōs fən **väs**-sən-hō-və)
m. Dutch painter, act. c. 1460–75

K

KABAKOV, ILYA kä-bə-**kȯf, ēl**-yə
m. Russian conceptual artist, 1933–

KABOTIE, FRED kä-**bō**-tē, fred
m. American (Hopi) painter, 1900–

KAHLO, FRIDA **kä**-lō, **frē**-dä
f. Mexican painter, 1907–54

KALF, WILLEM kälf, **vil**-əm
m. Dutch painter, 1619–93

KALLSTENIUS, GOTTFRIED käl-**stän**-yœs, **gȯt**-frid
m. Swedish painter, 1861–1943

KANAGA, CONSUELO ka-**näg**-ə, kän-**swä**-lō
f. American photographer, 1894–1978

KANDINSKY, WASSILY kən-**dyēn**-skē or kan-**din**-skē,
 və-**sēl**-yē
m. Russian painter, 1866–1944

KÄNDLER, JOHANN JOACHIM **kend**-lər, **yō**-hän **yō**-ä-k̲im
m. German sculptor, porcelain modeler, 1706–75

KANE, PAUL kān, pȯl
m. Canadian (b. Ireland) painter, 1810–71

KAPOOR, ANISH kä-**pür**, ä-**nēsh**
m. Indian (act. England) sculptor, 1954–

KAPROW, ALLAN **kap**-rō, **al**-ən
m. American performance artist, 1927–

KARSH, YOUSUF kärsh, **yü**-səf
m. Canadian (b. Armenia) photographer, 1908–

KÄSEBIER, GERTRUDE **kā**-zə-bēr, **gər**-trüd
f. American photographer, 1852–1934

KASTEN, BARBARA **kast**-ən, **bär**-bə-rə
f. American photographer, 1959–

KATZ, ALEX kats, **al**-əks
m. American painter, 1927–

KAUFFMANN, ANGELICA **kaúf**-män, äng-**gā**-lē-kä
f. Swiss (act. Italy) painter, 1741–1807

KAULBACH, WILHELM VON **kaúl**-bäḵ, **vil**-helm fón
m. German painter, illustrator, 1805–74

KAWARA, ON kä-wä-rä, ōn
m. American (b. Japan) painter, 1931–

KELLEY, MIKE **kel**-ē, mīk
m. American painter, sculptor, 1954–

KELLY, ELLSWORTH **kel**-ē, **elz**-wərth
m. American painter, sculptor, 1923–

KEMÉNY, ZOLTAN ke-mā-nē, **zōl**-tän
m. Swiss (b. Hungary) sculptor, 1907–65

KENSETT, JOHN FREDERICK **ken**-sət, jän **fred**-rik
m. American painter, 1816/8–72

KEPES, GYORGY **kep**-ish, **júr**-ē
m. American (b. Hungary) photographer, painter, kinetic and light
artist, 1906–

KERTÉSZ, ANDRÉ **ker**-tesh, än-drā
m. American (b. Hungary) photographer, 1894–1985

KESSEL, JAN VAN **kes**-əl, yän fən
m. Flemish painter, 1626–79

KETCHUM, ROBERT GLENN **ke**-chəm, **räb**-ərt glen
m. American photographer, 1948–

KETEL, CORNELIS **kā**-təl, kór-**nā**-lis
m. Dutch painter, 1548–1616

KEY, ADRIAEN kī, **ä**-drē-än
m. Flemish painter, c. 1544–after 1589

KEY, WILLEM kī, **vil**-əm
m. Flemish painter, c. 1515–68

KEYSER, HENDRICK DE **kī**-zer, **hen**-drik də
m. Dutch sculptor, architect, 1565–1621

KEYSER, THOMAS DE **kī**-zər, **tȯ**-mäs də
m. Dutch painter, 1596/7–1667

KIEFER, ANSELM **kēf**-ər, **än**-zelm
m. German painter, sculptor, printmaker, 1945–

KIENHOLZ, EDWARD **kēn**-hōlts, **ed**-wərd
m. American sculptor, installation artist, 1927–

KIENHOLZ, NANCY REDDIN **kēn**-hōlts, **nan**-sē **red**-ən
f. American sculptor, installation artist, 1944–

KIMBALL, YEFFE **kim**-bəl, **yef**-ē
f. American (Osage) painter, 1914–78

KIPPENBERGER, MARTIN **kip**-ən-ber-gər, **mär**-tēn
m. German painter, sculptor, photographer, 1953–

KIPRENSKY, OREST ADAMOVICH kē-**prē**-en-skē, ȯ-**rē**-est
ə-**däm**-ō-vich
m. Russian painter, 1782–1836

KIRCHNER, ERNST LUDWIG **kirk**-nər, ernst **lüt**-vik
m. German painter, sculptor, printmaker, 1880–1938

KIRKEBY, PER **kir**-kə-bē, per
m. Danish painter, 1938–

KISLING, MOÏSE kis-ling, mȯ-ēs
m. French (b. Poland) painter, 1891–1953

KITAJ, RON B. kē-**tī**, rän
m. American (act. England) painter, 1932–

KLAUKE, JÜRGEN **klau̇**-kə, **yu̇er**-gən
m. German photographer, 1943–

KLEE, PAUL klā, pau̇l
m. Swiss painter, printmaker, 1879–1940

KLEIN, ASTRID klīn, **äs**-trid
f. German photographer, 1951–

KLEIN, WILLIAM klīn, **wil**-yəm
m. American (act. France) photographer, 1928–

KLEIN, YVES klīn, ēv
m. French painter, 1928–62

KLETT, MARK klet, märk
m. American photographer, 1952–

KLIMT, GUSTAV klimt, **güs**-täf
m. Austrian painter, 1862–1918

KLINE, FRANZ klīn, fränts
m. American painter, 1910–62

KLINGER, MAX **kling**-ər, mäks
m. German painter, 1857–1920

KLIUN, IVAN VASILIEVICH klē-**ün**, ē-**vän** və-**sēl**-ē-ə-vich
m. Russian painter, 1870–1942

KLODT, PYOTR KARLOVICH klōt, pē-**ōt**-ər **kär**-lō-vich
m. Russian sculptor, 1805–67

KLUCIS, GUSTAV GUSTAVOVICH **klü**-sis, güs-**täf** güs-**täf**-ō-vich
m. Latvian painter, 1895–1944

KNELLER, GODFREY **nel**-ər, **gäd**-frē
m. English (b. Germany) painter, 1646–1723

KNOEBEL, IMI **knœ**-bəl, **ē**-mē
m. German painter, 1940–

KØBKE, CHRISTEN **kœb**-kə, **kris**-tən
m. Danish painter, 1810–48

KOCH, JOSEPH ANTON kók, **yō**-zef **än**-tōn
m. Austrian painter, 1768–1839

KOEKKOEK, BAREND CORNELIS **kük**-kük, **bär**-ənd kòr-**nā**-lis
m. Dutch painter, 1803–62

KOKOSCHKA, OSKAR kō-**kósh**-kä, **ós**-kär
m. British (b. Austria) painter, 1886–1980

KOLÁŘ, JIŘÍ **kō**-lärzh, **yi**-rē
m. French (b. Bohemia) collagist, 1914–

KOLLWITZ, KÄTHE **kȯl**-vits, **kā**-tə
f. German printmaker, painter, 1867–1945

KONENKOV, SERGEI TIMOFEEVICH kə-**nyeng**-kȯf, sir-**gā**-ē
tim-ō-**fē**-ə-vich
m. Russian sculptor, 1874–1971

KONIJNENBURG, WILLEM ADRIAAN VAN
kō-**ni**-nən-bu̇rk or -bu̇rg,
vil-əm **ä**-drē-än fən
m. Dutch painter, 1868–1943

KONINCK, PHILIPS DE **kō**-ningk, **fil**-ips də
m. Dutch painter, 1619–88

KOROVIN, KONSTANTIN ALEKSEEVICH kə-**rō**-vin, kȯn-stən-**tēn**
əl-ik-**sē**-ə-vich
m. Russian painter, 1861–1939

KOSSOY, BORIS kō-**sȯi**, bō-**rēs**
m. Brazilian photographer, 1941–

KOSUTH, JOSEPH **kō**-səth, **jō**-zəf
m. American conceptual artist, 1945–

KOUDELKA, JOSEF **kō**-del-kə, **yō**-zef
m. Czech photographer, 1938–

KOUNELLIS, JANNIS kü-**nel**-ēs, **yän**-ēs
m. Greek (act. Italy) painter, installation artist, 1936–

KRAMSKOI, IVAN NIKOLAIEVICH kräm-**skȯi**, ē-**vän** nēk-ə-**li**-ə-vich
m. Russian painter, 1837–87

KRASNER, LEE **kraz**-nər, lē
f. American painter, 1908–84

KRICKE, NORBERT **krēk**-kə, **nȯr**-bert
m. German sculptor, 1922–84

KRIEGHOFF, CORNELIUS **krēg**-hȯf, kȯr-**nē**-lē-əs
m. Canadian (b. Holland) painter, 1815–72

KROHG, CHRISTIAN krōg, **krist**-yän
m. Norwegian painter, 1852–1925

KROHG, PER krōg, pär
m. Norwegian painter, 1889–1965

KRØYER, PETER SEVERIN **kroe**-yər, **pā**-tər **sā**-ver-in
m. Danish (b. Norway) painter, 1851–1909

KRUGER, BARBARA **krü**-gər, **bär**-bə-rə
f. American collagist, conceptual artist, 1945–

KUBIN, ALFRED **kü**-bin, **äl**-fred
m. Austrian printmaker, 1877–1959

KUBOTA, SHIGEKO kü-bō-tä, shē-ge-kō
f. Japanese (act. United States) video installation artist, 1937–

KÜHN, HEINRICH **kuen**, **hin**-rik̲
m. Austrian (b. Germany) photographer, 1866–1944

KUHN, WALT kün, wȯlt
m. American painter, 1877–1949

KUINDZHI, ARKHIP IVANOVICH kwu̇-**ēn**-jə, är-**kēp** ē-**vän**-ō-vich
m. Russian painter, act. 1870–81

KUITCA, GUILLERMO **kwēt**-sä, gē-**yer**-mō
m. Argentine painter, 1961–

KULMBACH, HANS SUESS VON **külm**-bäk̲, häns zu̇es fȯn
m. German painter, c. 1480–1522

KUNIYOSHI, YASUO ku̇n-ē-yō-shē, yä-sü-ō
m. American (b. Japan) painter, 1889–1953

KUPKA, FRANTISEK **ku̇p**-kä, **frän**-tyi-shek
m. Czech (act. France) painter, 1871–1957

LABAT, TONY lä-**bät**, **tō**-nē
m. Cuban (act. United States) video, installation artist, 1951–

LABILLE-GUIARD, ADÉLAÏDE lä-bē-y'–gē-yär, ä-dä-lä-ē-d'
f. French painter, 1749–1803

LACHAISE, GASTON lä-shez *or* lə-**shāz**, gas-tōⁿ
m. American (b. France) sculptor, 1882–1935

LACY, SUZANNE **lā**-sē, sü-**zan**
f. American conceptual artist, 1945–

LAER, PIETER VAN (IL BAMBOCCIO) lär, **pē**-tər fən (ēl bäm-**bót**-chō)
m. Dutch painter, 1599–1642

LA FOSSE, CHARLES DE lä fós, shärl də
m. French painter, 1636–1716

LA FRESNAYE, ROGER DE lä frä-nā, rō-zhā də
m. French painter, 1885–1925

LAIB, WOLFGANG lip, **vólf**-gäng
m. German sculptor, 1950–

LAIRESSE, GERARD DE lā-res, zhā-rär də
m. Dutch painter, 1641–1711

LAM, WIFREDO läm, vē-**frä**-dō
m. Cuban (act. France) painter, sculptor, 1902–82

LAMBERT, GEORGE **lam**-bert, jórj
m. English painter, 1710–65

LAMI, EUGÈNE-LOUIS lä-mē, œ-zhen–lü-ē
m. French painter, 1800–90

LANCRET, NICOLAS läⁿ-krä, nē-kō-lä
m. French painter, 1690–1745

LANDSEER, EDWIN **lan**-sēr, **ed**-win
m. English painter, sculptor, 1802–73

LANE, FITZ HUGH län, fits hyü
m. American painter, 1804–65

LANFRANCO, GIOVANNI län-**frän**-kō, jō-**vän**-nē
m. Parmesan painter, 1582–1647

LANGE, DOROTHEA lang, dȯr-ə-**thē**-ə
f. American photographer, 1895–1965

LARATTE, GEORGES lä-rät, zhȯrzh
m. Haitian sculptor, 1933–

LARGILLIÈRE, NICOLAS DE lär-zhēl-yer, nē-kō-lä də
m. French painter, 1656–1746

LARIONOV, MIKHAIL FEODOROVICH lär-ē-**ō**-nȯf, mēk-**hä**-il fē-dō-**rō**-vich
m. Russian painter, 1881–1964

LARRAZ, JULIO lär-**räs**, **kül**-yō
m. Cuban (act. United States) painter, 1944–

LARSSON, CARL lärs-sȯn, kärl
m. Swedish painter, 1853–1919

LARTIGUE, JACQUES-HENRI lär-tē-g', zhak–äⁿ-rē
m. French photographer, painter, 1894–1986

LASANSKY, MAURICIO lä-**sän**-skē, maủ-**rē**-syō
m. Argentine draughtsman, printmaker, 1914–

LASSAW, IBRAM **las**-sȯ, **ē**-bräm
m. American (b. Egypt) sculptor, 1916–

LA TOUR, GEORGES DE lä tür, zhȯrzh də
m. French painter, 1593–1652

LA TOUR, MAURICE QUENTIN DE lä tür, mō-rēs käⁿ-taⁿ də
m. French painter, 1704–88

LAUGHLIN, CLARENCE JOHN **lȯf**-lin, **kla**-rəns jän
m. American photographer, 1905–85

LAURANA, FRANCESCO laù-**rä**-nä, frän-**ches**-kō
m. Dalmatian sculptor, c. 1420–1502

LAURENCIN, MARIE lō-rän-san, ma-rē
f. French painter, 1885–1956

LAURENS, HENRI lō-rän, än-rē
m. French sculptor, 1885–1954

LAUTREC: see TOULOUSE-LAUTREC

LAVERY, JOHN **lav**-rē, jän
m. Irish painter, 1856–1941

LAWLER, LOUISE **lȯ**-lər, lü-**ēz**
f. American photographer, 1947–

LAWRENCE, JACOB **lȯ**-rəns, **jā**-kəb
m. American painter, 1917–

LAWRENCE, THOMAS **lȯ**-rəns, **täm**-əs
m. English painter, 1769–1830

LEAL, FERNANDO lā-**äl**, fer-**nän**-dō
m. Mexican painter, 1900–64

LEBRUN, CHARLES lə-brən, shärl
m. French painter, 1619–90

LECCIA, ANGE **lāch**-yä, änzh
m. French (b. Corsica) painter, projection artist, 1952–

LECK, BART ANTHONY VAN DER lek, bärt **än**-tō-nē fən dər
m. Dutch painter, 1876–1958

LEDUC, OZIAS lə-dœk, ō-zē-äs
m. Canadian painter, 1864–1955

LE FAUCONNIER, HENRI lə fō-kən-yā, än-rē
m. French painter, 1881–1946

LEGA, SILVESTRO **lā**-gä, sēl-**ves**-trō
m. Italian painter, 1826–95

LE GAC, JEAN lə gäk, zhän
m. French painter, collagist, 1936–

LÉGER, FERNAND lā-zhā, fer-nän
m. French painter, 1881–1955

LEHMBRUCK, WILHELM **lām**-brük, **vil**-helm
m. German painter, sculptor, 1881–1919

LEIBL, WILHELM **lī**-bəl, **vil**-helm
m. German painter, 1844–1900

LEIBOVITZ, ANNIE **lē**-bə-vits, **an**-ē
f. American photographer, 1950–

LEIGHTON, FREDERIC **lā**-tən, **fred**-rik
m. English painter, sculptor, 1830–96

LEIRNER, JAC **ler**-nər, zhak
f. Brazilian sculptor, installation artist, 1961–

LELY, PETER **lē**-lē, **pē**-tər
m. English (b. Holland) painter, 1618–80

LEMIEUX, ANNETTE loe-**myoe**, ə-**net**
f. American conceptual artist, painter, 1957–

LEMIEUX, JEAN-PAUL lə-myoe, zhän–pōl
m. Canadian painter, 1904–90

LEMOYNE, FRANÇOIS lə-mwän, frän-swä
m. French painter, 1688–1737

LEMOYNE, JEAN-BAPTISTE THE YOUNGER
lə-mwän, zhän–bat-tēst
m. French sculptor, 1704–78

LE NAIN, ANTOINE lə nan, än-twän
m. French painter, 1588–1648

LE NAIN, LOUIS lə nan, lü-ē
m. French painter, 1593–1648

LE NAIN, MATHIEU lə nan, ma-tyoe
m. French painter, 1607–77

LENBACH, FRANZ VON **len**-bäk, fränts fȯn
m. German painter, 1836–1904

LEOCHARES lē-**äk**-ə-rēz
m. Greek sculptor, mid–4th c. BC

LEONARDO DA VINCI lā-ō-**när**-dō dä **vin**-chē
m. Florentine draughtsman, painter, sculptor, 1452–1519

LEONI, LEONE lā-**ō**-nē, lā-**ō**-nä
m. Italian sculptor, 1509–90

LE PARC, JULIO lə pärk, **kül**-yō
m. Argentine painter, kinetic artist, 1928–

LEPÈRE, AUGUSTE lə-per, ō-guest
m. French engraver, 1849–1918

LE SECQ, HENRI lə sek, än-rē
m. French photographer, 1818–82

LE SIDANER, HENRI lə sē-dä-nā, än-rē
m. French painter, 1862–1939

LESSING, KARL FRIEDRICH **les**-sing, kärl **frēd**-ri<u>k</u>
m. German painter, 1808–80

LESUEUR, EUSTACHE (LE SUEUR) lə-sue-œr, œ-stäsh
m. French painter, 1617–55

LETHBRIDGE, JOHN **leth**-brij, jän
m. Australian (b. New Zealand) painter, 1948–

LEU, HANS THE YOUNGER lói, häns
m. Swiss painter, c. 1490–1531

LEVINE, SHERRIE lə-**vēn**, **sher**-ē
f. American photographer, sculptor, 1947–

LEVITAN, ISAAC ILICH le-vē-**tän**, ē-**säk** ē-**lēch**
m. Russian painter, 1860–1900

LEVITT, HELEN **lev**-it, **hel**-ən
f. American photographer, 1913–

LEWIS, EDMONIA **lü**-is, ed-**mōn**-ē-ə
f. American sculptor, c. 1843–after 1911

LEWIS, JOHN FREDERICK **lü**-is, jän **fred**-rik
m. English painter, 1805–76

LEWIS, NORMAN **lü**-is, **nòr**-mən
m. American painter, 1909–79

LEWIS, (PERCY) WYNDHAM **lü**-is, (**pər**-sē) **win**-dəm
m. English painter, novelist, 1882–1957

LEWITT, SOL lə-**wit**, säl
m. American sculptor, 1928–

LEYSTER, JUDITH **li**-stər, **yue**-dēt
f. Dutch painter, 1609–60

LHOTE, ANDRÉ lōt, än-drā
m. French painter, illustrator, 1885–1962

LIAUTAUD, GEORGES lē-ō-tō, zhȯrzh
m. Haitian sculptor, 1899–

LICHTENSTEIN, ROY **lik**-tən-stīn, rȯi
m. American painter, sculptor, 1923–

LIEBERMANN, MAX **lē**-bər-män, mäks
m. German painter, 1847–1935

LIEVENS, JAN **lē**-vəns, yän
m. Dutch painter, 1607–74

LIGON, GLENN **lē**-gən, glen
m. American painter, 1960–

LINDNER, RICHARD **lind**-nər, **rich**-ərd
m. German (act. United States) painter, draughtsman, 1901–78

LINNELL, JOHN li-**nel**, jän
m. English painter, 1792–1882

LIOTARD, JEAN-ÉTIENNE lē-ō-tär, zhän–ā-tyen
m. Swiss painter, 1702–89

LIPCHITZ, JACQUES lēp-shēts, zhak
m. French (b. Lithuania) sculptor, 1891–1973

LIPPI, FILIPPINO **lip**-pē, fi-li-**pē**-nō
m. Florentine painter, c. 1457–1504

LIPPI, FRA FILIPPO **lip**-pē, frä fi-**lip**-pō
m. Florentine painter, c. 1406–69

LIPSKY, DONALD **lip**-skē, **dän**-əld
m. American sculptor, 1947–

LIPTON, SEYMOUR **lip**-tən, **sē**-mȯr
m. American sculptor, 1903–86

LISBOA, ANTÔNIO FRANCISCO (O ALEIJADINHO)
lēzh-**vō**-ə, än-**tōn**-yō frän-**sēs**-kō
(ù ä-lä-zhä-**dē**-nyō)
m. Brazilian sculptor, 1738–1814

LISMER, ARTHUR **lis**-mər, **är**-thər
m. Canadian painter, 1885–1969

LISS, JOHANN lis, yō-**hän**
m. German painter, 1590–1629

LISSITZKY, EL (LAZAR MARKOWICH) lyi-**syēts**-kē or li-**sits**-kē, el
(**lä**-zər **mär**-kō-vich)
m. Russian painter, 1890–1941

LOCHNER, STEFAN **lók**-nər, **shtä**-fän
m. German painter, act. 1412–51

LOIR, MARIE ANN lwär, ma-rē än
f. French painter, c. 1715–69

LOISEAU, GUSTAVE lwä-zō, gües-täv
m. French painter, 1865–1935

LOMAS-GARZA, CARMEN **lō**-mäs–**gär**-sä, **kär**-men
f. American painter, 1948–

LONE WOLF (HART MERRIAM SCHULTZ)
lōn wùlf (härt **mer**-ē-əm shùlts)
m. American (Blackfoot) painter, sculptor, 1882–1970

LONG, BERT lòng, bərt
m. American sculptor, 1940–

LONG, RICHARD lòng, **rich**-ərd
m. English sculptor, siteworks artist, 1945–

LONGFISH, GEORGE C. lòng-fish, jòrj
m. Canadian (Iroquois) painter, 1942–

LONGHI, PIETRO **lòng**-gē, **pyä**-trō
m. Venetian painter, 1702–85

LONGMAN, EVELYN BEATRICE **lòng**-mən, **ev**-ə-lin **bē**-ə-tris
f. American sculptor, 1874–1954

LONGO, ROBERT **lòng**-gō, **räb**-ərt
m. American sculptor, draughtsman, painter, 1953–

LÓPEZ, YOLANDA M. **lō**-pes, yō-**län**-dä
f. American painter, installation artist, 1942–

LÓPEZ GARCÍA, ANTONIO **lō**-peth gär-**thē**-ä, än-**tōn**-yō
m. Spanish painter, sculptor, 1936–

LÓPEZ-LOZA, LUIS **lō**-pes–**lō**-sä, lü-**ēs**
m. Mexican painter, 1939–

LÓPEZ Y PORTAÑA, VICENTE **lō**-peth ē pȯr-**tä**-nyä, vē-**then**-tä
m. Spanish painter, 1772–1850

LORENZETTI, AMBROGIO lō-rent-**set**-tē, äm-**brō**-jō
m. Sienese painter, act. 1319–48

LORENZETTI, PIETRO lō-rent-**set**-tē, **pyä**-trō
m. Sienese painter, act. 1320–48

LORENZO MONACO lō-**rent**-sō **mō**-nä-kō
m. Sienese painter, c. 1370–c. 1425

LORRAIN, CLAUDE: see GELLÉE, CLAUDE

LOTTO, LORENZO (LORENZETTO) **lȯt**-tō, lō-**rent**-sō (lō-rent-**set**-tō)
m. Venetian painter, 1480–1556/7

LOUIS, MORRIS **lü**-is, **mȯr**-is
m. American painter, 1912–62

LOUTHERBOURG, PHILIPPE-JACQUES DE (PHILIP JAMES)
lü-ter-bür, fē-lē-p'–zhak də or
lü-thər-bərg, **fil**-ip jāmz
m. French (act. England) painter, 1740–1812

LOZANO, ALFREDO lō-**sä**-nō, äl-**frä**-thō
m. Cuban (act. Puerto Rico) painter, 1913–

LOZOWICK, LOUIS **lä**-zə-wik, **lü**-is
m. American (b. Russia) printmaker, painter, 1892–1973

LUCAS VAN LEYDEN **lue**-käs fən **li**-dən
m. Dutch painter, printmaker, 1494–1533

LUCE, MAXIMILIEN lues, mäk-sē-mēl-ya[n]
m. French painter, 1858–1941

LUCERO-GIACCARDIO, FELICE lü-**ser**-ō–jäk-**kär**-dyō, fə-**lēs**
f. American (Pueblo) painter, contemporary

LUINI, BERNARDINO lü-**ē**-nē, ber-när-**dē**-nō
m. Milanese painter, c. 1485–1532

LUIS, FERNANDO lü-**ēs**, fer-**nän**-dō
m. Cuban (act. United States) painter, 1931–83

LUJÁN, GILBERT "MAGU" lü-**kän**, **gil**-bert me-**gü**
m. American mixed-media artist, 1940–

LUKS, GEORGE lüks, jòrj
m. American painter, 1867–1933

LUNA Y NOVICO, JUAN **lü**-nä ē nō-**vē**-kō, ḵwän
m. Filippino painter, 1857–99

LÜPERTZ, MARKUS **lue**-perts, **mär**-kùs
m. German (b. Czechoslovakia) sculptor, 1941–

LURÇAT, JEAN luer-sä, zhän
m. French painter, designer, 1892–1966

LUSKAČOVÁ, MARKÉTA **lüs**-ke-chō-vä, **mär**-kā-te
f. Czech photographer, 1944–

LYNES, GEORGE PLATT līnz, jòrj plat
m. American photographer, 1907–55

LYSIPPUS lī-**sip**-es
m. Greek sculptor, mid-late 4th c. BC

MABE, MANABU mä-be, mä-nä-bü
m. Brazilian (b. Japan) painter, 1924–

MABUSE: see GOSSAERT

MACCIÓ, RÓMULO mäk-**syō**, **rō**-mü-lō
m. Argentine painter, 1931–

MACDONALD, JAMES EDWARD HERVEY
 mək-**dän**-əld,
 jāmz **ed**-wərd **här**-vē
m. Canadian painter, 1873–1932

MACDONALD, JOCK (JAMES WILLIAMSON GALLOWAY)
 mək-**dän**-əld, jäk
 (jāmz **wil**-yəm-sən **gal**-ə-wā)
m. Canadian (b. Scotland) painter, 1897–1960

MACDONALD-WRIGHT, STANTON mək-**dän**-əld–rīt, **stant**-ən
m. American painter, 1890–1973

MACK, HEINZ mäk, hīnts
m. German kinetic/light artist, 1931–

MACKE, AUGUST **mä**-kə, **au**-gùst
m. German painter, 1887–1914

MACLISE, DANIEL mək-**lēs**, **dan**-yəl
m. Irish painter, 1806–70

MACMONNIES, FREDERICK mək-**män**-ēz, **fred**-rik
m. American sculptor, 1863–1937

MADRAZO Y AGUDO, JOSÉ mä-**thrä**-thō ē ä-**gü**-tho, kō-**sā**
m. Spanish painter, 1781–1859

MADRAZO Y KUNTZ, FEDERICO DE mä-**thrä**-thō y künts, fā-thā-**rē**-kō dā
m. Spanish painter, 1815–94

MAEMOTO, SHOKO mä-e-mō-tō, shō-kō
f. Japanese sculptor, 1957–

MAES, NICOLAES mäs, **nē**-kō-läs
m. Dutch painter, 1634–93

MAGNASCO, ALESSANDRO män-**yäs**-kō, ä-les-**sänd**-rō
m. Genoese painter, 1677–1749

MAGNELLI, ALBERTO mä-**nyel**-lē, äl-**ber**-tō
m. Italian painter, 1888–1971

MAGRITTE, RENÉ ma-grēt, rə-nā
m. Belgian painter, 1898–1967

MAILLOL, ARISTIDE mä-yȯl, ä-rē-stēd
m. French sculptor, painter, 1861–1944

MAINARDI, SEBASTIANO mī-**när**-dē, sā-bäst-**yä**-nō
m. Florentine painter, c. 1450–1513

MAKART, HANS **mä**-kärt, häns
m. Austrian painter, 1840–84

MAKOVSKY, VLADIMIR EGOROVICH mə-**kȯf**-skē, vlə-**dē**-mir ē-**gȯr**-ō-vich
m. Russian painter, 1846–1920

MALEVICH, KAZIMIR SEVERINOVICH mə-**lā**-vich, kə-**zē**-mir sev-er-in-**ō**-vich
m. Russian painter, 1878–1935

MALMSTRÖM, AUGUST **mälm**-strœm, **aú**-güst
m. Swedish painter, 1829–1901

MAMARIKA, MINIMINI mä-mə-rē-kä, mi-nē-mi-nē
m. Australian (Anindilyakawa) painter, 1900–72

MAN RAY man rā
m. American painter, draughtsman, sculptor, photographer,
1890–1977

MANDER, KAREL VAN I **män**-dər, **kä**-rel fən
m. Dutch painter, 1548–1606

MÁNES, JOSEF **mä**-nes, **yȯ**-zef
m. Czech painter, 1820–71

MANET, ÉDOUARD ma-nā, ā-dwär
m. French painter, 1832–83

MANFREDI, BARTOLOMEO män-**frä**-dē, bär-tō-lō-**mä**-ō
m. Roman painter, c. 1580–c. 1620/1

MANGOLD, ROBERT **man**-gōld, **räb**-ərt
m. American painter, draughtsman, 1937–

MANGOLD, SYLVIA **man**-gōld, **sil**-vē-ə
f. American painter, 1938–

MANGUIN, HENRI-CHARLES män-gan, än-rē–shärl
m. French painter, 1874–1943/9

MANN, SALLY man, **sal**-ē
f. American photographer, 1951–

MANSHIP, PAUL **man**-ship, pòl
m. American sculptor, 1885–1966

MANTEGNA, ANDREA män-**ten**-yä, än-**drä**-ä
m. Mantuan painter, 1431–1506

MANUEL, VÍCTOR: see GARCÍA, VÍCTOR MANUEL

MANZONI, PIERO män-**dzō**-nē, **pyä**-rō
m. Italian painter, conceptual artist, 1933–63

MANZÙ, GIACOMO män-**dzü**, **jä**-kō-mō
m. Italian sculptor, 1908–91

MAPPLETHORPE, ROBERT **mä**-pəl-thòrp, **räb**-ərt
m. American photographer, 1946–89

MARATTI, CARLO mä-**rät**-tē, **kär**-lō
m. Roman painter, 1625–1713

MARC, FRANZ märk, fränts
m. German painter, printmaker, 1880–1916

MARCKS, GERHARD märks, **ger**-härt
m. German sculptor, 1889–1981

MARCOUSSIS, LOUIS (LUDWIG MARKUS)
 mär-küs-sē, lü-ē (**lüt**-vēk **mär**-kús)
m. French (b. Poland) painter, 1883–1941

MARDEN, BRICE **mär**-dən, brīs
m. American painter, printmaker, 1938–

MAREES, HANS VON mä-**rās**, häns fón
m. German painter, 1837–87

MARGARITONE D'AREZZO mär-gä-rē-**tō**-nä dä-**ret**-sō
m. Florentine painter, c. 1216–1290

MARIESCHI, JACOPO mä-rē-**es**-kē, **yä**-kō-pō
m. Venetian painter, 1711–91

MARIESCHI, MICHELE mä-rē-**es**-kē, mē-**kā**-lā
m. Venetian painter, 1710–43

MARIKA, MAWALAN mä-rē-kä, mä-wə-län
m. Australian (Rirratjingu) painter, 1908–67

MARIN, JOHN **mar**-in, jän
m. American painter, 1870–1953

MARINI, MARINO mä-**rē**-nē, mä-**rē**-nō
m. Italian sculptor, 1901–80

MARINUS VAN REYMERSWAELE mä-**rē**-nʉes fən **ri**-mərs-vä-lə
m. Flemish painter, d. after 1567

MARIS, JACOB **mä**-ris, **yä**-kȯp
m. Dutch painter, 1837–99

MARIS, MATTHIJS **mä**-ris, mä-**tis**
m. Dutch painter, 1839–1917

MARIS, WILLEM **mä**-ris, **vil**-əm
m. Dutch painter, 1844–1910

MARISOL (MARISOL ESCOBAR) mä-rē-**sōl** (mä-rē-**sōl** es-kō-**vär**)
f. Venezuelan (b. Paris, act. United States) sculptor, 1930–

MARK, MARY ELLEN märk, **mer**-ē **el**-ən
f. American photographer, 1940–

MARMION, SIMON mär-mē-ōn, sē-mōn
m. French painter, c. 1425–89

MARQUET, ALBERT mär-kā, äl-ber
m. French painter, 1875–1947

MARSH, REGINALD märsh, **rej**-ə-nəld
m. American painter, 1898–1954

MARTIN, AGNES **märt**-ən, **ag**-nəs
f. American (b. Canada) painter, 1912–

MARTINEZ, CÉSAR A. mär-**tē**-nes, **sā**-sär
m. American painter, 1944–

MARTINEZ, DANIEL J. mär-**tē**-nes, **dan**-yəl
m. American conceptual artist, 1957–

MARTÍNEZ, MARÍA MONTOYA mär-**tē**-nes, mä-**rē**-ä mȯn-**tȯ**-yä
f. American ceramicist, 1887–1980

MARTÍNEZ, RAUL mär-**tē**-nes, rä-**ül**
m. Cuban painter, 1927–

MARTINEZ, SANTOS mär-**tē**-nes, **sän**-tōs
m. American draughtsman, 1951–

MARTÍNEZ-CAÑAS, MARÍA mär-**tē**-nes–**kä**-nyäs, mä-**rē**-ä
f. Cuban (act. United States) photographer, 1960–

MARTÍNEZ MONTAÑES, JUAN: see MONTAÑES, JUAN MARTÍNEZ

MARTÍNEZ-PEDRO, LUIS mär-**tē**-nes–**pā**-<u>th</u>rō, lü-**ēs**
m. Cuban painter, 1910–89

MARTINI, SIMONE mär-**tē**-nē, sē-**mō**-nä
m. Sienese painter, 1284–1344

MARTINS, MARIA **mär**-tins, mä-**rē**-ä
f. Brazilian sculptor, 1900–73

MARTORELL, ANTONIO mär-tō-**rel**, än-**tōn**-yō
m. Puerto Rican printmaker, 1939–

MARTORELL, BERNARDO mär-tō-**rel**, ber-**när**-dō
m. Catalan painter, illuminator, c. 1400–52

MARVILLE, CHARLES mär-vēl, shärl
m. French photographer, painter, 1816–c. 1880

MASACCIO (TOMASSO DI SER GIOVANNI DI MONE)
 mä-**zät**-chō (tō-**mä**-sō dē ser
 jō-**vän**-nē dē **mō**-nä)
m. Florentine painter, 1401–c. 1428

MASEREEL, FRANS mä-sä-**rāl**, fräns
m. Belgian painter, printmaker, 1889–1972

MASO DI BANCO **mä**-zō dē **bän**-kō
m. Florentine painter, act. 2nd quarter 14th c.

MASOLINO DA PANICALE mä-zō-**lē**-nō dä pä-nē-**kä**-lā
m. Florentine painter, c. 1383–c. 1447

MASON, ALICE TRUMBULL **mā**-sən, **a**-lis **trəm**-bəl
f. American painter, 1904–71

MASSON, ANDRÉ mas-sōn, än-drā
m. French painter, sculptor, 1896–1987

MASSYS, QUENTIN mä-**sis**, **kven**-tin
m. Flemish painter, 1465/6–1530

MASTER OF ALKMAAR **älk**-mär
Dutch painter, act. early 16th c.

MASTER OF FLÉMALLE flā-mäl
m. Netherlandish painter, 1378–1444

MASTER OF FRANKFURT **frängk**-fùrt
Netherlandish painter, 1460–1533

MASTER OF LIESBORN ALTAR **lēs**-bòrn
German painter, act. c. 1470

MASTER OF MOULINS mü-lan
French painter, act. c. 1480–1500

MASTER OF NAUMBURG **naùm**-bùrg
m. German sculptor, act. 1240

MASTER THEODERIC thē-**äd**-ə-rik
m. Bohemian painter, act. mid–14th c.

MASTER OF VIRGO INTER VIRGINES **vir**-gō **in**-ter **vir**-ji-nās
Dutch painter, act. c. 1470–1500

MATEO DE COMPOSTELA mä-**tā**-ō dā kōm-pō-**stä**-lä
m. Spanish sculptor, act. late 12th c.

MATHIEU, GEORGES ma-tyœ, zhòrzh
m. French painter, 1921–

MATISSE, HENRI ma-tēs, än-rē
m. French painter, sculptor, 1869–1954

MATIUSHIN, MIKHAIL VASILIEVICH mə-**tyü**-shin,
m. Russian painter, 1861–1934 mēk-**hä**-il və-**sēl**-ē-ə-vich

MATSUZAWA, YUTAKA mä-tsü-zä-wä, yü-tä-kä
m. Japanese painter, 1922–

MATTA (ROBERTO SEBASTIANO MATTA ECHAURREN)
 mät-tä (rō-**ver**-tō sā-väs-**tyä**-nō
 mät-tä e-**kär**-ren)
m. Chilean painter, 1911–

MATTA-CLARK, GORDON **mat**-ə–klärk, **gȯr**-dən
m. American sculptor, 1945–78

MATTEO DI GIOVANNI mät-**tā**-ō dē jō-**vän**-nē
m. Sienese painter, c. 1430–95

MATULKA, JAN **mä**-tùl-kə, yän or jan
m. American (b. Czechoslovakia) painter, 1890–1972

MATVEEV, ALEKSANDR mət-**vē**-ef, əl-ik-**sän**-dər
m. Russian sculptor, 1878–1960

MAUFRA, MAXIME mō-frä, mäk-sēm
m. French painter, 1862–1918

MAULPERTSCH, FRANZ ANTON **maùl**-perch, fränts **än**-tōn
m. Austrian painter, 1724–96

MAUVE, ANTOINE (ANTON) **mō**-və, än-twän (**än**-tōn)
m. Dutch painter, 1838–88

MAYHEW, RICHARD **mä**-hyü, **rich**-ərd
m. American painter, 1924–

MAYMURRU, NARRITJIN mä-mùr-rü, när-rit-chin
m. Australian (Manggalili) painter, 1922–82

MAYNE, ROGER mān, **räj**-ər
m. British photographer, 1929–

MAYNO, JUAN BAUTISTA **mi**-nō, k̲wän baù-**tē**-stä
m. Spanish painter, 1578–1649

MAZO, JUAN BAUTISTA MARTINEZ DEL
 mä-thō, k̲wän baù-**tē**-stä
 mär-**tē**-neth del
m. Spanish painter, c. 1610/5–67

MAZZONI, SEBASTIANO mät-**sō**-nē, sä-bäst-**yä**-nō
m. Italian painter, c. 1611–78

MCBEAN, ANGUS mək-**bēn**, **ang**-gəs
m. British photographer, 1904–90

MCCOLLUM, ALLAN mə-**käl**-əm, **al**-ən
m. American painter, sculptor, 1944–

MCCUBBIN, FREDERICK mə-**kəb**-in, **fred**-rik
m. Australian painter, 1855–1917

MEATYARD, RALPH EUGENE **mēt**-yärd, ralf yü-**jēn**
m. American photographer, 1925–72

MECKENEM, ISRAHEL VON, THE YOUNGER
 mek-e-nem, **is**-rä-hel fȯn
m. German engraver, c. 1450–1503

MEDELLÍN, OCTAVIO mā-t͟hā-**yēn**, ȯk-**täv**-yō
m. American sculptor, 1907–

MEISSONIER, ERNEST mā-sən-yā, er-nest
m. French painter, printmaker, 1815–91

MELÉNDEZ, LUIS mā-**len**-deth, lü-**ēs**
m. Spanish painter, 1716–80

MELLAN, CLAUDE mel-län, klōd
m. French engraver, 1598–1688

MELOZZO DA FORLÌ mā-**lȯt**-sō dä fȯr-**lē**
m. Umbrian painter, 1438–94

MEMLING, HANS (MEMLINC) **mem**-ling, häns (**mem**-lingk)
m. Flemish painter, c. 1430/40–94

MEMMI, LIPPO **mem**-mē, **lip**-pō
m. Sienese painter, act. 1317–47

MÉNDEZ, LEOPOLDO **men**-des, lā-ō-**pȯl**-dō
m. Mexican printmaker, painter, 1902–69

MENDIETA, ANA men-**dyä**-tä, **ä**-nä
f. Cuban (act. United States) sculptor, performance artist, 1948–85

MENDOZA, TONY men-**dō**-sä, **tō**-nē
m. Cuban (act. United States) photographer, 1941–

MENGS, ANTON RAFAEL mengks, **än**-tón **rä**-fä-el
m. German painter, 1728–79

MENZEL, ADOLF VON **ment**-səl, **ä**-dólf fón
m. German painter, engraver, 1815–1905

MERCIER, CHARLOTTE mer-sē-ā, shär-lət
f. French painter, d. 1762

MERIAN, MARIA SIBYLLA **mä**-rē-än, mä-**rē**-ä zi-**bue**-lä
f. German painter, 1647–1717

MÉRIDA, CARLOS **mä**-rē-<u>th</u>ä, **kär**-lòs
m. Guatemalan (act. Mexico) painter, 1891–1984

MERYON, CHARLES me-rē-ō[n], shärl
m. French watercolorist, 1821–68

MERZ, MARIO merts, **mä**-rē-ō
m. Italian sculptor, painter, 1925–

MESA-BAINES, AMALIA **mä**-sä–bänz, ä-**mäl**-yä
f. American installation artist, 1943–

MESSAGER, ANNETTE mäs-sä-zhä, än-net
f. French mixed-media artist, 1943–

MEŠTROVIČ, IVAN **mesh**-trō-vyich, **ē**-vän
m. American (b. Yugoslavia) sculptor, 1883–1962

METSU, GABRIEL **met**-sue, <u>**kä**</u>-brē-el or **gä**-brē-el
m. Dutch painter, 1629–67

METZINGER, JEAN met-sa[n]-zhä, zhä[n]
m. French painter, 1883–1956

MEUNIER, CONSTANTIN mœn-yä, kō[n]-stä[n]-ta[n]
m. Belgian sculptor, painter, 1831–1905

MEYER, PEDRO **mä**-yer, **pä**-<u>th</u>rō
m. Mexican (b. Spain) photographer, 1935–

MEYEROWITZ, JOEL **mi**-ər-ə-vits, **jō**-əl
m. American photographer, 1938–

MICHALLON, ACHILLE-ETNA mē-shäl-lō[n], ä-shēl–ät-nä
m. French painter, 1796–1822

MICHALS, DUANE **mi**-kəls, dwān
m. American photographer, 1932–

MICHEL, GEORGES mē-shel, zhȯrzh
m. French painter, 1763–1843

MICHELANGELO BUONARROTI mē-kel-**än**-jā-lō *or* mi-kəl-**an**-jə-lō
bwō-när-**rȯ**-tē
m. Florentine sculptor, painter, architect, 1475–1564

MICHELENA, ARTURO mē-chä-**lä**-nä, är-**tü**-rō
m. Venezuelan painter, 1863–98

MIEREVELT, MICHIEL JANSZ. VAN **mē**-rə-velt, mē-**kēl** yäns fən
m. Dutch painter, 1567–1641

MIERIS, FRANS VAN **mē**-ris, fräns fən
m. Dutch painter, 1635–81

MIGLIORI, NINO mēl-**yȯ**-rē, **nē**-nō
m. Italian photographer, 1926–

MIGNARD, PIERRE mēn-yär, pyer
m. French painter, 1612–95

MIGNON, ABRAHAM mēn-yōⁿ, **ä**-brä-häm
m. German painter, 1640–79

MIJARES, JOSÉ MARIA mē-**kä**-res, kō-**sā** mä-**rē**-ä
m. Cuban (act. United States) painter, 1921–

MILLAIS, JOHN EVERETT mi-**lā**, jän **ev**-ə-ret
m. English painter, 1829–96

MILLARES, MANOLO mē-**yä**-res, mä-**nō**-lō
m. Spanish (b. Tenerife) draughtsman, painter, 1926–72

MILLER, LEE **mil**-ər, lē
f. British photographer, 1907–77

MILLES, CARL **mil**-es, kärl
m. Swedish (act. United States) sculptor, 1875–1955

MILLET, JEAN-FRANÇOIS mē-lā, zhäⁿ–fräⁿ-swä
m. French painter, 1814–75

MILNE, DAVID BROWN miln, **dā**-vid braun
m. Canadian painter, 1882–1953

MINARDI, TOMMASO mē-**när**-dē, tòm-**mä**-sō
m. Italian painter, 1787–1871

MINO DA FIESOLE **mē**-nō dä fē-**ā**-zō-lā
m. Florentine sculptor, 1431–84

MINUJÍN, MARTA mē-nü-**kēn**, **mär**-tä
f. Argentine sculptor, installation artist, 1943–

MIRÓ, JOAN mē-**rō**, kō-**än**
m. Spanish painter, printmaker, 1893–1983

MISHIMA, KIMIYO mē-shē-mä, kē-mē-yō
f. Japanese sculptor, contemporary

MISRACH, RICHARD **miz**-rak, **rich**-erd
m. American photographer, 1949–

MISS, MARY mis, **mer**-ē
f. American siteworks artist, 1944–

MITCHELL, JOAN **mich**-əl, jōn
f. American (act. France) painter, 1926–92

MIYAJIMA, TATSUO mē-yä-jē-mä, tä-tsü-ō
m. Japanese sculptor, 1957–

MIYAWAKI, AIKO mē-yä-wä-kē, ä-ē-kō
f. Japanese sculptor, 1929–

MODERSOHN-BECKER, PAULA **mō**-dər-zòn–**bek**-ər, **paủ**-lä
f. German painter, 1876–1907

MODIGLIANI, AMEDEO mō-dēl-**yä**-nē, ä-mä-**dā**-ō
m. Italian painter, sculptor, 1884–1920

MODOTTI, TINA mō-**dòt**-tē, **tē**-nä
f. Mexican (b. Italy) photographer, 1896–1942

MOHOLY-NAGY, LÁSZLÓ **mò**-hò-lē–nä-j′, **lä**-slō
m. American (b. Hungary) painter, sculptor, collagist, 1895–1946

MOILLIET, LOUIS mwä-yā, lü-ē
m. Swiss painter, 1880–1962

MOILLON, LOUISE mwä-yōn, lü-ēz
f. French painter, 1610–96

MOLA, PIER FRANCESCO **mō**-lä, pyer frän-**ches**-kō
m. Roman painter, 1612–66

MOLENAER, JAN MIENSE **mō**-le-när, yän **mēn**-se
m. Dutch painter, c. 1610–68

MOMPER, JOOS DE **mȯm**-pər, yōs də
m. Flemish painter, 1564–1634/5

MONDRIAN, PIET **mȯn**-drē-än, pēt
m. Dutch painter, 1872–1944

MONET, CLAUDE mō-nā, klōd
m. French painter, 1840–1926

MONNOYER, JEAN-BAPTISTE mən-wä-yā, zhän–bat-tēst
m. French painter, 1634–99

MONTAGNA, BARTOLOMEO mōn-**tän**-yä, bär-tō-lō-**mā**-ō
m. Brescian painter, c. 1450–1523

MONTAÑES, JUAN MARTÍNEZ mōn-**tä**-nyes, ⸝kwän mär-**tē**-neth
m. Spanish sculptor, 1568–1649

MONTENEGRO, ROBERTO mōn-tā-**nā**-grō, rō-**ver**-tō
m. Mexican painter, 1887–1968

MONTICELLI, ADOLPHE mōⁿ-tē-sel-lē, a-dȯlf
m. French painter, 1824–86

MONTOYA, JOSÉ mōn-**tȯi**-ä, ⸝kō-**sā**
m. American draughtsman, 1932–

MONTOYA, MALAQUÍAS mōn-**tȯi**-ä, mä-lä-**kē**-äs
m. American printmaker, 1938–

MOORE, HENRY mu̇(ə)r, **hen**-rē
m. English sculptor, 1898–1986

MORA, JOSÉ DE **mō**-rä, ⸝kō-**sā** dā
m. Spanish sculptor, 1642–1724

MORALES, ARMANDO mō-**rä**-les, är-**män**-dō
m. American (b. Nicaragua) painter, 1927–

MORALES, DARIO mō-**rä**-les, **där**-yo
m. Colombian sculptor, painter, 1944–

MORALES, JOSÉ mō-**rä**-les, kō-**sä**
m. Puerto Rican collagist, 1947–

MORALES, LUÍS DE mō-**rä**-les, lü-**ēs** dā
m. Spanish painter, 1509–86

MORAN, THOMAS mə-**ran**, **täm**-əs
m. American painter, 1837–1926

MORANDI, GIORGIO mō-**rän**-dē, **jȯr**-jō
m. Italian painter, 1890–1964

MOREAU, GUSTAVE mȯ-rō, gᵫs-täv
m. French painter, 1826–98

MOREAU, JEAN-MICHEL THE YOUNGER
 mȯ-rō, zhäⁿ–mē-shel
m. French draughtsman, 1741–1814

MOREELSE, PAULUS mō-**rāl**-se, **pau̇**-lᵫs
m. Dutch painter, 1571–1638

MORELLI, DOMENICO mō-**rel**-lē, dō-**mä**-nē-kō
m. Italian painter, 1826-1901

MORETTO (ALESSANDRO BONVICINO) mō-**ret**-tō (ä-les-**sänd**-rō
 bȯn-vē-**chē**-nō)
m. Brescian painter, 1498–1555

MORGAN, SISTER GERTRUDE **mȯr**-gən, **gər**-trüd
f. American painter, 1900–80

MORIMURA, YASUMASA mō-rē-mü-rä, yä-sü-mä-sä
m. Japanese photographer, contemporary

MORISOT, BERTHE mō-rē-zō, bert
f. French painter, 1841–95

MORLEY, MALCOLM **mȯr**-lē, **mal**-kəm
m. English (act. United States) painter, 1931–

MORO, ANTONIO (MOR, ANTHONIS) **mō**-rō, än-**tōn**-yō (mȯr, än-**tō**-nis)
m. Dutch painter, c. 1517/20–1576/7

MORO, LILIANA **mō**-rō, lēl-**yä**-nä
f. Italian sculptor, 1961–

MORONE, DOMENICO mō-**rō**-nä, dō-**mä**-nē-kō
m. Veronese painter, c. 1442–after 1517

MORONE, FRANCESCO mō-**rō**-nā, frän-**ches**-kō
m. Veronese painter, c. 1470–1529

MORONI, GIOVANNI BATTISTA mō-**rō**-nē, jō-**vän**-nē bät-**tē**-stä
m. Brescian painter, c. 1525–78

MORRICE, JAMES WILSON **mȯr**-is, jāmz **wil**-sən
m. Canadian painter, 1865–1944

MORRIS, ROBERT **mȯr**-is, **räb**-ərt
m. American sculptor, 1931–

MORRIS, WILLIAM **mȯr**-is, **wil**-yəm
m. English painter, designer, 1834–96

MORRISON, GEORGE **mȯr**-ə-sən, jȯrj
m. American (Chippewa) painter, sculptor, 1919–

MORRISON, KEITH **mȯr**-ə-sən, kēth
m. American (b. Jamaica) painter, 1942–

MORRISSEAU, NORVAL mō-rē-sō, nȯr-väl
m. Canadian (Ojibwa) painter, 1933–

MORTIMER, JOHN HAMILTON **mȯr**-tə-mər, jän **ham**-əl-tən
m. English painter, engraver, 1740–79

MOSES, ED **mō**-zez, ed
m. American painter, 1926–

MOSLER, HENRY **mōz**-lər, **hen**-rē
m. American painter, 1841–1920

MOSS, MARLOW mȯs, **mär**-lō
f. English painter, 1890–1958

MOSTAERT, JAN **mȯs**-tärt, yän
m. Flemish painter, c. 1475–1555/6

MOTHERWELL, ROBERT **məth**-ər-wel, **räb**-ərt
m. American painter, collagist, 1915–91

MUCHA, ALPHONSE **mu̇k**-ä, äl-fōⁿs
m. Czech painter, 1860–1939

MUCHA, REINHARD **mu̇k**-ä, **rin**-härt
m. German sculptor, installation artist, 1950–

MUELLER, OTTO **mue**-lər, **ȯt**-tō
m. German painter, 1874–1930

MULLICAN, MATT **məl**-ə-kən, mat
m. American painter, 1951–

MULTSCHER, HANS **mült**-shər, häns
m. German (Ulm) sculptor, c. 1400–before 1467

MUNCH, EDVARD mùngk, **ed**-värt
m. Norwegian painter, printmaker, 1863–1944

MUNKACSI, MARTIN **mùn**-kä-chi, **mär**-tin
m. American (b. Hungary) photographer, 1896–1963

MUNKÁCSY, MIHÁLY VON **mùn**-kä-chi, **mi**-häl-yə fȯn
m. Hungarian painter, 1844–1900

MUNNINGS, ALFRED **mən**-ingz, **al**-frəd
m. English painter, 1878–1959

MUÑOZ, CELIA ALVAREZ mü-**nyōs**, **sāl**-yä **äl**-vä-res
f. American mixed-media artist, 1937–

MÜNTER, GABRIELE **muen**-tər, gä-brē-**ā**-lā
f. German painter, 1877–1962

MURILLO, BARTOLOMÉ ESTÉBAN mü-**rē**-yō, bär-tō-lō-**mā** es-**tā**-vän
m. Spanish painter, 1617/8–82

MURPHY, CATHERINE **mər**-fē, **kath**-rən
f. American painter, 1946–

MURRAY, ELIZABETH **mər**-ē, ə-**liz**-ə-bəth
f. American painter, 1940–

MUYBRIDGE, EADWEARD **mi**-brij, **ed**-wərd
m. American (b. England) photographer, 1830–1904

MYRON **mi**-rən
m. Greek sculptor, mid–5th c. BC

MYTENS, DANIEL **mi**-təns, **dän**-yel
m. Dutch (act. England) painter, c. 1590–1647

NADAR (GASPAR-FÉLIX TOURNACHON)
nä-där (gas-pär–fā-lēks tür-nä-shōⁿ)
m. French photographer, 1820–1910

NADELMAN, ELIE **nä**-dəl-mən, **ā**-lē
m. American (b. Poland) sculptor, 1882–1946

NAGEL, ANDRÉS nä-**kel**, än-**dres**
m. Spanish sculptor, painter, 1947–

NAKABAYASHI, TADAYOSHI nä-kä-bä-yä-shē, tä-dä-yō-shē
m. Japanese printmaker, 1937–

NAKAZATO, HITOSHI nä-kä-zä-tō, hi-tō-shē
m. Japanese painter, 1936–

NAMATJIRA, ALBERT nä-mə-chir-ä, **al**-bert
m. Australian (Arunta) painter, 1902–59

NANNI DI BANCO **nän**-nē dē **bäng**-kō
m. Florentine sculptor, c. 1384–1421

NANTEUIL, ROBERT näⁿ-tœē, rō-ber
m. French engraver, 1623–78

NASH, PAUL nash, pȯl
m. English painter, 1889–1946

NASMYTH, ALEXANDER **nā**-smith, ə-leg-**zan**-dər
m. Scottish painter, 1758–1840

NATOIRE, CHARLES-JOSEPH na-twär, shärl–zhō-zef
m. French painter, 1700–77

NATTIER, JEAN-MARC nat-yä, zhäⁿ–märk
m. French painter, 1685–1766

NAUMAN, BRUCE **naú**-mən, brüs
m. American painter, sculptor, installation artist, 1941–

NAVARRE, MARIE-GENEVIÈVE nä-vär, ma-rē–zhən-vyev
f. French painter, 1737–95

NAVARRETE, JUAN FERNÁNDEZ DE nä-vä-**rā**-tā, kwän fer-**nän**-deth dā
m. Spanish painter, c. 1526–79

NAVEZ, FRANÇOIS JOSEPH na-vā, frän-swä zhō-zef
m. Belgian painter, 1787–1869

NEEFFS, PIETER THE ELDER nāfs, **pē**-tər
m. Flemish painter, c. 1578–1656/61

NEEL, ALICE nēl, **a**-lis
f. American painter, 1900–84

NEER, AERT VAN DER när, ärt fən dər
m. Dutch painter, 1603/4–77

NEGRET, ÉDGAR nā-**gret**, **ed**-gär
m. Colombian sculptor, 1920–

NEIMANAS, JOYCE nī-**man**-əs, jóis
f. American photographer, 1944–

NELSON, MICHAEL (TJAKAMARRA) **nel**-sən, **mī**-kəl (chäk-ə-mär-rä)
m. Australian (Walpiri) painter, 1946–

NERI, MANUEL **nā**-rē, män-**wel**
m. American sculptor, 1930–

NETSCHER, CASPAR **net**-shər, **käs**-pər
m. Dutch painter, 1635/9–84

NEVELSON, LOUISE **nev**-əl-sən, lü-**ēz**
f. American (b. Russia) sculptor, 1899–1988

NEWMAN, ARNOLD **nü**-mən, **är**-nəld
m. American photographer, 1918–

NEWMAN, BARNETT **nü**-mən, bär-**net**
m. American painter, 1905–70

NICHOLSON, BEN **nik**-əl-sən, ben
m. British painter, printmaker, 1894–1982

NIELSEN, KAY **nēl**-sən, kī
m. Danish illustrator, painter, 1886–1957

NIEPCE, JOSEPH NICÉPHORE nyeps, zhō-zef nē-sä-for
m. French heliographer (early photography), 1765–1833

NITTIS, GIUSEPPE DE **nēt**-tēs, jü-**zep**-pā dā
m. Italian painter, 1846–86

NIXON, JOHN **nik**-sən, jän
m. Australian painter, 1949–

NIXON, NICHOLAS **nik**-sən, **nik**-ə-ləs
m. American photographer, 1947–

NOÉ, LUIS FELIPE nō-**ā**, lü-**ēs** fā-**lē**-pā
m. Argentine painter, installation artist, 1933–

NOGUCHI, ISAMU nō-**gü**-chē, ē-**sä**-mü
m. American sculptor, designer, 1904–88

NOLAN, SIDNEY **nō**-lən, **sid**-nē
m. Australian painter, printmaker, 1917–92

NOLAND, KENNETH **nō**-lənd, **ken**-əth
m. American painter, 1924–

NOLDE, EMIL **nȯl**-də, **ā**-mēl
m. German painter, printmaker, 1867–1956

NOLLEKENS, JOSEPH **näl**-i-kənz, **jō**-zəf
m. English sculptor, 1737–1823

NOLLEKENS, JOSEPH FRANS **nȯl**-lə-kənz, **jō**-zəf fränts
m. Flemish painter, 1702–48

NONELL Y MONTURIOL, ISIDRO nō-**nel** ē mōn-tür-**yōl**, ē-**sē**-thrō
m. Spanish painter, 1873–1911

NOTKE, BERNT **nȯt**-kə, bernt
m. German sculptor, painter, c. 1440–1509

NOTMAN, WILLIAM **nät**-mən, **wil**-yəm
m. Canadian (b. Scotland) photographer, 1826–91

NUTT, JIM nət, jim
m. American painter, 1938–

O Aleijadinho: see Lisboa, Antônio Francisco

Obin, Philomé ō-baⁿ, fē-lō-mā
m. Haitian painter, 1891–

Obregón, Alejandro ō-vrā-**gōn**, ä-lā-**kän**-drō
m. Colombian (b. Spain) painter, 1920–

Ochoa, Victor Orozco ō-**chō**-ä, vēk-**tȯr** ō-**rō**-skō
m. American painter, 1948–

Ochtervelt, Jacob **ȯk**-tər-velt, yä-**kōb**
m. Dutch painter, 1634–82

Oehlin, Albert œ-lin, **äl**-bert
m. German painter, 1954–

O'Gorman, Juan ō-**gȯr**-mən, kwän
m. Mexican painter, architect, 1905–82

O'Higgins, Pablo ō-**hig**-enz, **päv**-lō
m. Mexican (b. United States) painter, printmaker, 1904–83

Oji, Helen Shizuko ō-jē, **hel**-en shē-**zū**-kō
f. American painter, 1950–

Okada, Kenzo ō-kä-dä, ken-zō
m. Japanese (act. United States) painter, 1902–82

O'Keeffe, Georgia ō-**kēf**, **jȯr**-jə
f. American painter, 1887–1986

Oldenburg, Claes **ōl**-dən-bůrg, kläs
m. American (b. Sweden) sculptor, 1929–

Olitski, Jules ȯ-**lit**-skē, jülz
m. American (b. Russia) painter, sculptor, 1922–

OLLER, FRANCISCO ō-**zhär**, frän-**sēs**-kō
m. Puerto Rican painter, 1833–1917

OLSEN, JOHN **ōl**-sən, jän
m. Australian painter, 1928–

ONUS, LIN **ōn**-əs, lin
m. Australian painter, sculptor, 1948–

OOSTERWYCK, MARIA VAN **ō**-stər-vīk, mä-**rē**-ä fən
f. Dutch painter, 1630–93

OPIE, JOHN **ō**-pē, jän
m. English painter, 1761–1807

OPPENHEIM, MERET **òp**-ən-hīm, **mer**-ət
f. German sculptor, 1913–85

ORCAGNA, ANDREA òr-**kän**-yä, än-**drä**-ä
m. Florentine painter, sculptor, before 1308–68/9

ORCHARDSON, WILLIAM QUILLER **òr**-chərd-sən, **wil**-yəm **kwil**-ər
m. Scottish painter, 1832–1910

ORDÓÑEZ, BARTOLOMÉ òr-**dō**-nyeth, bär-tō-lō-**mā**
m. Spanish sculptor, d. 1520

ORLEY, BAREND VAN (BERNARD) **òr**-lā, **bä**-rənt fən (**ber**-närt)
m. Flemish painter, 1488–1541

ORLOVSKY, BORIS ər-**lòf**-skē, bə-**rēs**
m. Russian sculptor, 1796–1838

OROZCO, JOSÉ CLEMENTE ō-**rōs**-kō, k̄ō-**sā** klä-**män**-tā
m. Mexican painter, 1883–1949

ORSI, LELIO **òr**-sē, **lāl**-yō
m. Italian painter, c. 1511–87

OSONA, RODRIGO DE ō-**sō**-nä, rò-**thrē**-gō dä
m. Spanish painter, act. 1476–84

OSTADE, ADRIAEN VAN **ò**-stä-də, **ä**-drē-än fən
m. Dutch painter, 1610–85

OTERO, ALEJANDRO ō-**tä**-rō, ä-lä-**kän**-drō
m. Venezuelan painter, sculptor, 1921–

OTTERNESS, TOM — **ät**-ər-nes, täm
m. American sculptor, 1952–

OUDRY, JEAN-BAPTISTE — ü-drē, zhän̄–bat-tēst
m. French painter, 1686–1755

OUTERBRIDGE, PAUL — **au̇**-tər-brij, pȯl
m. American photographer, 1896–1958

OUTTERBRIDGE, JOHN — **au̇**-tər-brij, jän
m. American sculptor, 1933–

OVERBECK, FRIEDRICH — **ō**-fər-bek, **frēd**-ri̲k
m. German painter, 1789–1869

OVERSTREET, JOE — **ō**-vər-strēt, jō
m. American painter, printmaker, 1934–

OZENFANT, AMÉDÉE — ō-zän̄-fän̄, ä-mā-dā
m. French painter, 1886–1966

P

PACHECO, FRANCISCO
m. Spanish painter, 1564–1654
pä-**chä**-kō, frän-**thēs**-kō

PACHECO, MARÍA LUISA
f. Bolivian painter, 1919–82
pä-**chä**-kō, mä-**rē**-ä lü-**ē**-sä

PACHER, MICHAEL
m. Austrian painter, sculptor, c. 1435–98
päk-ər, **mik**-ä-el

PAEONIUS
m. Greek sculptor, mid-late 5th c. BC
pē-**ō**-nē-əs

PAIK, NAM JUNE
m. Korean video installation artist, 1932–
pīk, näm jün

PAJOU, AUGUSTIN
m. French sculptor, 1730–1809
pä-zhü, ō-gʉs-tan

PALACIOS, ALIRIO
m. Venezuelan painter, draughtsman, 1944–
pä-**lä**-syōs, ä-**lēr**-yō

PALADINO, MIMMO
m. Italian painter, sculptor, 1948–
pä-lä-**dē**-nō, **mēm**-mō

PALAMEDESZ., ANTONIS STEVAERTS
m. Dutch painter, 1601–73
pä-lä-**mä**-des, än-**tō**-nis **stä**-värts

PALISSY, BERNARD
m. French ceramicist, c. 1510–90
pä-lis-sē, ber-när

PALMA, JACOPO (IL GIOVANE)
m. Venetian painter, 1548–1628
päl-mä, **yä**-kō-pō (ēl **jō**-vä-nä)

PALMA, JACOPO (IL VECCHIO)
m. Venetian painter, 1480–1528
päl-mä, **yä**-kō-pō (ēl **vek**-yō)

PALMER, ERASTUS DOW **pä**-mər, e-**ras**-təs daủ
m. American sculptor, 1817–1904

PALMER, SAMUEL **pä**-mər, **sam**-yü-əl
m. English painter, 1805–81

PANNINI, GIOVANNI PAOLO pän-**nē**-nē, jō-**vän**-nē **paủ**-lō
m. Italian painter, 1691/2–1765

PAOLINI, GIULIO paủ-**lē**-nē, **jül**-yō
m. Italian painter, sculptor, 1940–

PAOLOZZI, EDUARDO paủ-**lȯt**-sē, ed-**wär**-dō
m. English sculptor, printmaker, 1924–

PARKER, OLIVIA **pär**-kər, ō-**liv**-ē-ə
f. American photographer, 1941–

PARLER, PETER **pär**-lər, **pā**-tər
m. German sculptor, architect, c. 1330–99

PARMIGGIANI, CLAUDIO pär-mē-**jä**-nē, **klaủ**-dyō
m. Italian sculptor, 1943–

PARMIGIANINO (GIROLAMO FRANCESCO MAZZOLA)
 pär-mē-jä-**nē**-nō (jē-rō-**lä**-mō
 frän-**ches**-kō mät-**sō**-lä)
m. Parmesan painter, 1503–40

PARR, MARTIN pär, **mär**-tən
m. British photographer, 1952–

PARR, MIKE pär, mīk
m. Australian draughtsman, installation artist, 1945–

PARRHASIUS pə-**rā**-shē-əs
m. Greek painter, late 5th c. BC

PARTOS, PAUL **pär**-tōs, pȯl
m. Australian (b. Czechoslovakia) painter, 1943–

PASCHKE, ED **pash**-kē, ed
m. American painter, 1939–

PASCIN, JULES pas-kan or pas-kēn, zhuel
m. American (b. Bulgaria) painter, 1885–1930

PASMORE, VICTOR **pas**-mȯr, **vik**-tər
m. English painter, sculptor, 1908–

PASSAROTTI, BARTOLOMMEO pä-sä-**rót**-tē, bär-tō-lō-**mä**-ō
m. Bolognese painter, printmaker, 1529–92

PATER, JEAN-BAPTISTE-JOSEPH pä-ter, zhäⁿ–bat-tēst–zhō-zef
m. French painter, 1695–1736

PATERNOSTO, CÉSAR pä-ter-**nōs**-tō, **sā**-sär
m. Argentine painter, 1931–

PATINIR (PATENIER), JOACHIM pä-ti-**nēr**, **yō**-ä-kim
m. Flemish painter, d. 1524

PAUSIAS OF SICYON **pó**-shē-əs, **sish**-ē-än or **sis**-ē-än
m. Greek painter, mid–4th c. BC

PEALE, ANNA CLAYPOOLE pēl, **an**-ə **klā**-pül
f. American painter, 1791–1878

PEALE, CHARLES WILLSON pēl, chärlz **wil**-sən
m. American painter, 1741–1827

PEALE, JAMES pēl, jāmz
m. American painter, 1749–1831

PEALE, RAPHAELLE pēl, rä-fä-**el**
m. American painter, 1774–1825

PEALE, REMBRANDT pēl, **rem**-brant
m. American painter, 1778–1860

PEARLSTEIN, PHILIP **pərl**-stīn, **fil**-əp
m. American painter, printmaker, 1924–

PECHSTEIN, MAX **pek**-shtīn, mäks
m. German painter, printmaker, 1881–1955

PEEL, PAUL pēl, pól
m. Canadian painter, 1861–92

PEETERS, BONAVENTURA THE ELDER **pā**-tərs, bō-nä-ven-**tü**-rä
m. Flemish painter, printmaker, 1614–52

PEETERS, CLARA **pā**-tərs, **klä**-rä
f. Flemish painter, 1594–1657?

PELÁEZ, AMELIA pā-**lä**-es, ä-**māl**-yä
f. Cuban painter, 1897–1968

PELLÓN, GINA pā-**yōn**, **zhē**-nä
f. Cuban (act. France) painter, 1926–

PEÑA, TONITA **pā**-nyä, tō-**nē**-tä
f. American (Pueblo) painter, 1895–1949

PEÑALBA, ALICIA pā-**nyäl**-bä, ä-**lēs**-yä
f. Argentine sculptor, 1918–

PENCK, A. R. (RALF WINKLER) pengk (rälf **vin**-klər)
m. German painter, sculptor, printmaker, 1939–

PENCZ, GEORG (JÖRG) pents, **gā**-órg (yœrg)
m. German painter, printmaker, c. 1500–50

PÈNE DU BOIS, GUY pen dü bwä, gē
m. American painter, 1884–1958

PÉNICAUD, NARDON (LÉONARD) pā-nē-kō, när-dōn (lā-ō-när)
m. French ceramicist, c. 1470–c. 1542

PENN, IRVING pen, **ər**-ving
m. American photographer, 1917–

PENNELL, JOSEPH **pen**-əl, **jō**-zəf
m. American printmaker, 1857–1926

PENONE, GIUSEPPE pā-**nō**-nā, jü-**zep**-pā
m. Italian sculptor, 1947–

PENROSE, ROLAND **pen**-rōz, **rō**-lənd
m. English painter, 1900–84

PEPPER, BEVERLY **pep**-ər, **bev**-ər-lē
f. American sculptor, painter, 1924–

PEREDA Y SALGADO, ANTONIO DE pā-**rā**-<u>th</u>ä ē säl-**gä**-thō,
 än-**tōn**-yō dā
m. Spanish painter, 1608–78

PEREIRA, IRENE RICE pə-**rā**-rə, ī-**rēn** rīs
f. American painter, 1907–71

PEREIRA, MANUEL pā-**rā**-rä, män-**wel**
m. Portuguese (act. Spain) sculptor, 1588–1683

PERMEKE, CONSTANT per-**māk**-ā, kōn-stän
m. Belgian painter, 1886–1952

PERMOSER, BALTHASAR per-**mō**-zər, bäl-**tä**-zär
m. German sculptor, 1651–1732

PEROV, VASILY GRIGORIEVICH pi-**ròf**, və-**sēl**-ē gri-**gòr**-ē-ə-vich
m. Russian painter, 1834–82

PERRÉAL, JEAN per-rā-äl, zhän
m. French painter, architect, sculptor, c. 1455–1530

PERRONEAU, JEAN-BAPTISTE per-rō-nō, zhän–bat-tēst
m. French painter, engraver, 1715–83

PERRY, LILLA CABOT **per**-ē, **lil**-ə **kab**-ət
f. American painter, 1848–1933

PERUGINO, PIETRO (PIETRO DI CRISTOFORO DI VANNUCCI)
 pā-rü-**jē**-nō, **pyā**-trō
 (dē krē-**stò**-fô-rō dē vän-**nü**-chē)
m. Umbrian painter, 1445/50–1523

PERUZZI, BALDASSARE pā-**rüt**-sē, bäl-dä-**sä**-rā
m. Sienese painter, 1481–1536

PESELLINO (FRANCESCO DI STEFANO) pā-zel-**lē**-nō
 (frän-**ches**-kō dē **stā**-fä-nō)
m. Florentine painter, c. 1422–57

PETO, JOHN FREDERICK **pē**-tō, jän **fred**-rik
m. American painter, 1854–1907

PETROV-VODKIN, KUZMA SERGEEVICH
 pi-**tròf**–**vòd**-kin,
 küz-**mä** sir-**gā**-ə-vich
m. Russian painter, 1878–1939

PETTORUTI, EMILIO pet-tō-**rü**-tē, ā-**mēl**-yō
m. Argentine painter, 1892–1971

PEVSNER, ANTOINE **pyevz**-nər, än-twän
m. French (b. Russia) sculptor, painter, 1886–1962

PFAFF, JUDY pfaf, **jü**-dē
f. American (b. England) sculptor, 1946–

PFORR, FRANZ pfòr, fränts
m. German painter, 1788–1812

PHELAN, ELLEN **fā**-lən, **el**-ən
f. American painter, draughtsman, 1943–

PHIDIAS **fid**-ē-əs
m. Greek sculptor, d. c. 432 BC

PHILIPPE-AUGUSTE, SALNAVE fē-lēp–ō-gŭest, säl-näv
m. Haitian painter, 1908–

PIAZZETTA, GIOVANNI BATTISTA pē-ät-**set**-tä, jō-**vän**-nē bät-**tē**-stä
m. Venetian painter, printmaker, 1682–1754

PICABIA, FRANCIS pē-**käb**-yä, fräⁿ-sēs
m. French painter, sculptor, 1879–1953

PICASSO, PABLO pē-**käs**-sō, **päv**-lō
m. Spanish (act. France) painter, sculptor, printmaker,1881–1973

PIENE, OTTO **pē**-nə, **ȯt**-tō
m. American (b. Germany) painter, sculptor, 1928–

PIERO DELLA FRANCESCA (DE' FRANCESCHI)
pyā-rō **del**-lä frän-**ches**-kä
(dā frän-**ches**-kē)
m. Umbrian painter, c. 1410/20–92

PIERO DI COSIMO **pyā**-rō dē **kō**-zē-mō
m. Florentine painter, c. 1462–c. 1521

PIERRE, ANDRÉ pyer, äⁿ-drā
m. Haitian painter, 1914–

PIGALLE, JEAN-BAPTISTE pē-gäl-l', zhäⁿ–bat-tēst
m. French sculptor, 1714–85

PILLEMENT, JEAN-BAPTISTE pē-yə-mäⁿ, zhäⁿ–bat-tēst
m. French painter, designer, 1728–1808

PILO, CARL GUSTAF **pē**-lō, kärl **gŭs**-täf
m. Swedish painter, 1711–93

PILON, GERMAIN pē-lōⁿ, zher-maⁿ
m. French sculptor, c. 1535–90

PILOTY, KARL THEODOR VON pē-**lō**-tē, kärl **tā**-ō-dȯr fȯn
m. German painter, 1826–86

PINDELL, HOWARDENA pin-**del**, haȯ-ər-**dē**-nə
f. American painter, 1943–

PINEAU, NICOLAS pē-nō, nē-kō-lä
m. French sculptor, designer, 1684–1754

PINELLI, BARTOLOMEO pē-**nel**-lē, bär-tō-lō-**mā**-ō
m. Italian printmaker, painter, sculptor, 1781–1835

PINTURICCHIO (BERNARDINO DI BETTO)
 pēn-tü-**rēk**-yō
 (ber-när-**dē**-nō dē **bet**-tō)
m. Umbrian painter, 1454–1513

PIPER, ADRIAN **pī**-pər, **ā**-drē-ən
f. American installation artist, 1948–

PIPPIN, HORACE **pip**-pin, **hȯr**-əs
m. American painter, 1888–1946

PIRANESI, GIOVANNI BATTISTA pē-rä-**nā**-zē, jō-**vän**-ne bät-**tē**-stä
m. Italian etcher, architect, 1720–78

PISANELLO, IL (ANTONIO PISANO) pē-zä-**nel**-lō, ēl (än-**tōn**-yō
 pē-**zä**-nō)
m. Pisan painter, 1395–c. 1455

PISANO, ANDREA pē-**zä**-nō, än-**drā**-ä
m. Pisan sculptor, architect, c. 1290–1348/9?

PISANO, GIOVANNI pē-**zä**-nō, jō-**vän**-nē
m. Pisan sculptor, architect, d. after 1314

PISANO, NICOLA pē-**zä**-nō, nē-**kȯ**-lä
m. Pisan sculptor, architect, d. 1278/84

PISSARRO, CAMILLE pē-sä-rō, ka-mē-y'
m. French painter, 1830–1903

PISSARRO, LUCIEN pē-sä-rō, lᴜe-syan
m. French painter, 1863–1944

PISTOLETTO, MICHELANGELO pē-stō-**let**-tō, mē-kel-**än**-jä-lō
m. Italian sculptor, painter, 1933–

PITTONI, GIOVANNI BATTISTA pēt-**tō**-nē, jō-**vän**-nē bät-**tē**-stä
m. Venetian painter, 1687–1767

PLEYDENWURFF, HANS **plī**-dən-vürf, häns
m. German (Nuremberg) painter, d. 1472

POELENBURGH, CORNELIS VAN **pᴜ̈**-lən-bür<u>k</u> or **pᴜ̈**-lən-bürg,
 kȯr-**nā**-lis fən
m. Dutch painter, c. 1594/5–1667

POIRIER, ANNE pwä-rē-ā, än
f. French sculptor, 1942–

POIRIER, PATRICK pwä-rē-ā, **pat**-rik
m. French sculptor, 1942–

POITRAS, JANE ASH **pwä**-tras, jän ash
f. Canadian (Cree) collagist, 1951–

POLENOV, VASILY DMITRIEVICH pəl-**yen**-óf, və-**sēl**-ē dmē-**trē**-ə-vich
m. Russian painter, printmaker, 1844–1927

POLEO, HECTOR pō-**lā**-ō, ek-**tòr**
m. Venezuelan painter, 1918–

POLESELLO, ROGELIO pō-lā-**sā**-yō, rō-**kāl**-yō
m. Argentine painter, 1939–

POLIAKOFF, SERGE pə-lǐ-ə-**kòf**, serzh
m. French (b. Russia) painter, 1906–69

POLKE, SIGMAR **pōl**-kə, **zēg**-mär
m. German painter, printmaker, photographer, 1941–

POLLAIUOLO, ANTONIO DEL pōl-lä-yü-**ō**-lō, än-**tōn**-yō del
m. Florentine painter, sculptor, printmaker, c. 1432–98

POLLAIUOLO, PIERO DEL pōl-lä-yü-**ō**-lō, **pyā**-rō del
m. Florentine painter, sculptor, c. 1441–c. 1496

POLLOCK, JACKSON **päl**-ək, **jak**-sən
m. American painter, 1912–56

POLYCLITUS OF ARGOS pä-li-**klī**-təs, **är**-gòs
m. Greek sculptor, act. c. 450–c. 420 BC

POMODORO, ARNALDO pō-mō-**dō**-rō, är-**näl**-dō
m. Italian sculptor, painter, printmaker, 1926–

POMODORO, GIO pō-mō-**dō**-rō, jō
m. Italian sculptor, 1930–

PONCE DE LEON, FIDELIO **pōn**-sā dā lā-**ōn**, fē-**dāl**-yō
m. Cuban painter, 1895–1949

PONTI, CARLO **pòn**-tē, **kär**-lō
m. Italian photographer, 1821–93

PONTORMO (JACOPO CARRUCCI) pōn-**tȯr**-mō (**yä**-kō-pō kär-**rüt**-shē)
m. Florentine painter, 1494–1557

POONS, LARRY pünz, **lar**-ē
m. American painter, 1937–

POPOVA, LIUBOV SERGEEVNA pə-**pō**-və, lyü-**bȯf** sir-**gä**-ev-nə
f. Russian painter, 1889–1924

PORCELLIS, JAN pȯr-**sel**-is, yän
m. Flemish painter, printmaker, c. 1584–1632

PORDENONE (GIOVANNI ANTONIO DE SACCHIS)
 pȯr-dä-**nō**-nä
 (jō-**vän**-nē än-**tōn**-yō dä **säk**-kēs)
m. Northern Italian painter, printmaker, c. 1483–1539

PORTER, ELIOT **pȯr**-tər, **el**-ē-ət
m. American photographer, 1901–90

PORTER, FAIRFIELD **pȯr**-tər, **fār**-fēld
m. American painter, 1907–75

PORTER, JAMES A. **pȯr**-tər, jāmz
m. American painter, 1905–71

PORTER, KATHERINE **pȯr**-tər, **kath**-rin
f. American painter, 1941–

PORTER, LILIANA **pȯr**-tər, lē-**lyä**-nä
f. Argentine painter, printmaker, 1941–

PORTINARI, CANDIDO pȯr-tē-**nä**-rē, kän-**dē**-<u>th</u>ō
m. Brazilian painter, printmaker, ceramicist, 1903–62

PORTOCARRERO, RENÉ pȯr-tō-kä-**rä**-rō, rä-**nä**
m. Cuban painter, 1912–85

POSADA, JOSÉ GUADALUPE pō-**sä**-<u>th</u>ä, kō-**sā** gwä-<u>th</u>ä-**lü**-pā
m. Mexican printmaker, 1852–1913

POSSUM, CLIFFORD (TJAPALTJARRI) **päs**-əm, **klif**-ərd (chä-pəl-chär-rē)
m. Australian (Anmatyerre) painter, c. 1943–

POST, FRANS JANSZ. pōst, fräns yäns
m. Dutch painter, 1612–80

POT, HENDRIK GERRITSZ. pȯt, **hen**-drik **ker**-rits or **ger**-rits
m. Dutch painter, c. 1585–1657

POTTER, PAULUS **pȯt**-tər, **paú**-lᵊs
m. Dutch painter, 1625–54

POURBUS, FRANS THE ELDER **pür**-bᵊs, fräns
m. Flemish painter, 1545–81

POURBUS, FRANS THE YOUNGER **pür**-bᵊs, fräns
m. Dutch painter, 1569–1622

POURBUS, PIETER JANSZ. **pür**-bᵊs, **pē**-tər yäns
m. Flemish painter, c. 1523–84

POUSETTE-DART, RICHARD pü-**set**–därt, **rich**-ərd
m. American painter, 1916–92

POUSSIN, GASPARD (DUGHET) pü-saⁿ, gas-pär (dᵊ-gä)
m. French painter, 1615–75

POUSSIN, NICOLAS pü-saⁿ, nē-kō-lä
m. French painter, 1593/4–1665

POZZO, ANDREA **pȯt**-sō, än-**drä**-ä
m. Venetian painter, 1642–1709

PRAXITELES prak-**sit**-ə-lēz
m. Greek sculptor, act. c. 370–330 BC

PREDIS, GIOVANNI AMBROGIO DE **prä**-dis, jō-**vän**-nē äm-**brō**-jō dā
m. Milanese painter, c. 1455–after 1522

PRENDERGAST, MAURICE **pren**-dər-gast, mȯ-**rēs**
m. American painter, 1859–1924

PRETI, MATTIA **prä**-tē, **mät**-tyä
m. Neapolitan painter, 1613–99

PRIMATICCIO, FRANCESCO prē-mä-**tēch**-yō, frän-**ches**-kō
m. Bolognese painter, 1504–70

PRINA, STEPHEN **prē**-nə, **stē**-vən
m. American installation artist, 1954–

PRINCE, RICHARD prins, **rich**-ərd
m. American photographer, painter, 1949–

PROCACCINI, GIULIO CESARE prō-kä-**chē**-nē, **jü**-lē-ō **chä**-zä-rä
m. Bolognese painter, printmaker, 1574–1625

PROUT, SAMUEL praůt, **sam**-yü-əl
m. English painter, 1783–1852

PROVOST, JAN THE YOUNGER prȯ-**vȯst**, yän
m. Flemish painter, c. 1465–1529

PRUD'HON, PIERRE-PAUL prɶ-dōn, pyer–pōl
m. French painter, 1758–1823

PUENTE, ALEJANDRO **pwen**-tā, ä-lä-**kän**-drō
m. Argentine sculptor, conceptual artist, 1933–

PUGET, PIERRE pɶ-zhā, pyer
m. French sculptor, painter, 1620–94

PURYEAR, MARTIN **pər**-yēr, **mär**-tin
m. American sculptor, 1941–

PUVIS DE CHAVANNES, PIERRE CÉCILE

 pɶ-vē də sha-vän, pyer sā-sēl
m. French painter, 1824–98

PYNACKER, ADAM **pi**-näk-ər, **ä**-däm
m. Dutch painter, 1622–73

QUAST, PIETER JANSZ. kväst, **pē**-tər yäns
m. Dutch painter, printmaker, 1605–47

QUELLINUS, ARTUS I kvel-**ē**-nues, **är**-tues
m. Flemish sculptor, 1609–68

QUERCIA, JACOPO DELLA **kwer**-chä, **yä**-kō-pō **del**-lä
m. Sienese sculptor, c. 1374–1438

QUESADA, EUGENIO kā-**sä**-thä, āü-**kā**-nyō
m. American painter, 1927–

QUESNEL, FRANÇOIS ke-nel, frän-swä
m. French painter, c. 1543–1619

R

RABIN, OSKAR rä-**bēn**, **ȯs**-kär
m. Russian painter, 1928–

RABINOWITCH, DAVID rə-**bin**-ə-wich, **dā**-vid
m. Canadian sculptor, 1943–

RAEBURN, HENRY **rā**-bərn, **hen**-rē
m. Scottish painter, 1756–1823

RAFFET, AUGUSTE rä-fā, ō-guest
m. French printmaker, painter, 1804–60

RAIMONDI, MARCANTONIO rī-**mōn**-dē, märk-än-**tōn**-yō
m. Bolognese engraver, c. 1480–1534

RAINER, ARNULF **ri**-nər, **är**-nùlf
m. Austrian photographer, draughtsman, 1929–

RAINER, YVONNE **rā**-nər, ē-**vän**
f. American photographer, filmmaker, 1934–

RAMÍREZ VILLAMIZAR, EDUARDO rä-**mē**-res vē-yä-mē-**sär**,
 ā-**thwär**-thō
m. Colombian sculptor, painter, 1923–

RAMOS, MEL **rā**-mōs, mel
m. American painter, 1935–

RAMSAY, ALLAN II **ram**-zē, **al**-ən
m. Scottish painter, draughtsman, 1713–84

RAPHAEL (RAFFAELLO SANZIO) **ra**-fē-əl (rä-fä-**el**-lō **sänts**-yō)
m. Umbrian painter, architect, 1483–1520

RAQUEL RIVERA, CARLOS rä-**kel** rē-**vā**-rä, **kär**-lōs
m. Puerto Rican painter, printmaker, 1923–

RAUCH, CHRISTIAN DANIEL raúk, **kris**-tyän **dän**-yel
m. German sculptor, 1777–1857

RAUSCHENBERG, ROBERT **raú**-shen-berg, **räb**-ert
m. American painter, sculptor, printmaker, 1925–

RAVERAT, GWENDOLEN **rä**-ve-rä, **gwen**-de-len
f. English painter, 1885–1957

RAVESTEYN, JAN VAN **rä**-ve-stīn, yän fen
m. Dutch painter, c. 1570–1657

RAY, RICHARD (WHITMAN) rā, **rich**-erd (**hwit**-men)
m. American (Yuchi/Pawnee) painter, photographer, 1949–

RAYO, OMAR **ri**-ō, ō-**mär**
m. Colombian painter, 1928–

RAYSSE, MARTIAL rä-ēs, mär-syäl
m. French painter, photomontagist, 1936–

RECCO, GIUSEPPE **rāk**-kō, jü-**zep**-pā
m. Neapolitan (act. Spain) painter, 1634–95

REDON, ODILON re-dōn, ȯ-dē-lōn
m. French painter, printmaker, 1840–1916

REDPATH, ANNE **red**-path, an
f. Scottish painter, 1895–1965

REGNAULT, JEAN-BAPTISTE ren-yō, zhän–bat-tēst
m. French painter, printmaker, 1754–1829

REGO, PAULA **rā**-gō, **paú**-lä
f. Portuguese painter, 1935–

REINHARDT, AD **rin**-härt, ad
m. American painter, 1913–67

REJLANDER, OSCAR GUSTAVE **rä**-länd-er, **ȯs**-kär **gús**-täf
m. Swedish (act. England) photographer, 1813–75

REMBRANDT HARMENSZ. VAN RIJN **rem**-bränt or **rem**-brant
här-mens fen rīn
m. Dutch painter, etcher, 1606–69

REMINGTON, FREDERIC **rem**-ing-ten, **fred**-rik
m. American painter, sculptor, 1861–1909

RENAU, JOSÉ **rā**-naủ, <u>k</u>ō-**sā**
m. German (b. Spain) photomontagist, 1907–82

RENGER-PATZSCH, ALBERT **reng**-ər–päch, **äl**-bert
m. German photographer, 1897–1966

RENI, GUIDO **rā**-nē, **gwē**-dō
m. Bolognese painter, 1575–1642

RENOIR, PIERRE-AUGUSTE rən-wär, pyer–ō-gửest
m. French painter, 1841–1919

REPIN, ILYA **rep**-in, **ēl**-yä
m. Russian painter, 1844–1930

RETHEL, ALFRED **rä**-təl, **äl**-fred
m. German painter, printmaker, 1816–59

REVERÓN, ARMANDO rā-vā-**rōn**, är-**män**-dō
m. Venezuelan painter, 1889–1954

REYNOLDS, JOSHUA **ren**-əldz, **jäsh**-ü-ä
m. English painter, 1723–92

RIBALTA, FRANCISCO rē-**väl**-tä, frän-**thēs**-kō
m. Spanish painter, 1565–1628

RIBERA, JUSEPE DE (LO SPAGNOLETTO) rē-**vā**-rä, <u>k</u>ü-**sā**-pā dā
 (lō spä-nyō-**let**-tō)
m. Spanish (act. Italy) painter, 1591–1652

RIBOT, AUGUSTIN THÉODULE rē-bō, ō-gửes-taⁿ tā-ō-dửel
m. French painter, printmaker, 1823–91

RICCI, MARCO **rēt**-chē, **mär**-ko
m. Venetian painter, 1676–1729

RICCI, SEBASTIANO **rēt**-chē, sā-bäst-**yä**-nō
m. Venetian painter, 1659–1734

RICCIO, IL (ANDREA BRIOSCO) **rēt**-chē-ō, ēl (än-**drä**-ä brē-**ós**-kō)
m. Paduan sculptor, 1470–1532

RICHARDS, CERI **rich**-ərdz, **ker**-ē
m. English painter, printmaker, 1903–71

RICHIER, GERMAINE rēsh-yā, zher-men
f. French sculptor, 1904–59

RICHMOND, GEORGE **rich**-mənd, jȯrj
m. English painter, printmaker, 1809–96

RICHTER, GERHARD **ri<u>k</u>**-tər, **ger**-härt
m. German painter, 1932–

RICHTER, LUDWIG ADRIAN **ri<u>k</u>**-tər, **lüt**-vi<u>k</u> **ä**-drē-än
m. German painter, printmaker, 1803–84

RICKEY, GEORGE **rik**-ē, jȯrj
m. American sculptor, 1907–

RIEMENSCHNEIDER, TILMAN **rē**-mən-shnī-dər, **til**-män
m. German sculptor, c. 1460–1531

RIGAUD, HYACINTHE rē-gō, ē-ä-san-t'
m. French painter, 1659–1743

RIIS, JACOB AUGUST rēs, **yä**-kȯb **au̇**-gu̇st
m. American (b. Denmark) photographer, 1849–1914

RILEY, BRIDGET **ri**-lē, **brij**-ət
f. English painter, 1931–

RILEY, JOHN **ri**-lē, jän
m. English painter, 1646–91

RINGGOLD, FAITH **ring**-gōld, fāth
f. American painter, quiltmaker, 1934–

RIOPELLE, JEAN-PAUL rē-ō-pel, zhän–pōl
m. Canadian painter, sculptor, printmaker, 1923–

RIVERA, DIEGO rē-**vä**-rä, **dyä**-gō
m. Mexican painter, printmaker, 1886–1957

RIVERA, JOSÉ DE rē-**vä**-rä, <u>k</u>ō-**sä** dā
m. American sculptor, 1904–

RIVERS, LARRY **riv**-ərz, **la**-rē
m. American painter, sculptor, 1923–

ROBBIA, LUCA DELLA: see DELLA ROBBIA, LUCA

ROBERT, HUBERT rȯ-ber, ᴜe-ber
m. French painter, 1733–1808

ROBERTI, ERCOLE DE' rō-**ber**-tē, **er**-kō-lā dā
m. Ferrarese painter, c. 1456–96

ROBERTS, DAVID **räb**-ərts, **dā**-vid
m. Scottish painter, 1796–1864

ROBERTS, TOM **räb**-ərts, täm
m. Australian painter, 1856–1931

ROBINSON, HENRY PEACH **räb**-in-sən, **hen**-rē pēch
m. English photographer, painter, 1830–1901

ROCHE-RABELL, ARNALDO rōsh–rä-**bel**, är-**näl**-dō
m. Puerto Rican painter, 1956–

ROCKBURNE, DOROTHEA **räk**-bərn, dȯr-ə-**thē**-ə
f. Canadian (act. United States) painter, 1921–

RODCHENKO, ALEKSANDR MIKHAILOVICH
rōt-chen-kō, əl-ik-**sän**-dər
mē-k̬ə-**yēl**-ə-vich
m. Russian painter, sculptor, photographer, 1891–1956

RODIN, AUGUSTE rō-dan, ō-guest
m. French sculptor, 1840–1917

RODRÍGUEZ, MARIANO rȯ-**thrē**-ges, mär-**yä**-nō
m. Cuban painter, 1912–90

RODRIGUEZ, PATRICIA rȯd-**rē**-ges, pä-**trēs**-yä
f. American mixed-media artist, painter, 1944–

ROELAS, JUAN DE rō-**ä**-läs, k̬wän dā
m. Spanish painter, 1558/60–1625

ROHLFS, CHRISTIAN rȯlfs, **kris**-tyän
m. German painter, 1849–1938

ROJAS, ELMAR **rō**-käs, el-**mär**
m. Guatemalan painter, 1938–

ROJAS, MIGUEL ANGEL **rō**-käs, mē-**gel** än-**kel**
m. Colombian draughtsman, installation artist, 1946–

ROLDÁN, PEDRO rȯl-**dän**, **pā**-t̬hrō
m. Spanish sculptor, 1624–1700

ROMAÑACH, LEOPOLDO rō-mä-**nyäsh**, lä-ō-**pȯl**-dō
m. Cuban painter, 1862–1951

ROMBOUTS, THEODOOR **rȯm**-baùts, **tā**-ō-dȯr
m. Flemish painter, printmaker, 1597–1637

ROMERO, FRANK rō-**mä**-rō, frangk
m. American painter, 1941–

ROMNEY, GEORGE **räm**-nē, jȯrj
m. English painter, 1734–1802

ROONEY, ROBERT **rü**-nē, **räb**-ərt
m. Australian painter, photographer, 1937–

ROPS, FÉLICIEN rȯps, fā-lē-syan
m. Belgian printmaker, 1833–98

ROSA, SALVATOR **rō**-zä, säl-**vä**-tȯr
m. Neapolitan painter, 1615–73

ROSADO DEL VALLE, JULIO rō-**sä**-tho del **vi**-yā, **kül**-yō
m. Puerto Rican painter, 1922–

ROSENQUIST, JAMES **rō**-zən-kwist, jāmz
m. American painter, 1933–

ROSLIN, ALEXANDER **rōz**-lēn, ä-leg-**zän**-der
m. Swedish painter, 1718–93

ROSSELLI, COSIMO rōs-**sel**-lē, **kō**-zē-mō
m. Florentine painter, 1439–1507

ROSSELLINO, ANTONIO rōs-sel-**lē**-nō, än-**tōn**-yō
m. Florentine sculptor, 1427–79

ROSSELLINO, BERNARDO rōs-sel-**lē**-nō, ber-**när**-dō
m. Florentine sculptor, architect, 1409–64

ROSSETTI, DANTE GABRIEL rō-**set**-tē, **dan**-tā **gä**-brē-əl
m. English painter, poet, 1828–82

ROSSO, MEDARDO **rȯs**-sō, mä-**där**-dō
m. Italian sculptor, 1858–1928

ROSSO FIORENTINO (GIOVANNI BATTISTA DI JACOPO)
 rȯs-sō fyō-ren-**tē**-nō
 (jō-**vän**-nē bät-**tē**-stä dē **yä**-kō-pō)
m. Florentine painter, 1494–1540

ROSZAK, THEODORE **rȯ**-shäk, **thē**-ə-dȯr
m. American sculptor, 1907–81

ROTHENBERG, SUSAN **rȯth**-ən-berg, **sü**-zən
f. American painter, 1945–

ROTHKO, MARK **räth**-kō, märk
m. American (b. Russia) painter, 1903–70

ROTHSCHILD, JUDITH **ròths**-child, **jü**-dith
f. American painter, 1921–

ROTTENHAMMER, JOHANN **ròt**-tən-häm-mər, yō-**hän**
m. German painter, 1564–1625

ROTTMAN, KARL **ròt**-män, kärl
m. German painter, 1797–1850

ROUAULT, GEORGES rü-ō, zhòrzh
m. French painter, 1871–1958

ROUBILIAC, LOUIS-FRANÇOIS rü-bē-yak, lü-ē–fräⁿ-swä
m. French (act. England) sculptor, c. 1705–62

ROUSSE, GEORGES rüs, zhòrzh
m. French photographer, 1947–

ROUSSEAU, HENRI-JULIEN (LE DOUANIER)
rü-sō, äⁿ-rē–zhuel-yaⁿ (lə dü-än-yā)
m. French painter, 1844–1910

ROUSSEAU, THÉODORE rü-sō, tā-ō-dòr
m. French painter, 1812–67

ROWLANDSON, THOMAS **rō**-lən-sən, **täm**-əs
m. English caricaturist, 1756–1827

ROY, PIERRE rwä, pyer
m. French painter, 1880–1950

ROZANOVA, OLGA VLADIMIROVNA **rō**-zə-nō-və, **òl**-gə vlə-**dē**-mir-ōv-nə
f. Russian painter, 1886–1918

RUBENS, PETER PAUL **rü**-bənz, **pē**-tər pòl
m. Flemish painter, 1577–1640

RUBLEV, ANDREI **rüb**-lòf, än-**drā**-y'
m. Russian painter, c. 1360/70–1430

RUDE, FRANÇOIS rue-d', fräⁿ-swä
m. French sculptor, 1784–1855

RUFF, THOMAS rüf, **tō**-mäs
m. German photographer, 1958–

RUISDAEL, JACOB VAN **rœēs**-däl *or* **rȯis**-däl *or* **ris**-däl, **yä**-kȯp fən
m. Dutch painter, 1628/9–82

RUÍZ, ANTONIO M. (EL CORZO) rü-**ēs**, än-**tōn**-yō (el **kȯr**-sō)
m. Mexican painter, 1897–1964

RUNCIMAN, JOHN **rən**-si-mən, jän
m. Scottish painter, 1744–68

RUNGE, PHILIPP OTTO **runġ**-ə, **fē**-lip **ȯt**-tȯ
m. German painter, 1777–1810

RUOPPOLO, GIOVANNI BATTISTA rü-**ȯp**-pō-lō, jō-**vän**-nē bät-**tē**-stä
m. Neapolitan painter, 1629–93

RUPERT, PRINCE **rü**-pərt
m. German (Bohemia) etcher, 1619–82

RUSCHA, EDWARD rü-**shā**, **ed**-wərd
m. American painter, photographer, 1937–

RUSCONI, CAMILLO rüs-**kō**-nē, kä-**mēl**-ō
m. Roman sculptor, 1658–1728

RUSIÑOL Y PRATS, SANTIAGO rü-sē-**nyōl** ē präts, sän-tē-**ä**-gō
m. Spanish painter, 1861–1931

RUSSELL, MORGAN **rəs**-əl, **mȯr**-gən
m. American painter, 1886–1953

RUSSOLO, LUIGI **rü**-sō-lō, lü-**ē**-jē
m. Italian painter, 1885–1947

RUYSCH, RACHEL rœēs *or* rȯis, **rä**-kel
f. Dutch painter, 1664–1750

RUYSDAEL, SALOMON VAN **rœēs**-däl *or* **rȯis**-däl *or* **ris**-däl, **sä**-lō-mȯn fən
m. Dutch painter, c. 1600–70

RYDER, ALBERT PINKHAM **ri**-dər, **al**-bərt **ping**-kəm
m. American painter, 1847–1917

RYMAN, ROBERT **ri**-mən, **räb**-ərt
m. American painter, 1930–

RYSBRACK, JOHN MICHAEL **ris**-brak, jän **mi**-kəl
m. Flemish (act. England) sculptor, 1694–1770

RYSSELBERGHE, THÉO VAN **ri**-səl-ber-ke *or* **ri**-səl-ber-gə,
 tā-ō fən

m. Belgian painter, 1862–1926

S

SAAR, ALISON sär, **al**-ə-sən
f. American sculptor, 1956–

SAAR, BETYE sär, **bet**-ē
f. American sculptor, collagist, 1926–

SACCHI, ANDREA **säk**-kē, än-**drä**-ä
m. Roman painter, 1599–1661

SAENREDAM, PIETER JANSZ. **sän**-rə-däm, **pē**-tər yäns
m. Dutch painter, 1597–1665

SAFTLEVEN, CORNELIS **zäft**-lā-vən, kȯr-**nā**-lis
m. Dutch painter, 1607–81

SAFTLEVEN, HERMAN **zäft**-lā-vən, **her**-män
m. Dutch painter, 1609–85

SAGE, KAY sāj, kā
f. American painter, 1898–1963

SAINT-AUBIN, AUGUSTIN saⁿ–tō-baⁿ, ō-gues-taⁿ
m. French draughtsman, engraver, 1736–1807

SAINT-AUBIN, GABRIEL-JACQUES saⁿ–tō-baⁿ, ga-brē-el–zhak
m. French etcher, 1724–80

SAINT-GAUDENS, AUGUSTUS sānt–**gȯd**-ənz, ȯ-**ges**-təs
m. American sculptor, 1848–1907

SAINT PHALLE, NIKI DE saⁿ fäl, nē-kē də
f. French sculptor, 1930–

SAITO, YOSHISHIGE sä-ē-tō, yō-shē-shē-ge
m. Japanese painter, sculptor, 1904–

SALGADO, SEBASTIÃO säl-**gä**-dü, sä-bäs-**tya**ⁿ**ú**
m. Brazilian (act. France) photographer, 1944–

SALINAS, BARUJ sä-**lē**-näs, bä-**rük**
m. Cuban (act. Spain) painter, 1935–

SALLE, DAVID **sal**-ē, **dä**-vid
m. American painter, 1952–

SALOMÉ (WOLFGANG CILARZ) **zä**-lō-mā (**vòlf**-gäng **sē**-lärts)
m. German painter, photographer, performance artist, 1954–

SALOMON, ERICH **zä**-lō-mōn, **ā**-rik
m. German photographer, 1886–1944

SALVIATI, FRANCESCO DE' ROSSI säl-vē-**ä**-tē, frän-**ches**-kō dā **ròs**-sē
m. Florentine painter, 1510–63

SAMARAS, LUCAS sä-**mä**-rəs, **lü**-kəs
m. American (b. Greece) photographer, mixed-media artist, 1936–

SÁNCHEZ, EDGAR **sän**-ches, ed-**gär**
m. Venezuelan painter, draughtsman, 1940–

SÁNCHEZ, EMILIO **sän**-ches, ā-**mēl**-yō
m. Cuban (act. United States) painter, 1921–

SÁNCHEZ COELLO, ALONSO **sän**-cheth kō-**ā**-yō, ä-**lōn**-sō
m. Spanish painter, 1531/2–88

SÁNCHEZ COTÁN, JUAN **sän**-cheth kō-**tän**, kwän
m. Spanish painter, 1561–1627

SANDBY, PAUL **sand**-bē, pòl
m. English painter, 1725–1809

SANDER, AUGUST **zän**-dər, **aú**-gùst
m. German photographer, 1876–1964

SANO DI PIETRO **sä**-nō dē **pyä**-trō
m. Sienese painter, 1406–81

SANSOM, GARETH **san**-səm, **ga**-rəth
m. Australian painter, 1939–

SANSOVINO, ANDREA sän-sō-**vē**-nō, än-**drä**-ä
m. Florentine/Roman sculptor, architect, c. 1467/70–1529

SANSOVINO, JACOPO (JACOPO TATTI)
sän-sō-**vē**-nō, **yä**-kō-pō
(**yä**-kō-pō **tät**-tē)
m. Florentine/Venetian sculptor, architect, 1486–1570

SAPP, ALLEN sap, **al**-ən
m. Canadian (Cree) painter, 1929–

SARACENI, CARLO sä-rä-**chä**-nē, **kär**-lō
m. Venetian painter, c. 1580–1620

SARGENT, JOHN SINGER **sär**-jənt, jän **sing**-ər
m. American painter, 1856–1925

SARRAZIN, JACQUES sär-rä-zan, zhak
m. French sculptor, 1592–1660

SASSETTA (STEFANO DI GIOVANNI) sä-**set**-tä (**stä**-fä-nō dē jō-**vän**-nē)
m. Sienese painter, c. 1392–1450

SASSOFERRATO (GIOVANNI BATTISTA SALVI)
sä-sō-fer-**rä**-tō
(jō-**vän**-nē bät-**tē**-stä **säl**-vē)
m. Central Italian painter, 1609–85

SAUDEK, JAN **saů**-dek, yän
m. Czech photographer, 1935–

SAURA, ANTONIO **saů**-rä, än-**tōn**-yō
m. Spanish painter, 1930–

SAVAGE, AUGUSTA **sav**-ij, ȯ-**gəs**-tə
f. American sculptor, 1892–1962

SAVERY, ROELANDT sä-vä-rē, **rů**-länt
m. Flemish painter, 1576–1639

SAVOLDO, GIOVANNI GIROLAMO sä-**vōl**-dō, jō-**vän**-nē jē-rō-**lä**-mō
m. Venetian painter, act. 1508–after 1548

SAVRASOV, ALEKSEI KONDRATIEVICH səv-**rä**-sȯf, əl-ik-**sā**-ē
kȯn-**drä**-tē-ə-vich
m. Russian painter, 1830–97

SCARSELLINO, LO (IPPOLITO SCARSELLA)
skär-sel-**lē**-nō, lō
(ē-**pō**-lē-tō skär-**sel**-lä)
m. Ferrarese painter, 1551–1620

SCHADOW, JOHANN GOTTFRIED **shä**-dȯf, **yō**-hän **gȯt**-frēt
m. German sculptor, 1764–1850

SCHADOW, WILHELM VON **shä**-dȯf, **vil**-helm fȯn
m. German painter, 1788–1862

SCHALKEN, GODFRIED **shäl**-kən, **kȯd**-frēd or **gȯd**-frēd
m. Dutch painter, 1643–1706

SCHAPIRO, MIRIAM shə-**pir**-ō, **mir**-ē-əm
f. American painter, 1923–

SCHEEMAEKERS, PEETER **shä**-mäk-ərs, **pā**-tər
m. Flemish (act. England) sculptor, 1691–1781

SCHIAVONE, ANDREA MELDOLLA skē-ä-**vō**-nä, än-**drä**-ä mel-**dō**-lä
m. Venetian painter, c. 1510/5–63

SCHIELE, EGON **shē**-lə, **ā**-gȯn
m. Austrian painter, 1890–1918

SCHINKEL, KARL FRIEDRICH **shing**-kəl, kärl **frēd**-ri<u>k</u>
m. German painter, architect, 1781–1841

SCHLEMMER, OSKAR **shlem**-ər, **ȯs**-kär
m. German painter, sculptor, 1888–1943

SCHLÜTER, ANDREAS **shlue**-tər, än-**drä**-äs
m. German sculptor, c. 1660–1714

SCHMIDT-ROTTLUFF, KARL shmit-**rȯt**-lüf, kärl
m. German painter, sculptor, 1884–1976

SCHNABEL, JULIAN **shnä**-bəl, **jü**-lē-ən
m. American painter, 1951–

SCHOLDER, FRITZ **shōl**-dər, frits
m. American (Mission/Luiseño) painter, 1937–

SCHÖN, EVA-MARIA shœn, **ā**-vä–mä-**rē**-ä
f. German multimedia artist, 1948–

SCHONGAUER, MARTIN **shōn**-gau̇-ər, **mär**-tēn
m. German engraver, c. 1450–91

SCHRAGER, VICTOR **shrä**-gər, **vik**-tər
m. American photographer, 1950–

SCHÜTTE, THOMAS **shuet**-tə, **tō**-mäs
m. German sculptor, photographer, 1954–

SCHWARTZ (SHWARTZ), VIACHESLAV shwärts, vē-ə-ches-**läf**
m. Russian painter, 1838–69

SCHWITTERS, KURT **shvit**-ərs, kŭrt
m. German collagist, 1887–1948

SCOPAS OF PAROS **skō**-pəs, **pa**-rȯs
m. Greek sculptor, mid–4th c. BC

SCOREL, JAN VAN **skō**-rəl, yän fən
m. Flemish painter, 1495–1562

SCOTT, WILLIAM skät, **wil**-yəm
m. English painter, 1811–90

SCULLY, SEAN **skəl**-ē, shȯn
m. Irish (act. United States) painter, 1945–

SEBASTIANO DEL PIOMBO sā-bäst-**yä**-nō del **pyȯm**-bō
m. Venetian painter, c. 1485–1547

SEBREE, CHARLES **sē**-brē, chärlz
m. American painter, 1914–

SEGAL, GEORGE **sē**-gəl, jȯrj
m. American sculptor, 1924–

SEGALL, LASAR sā-**gäl**, lä-**sär**
m. Brazilian (b. Lithuania) painter, 1891–1957

SEGANTINI, GIOVANNI sā-gän-**tē**-nē, jō-**vän**-nē
m. Italian painter, 1858–99

SEGHERS, DANIEL **zā**-gərs, **dän**-yel
m. Flemish painter, 1590–1661

SEGHERS, GERARD **zā**-gərs, **kā**-rärt or **gā**-rärt
m. Flemish painter, 1591–1651

SEGHERS, HERCULES **zā**-gərs, **her**-kʉ-les
m. Dutch painter, etcher, 1589/90–1633/8

SEGUÍ, ANTONIO sā-**gē**, än-**tōn**-yō
m. Argentine painter, draughtsman, 1929–

SELIGMANN, KURT **sel**-ig-mən, kərt
m. American (b. Switzerland) painter, 1900–62

SÉRAPHINE (SÉRAPHINE LOUIS) sā-rä-fēn (sā-rä-fēn lü-ē)
f. French painter, 1864–1934

SERGEL, JOHAN TOBIAS ser-yəl, **yü**-hän tü-**bē**-äs
m. Swedish (b. Germany) sculptor, draughtsman, 1740–1814

SEROV, VALENTIN ALEKSANDROVICH **sēr**-óf, və-len-**tēn** əl-ik-**sän**-drō-vich
m. Russian painter, 1865–1911

SERPOTTA, GIACOMO ser-**pót**-tä, **jä**-kō-mō
m. Sicilian sculptor, 1656–1732

SERRA, JAUME **ser**-rä, **kaú**-mä
m. Aragonese painter, d. c. 1399

SERRA, PEDRO **ser**-rä, **pā**-thrō
m. Aragonese painter, d. 1404/9

SERRA, RICHARD **ser**-ə, **rich**-ərd
m. American sculptor, 1939–

SERRA-BADUÉ, DANIEL **ser**-rä–bä-**dwā**, dän-**yel**
m. Cuban painter, 1914–

SERRANO, ANDRES se-**rä**-nō, än-**drās**
m. American photographer, 1950–

SÉRUSIER, PAUL sā-ruez-yā, pōl
m. French painter, 1863–1927

SEURAT, GEORGES sœ-rä, zhórzh
m. French painter, 1859–91

SEVERINI, GINO sā-vä-**rē**-nē, **jē**-nō
m. Italian painter, 1883–1966

SHAHN, BEN shän, ben
m. American (b. Lithuania) painter, photographer, 1898–1969

SHAPIRO, JOEL shə-**pir**-ō, **jō**-əl
m. American sculptor, 1941–

SHCHEDRIN, SILVESTR FEODOSIEVICH shed-**rēn**, sil-**ves**-tər
fē-ə-**dō**-sē-ə-vich
m. Russian (act. Italy) painter, 1791–1830

SHEE, MARTIN ARCHER shē, **mär**-tin **är**-chər
m. Irish painter, 1769–1850

SHEELER, CHARLES **shē**-lər, chärlz
m. American painter, photographer, 1883–1965

SHERMAN, CINDY **shər**-mən, **sin**-dē
f. American photographer, 1954–

SHIMONURA, ROGER YUTAKA shē-mō-**nùr**-ə, **räj**-ər yü-**tä**-kə
m. American painter, 1939–

SHINOHARA, USHIO shē-nō-hä-rä, ü-shē-ō
m. Japanese sculptor, 1932–

SHIRAGA, KAZUO shē-rä-gä, kä-zü-ō
m. Japanese painter, 1924–

SHISHKIN, IVAN IVANOVICH **shēsh**-kin, ē-**vän** ē-**vän**-ō-vich
m. Russian painter, 1832–98

SHUBIN, FEDOT IVANOVICH **shü**-bin, fē-**dōt** ē-**vän**-ō-vich
m. Russian sculptor, 1740–1805

SICKERT, WALTER RICHARD **sik**-ərt, **wȯl**-tər **rich**-ərd
m. English painter, 1860–1942

SIEGEL, ARTHUR **sē**-gəl, **är**-thər
m. American photographer, 1913–78

SIEGEN, LUDWIG VON **zē**-gən, **lüt**-vik̠ fȯn
m. German printmaker, 1609–c. 1680

SIGNAC, PAUL sēn-yak, pōl
m. French painter, 1863–1935

SIGNORELLI, LUCA sēn-yō-**rel**-lē, **lü**-kä
m. Florentine painter, c. 1445/50–1523

SIGNORINI, TELEMACO sēn-yō-**rē**-nē, tä-**lä**-mä-kō
m. Italian painter, 1835–1901

SILOE, GIL DE sē-**lō**-ā, k̠ēl dā
m. Spanish sculptor, act. 1486–c. 1501

SILVA, RUFINO **sēl**-vä, rü-**fē**-nō
m. Puerto Rican painter, 1919–

SILVESTRE, ISRAËL sēl-ves-tr', ēz-rä-el
m. French etcher, 1621–91

SIMPSON, LORNA **simp**-sən, **lòr**-nə
f. American photographer, 1960–

SIQUEIROS, DAVID ALFARO sē-**kä**-rōs, dä-**vēth** äl-**fä**-rō
m. Mexican painter, 1896–1974

SIRANI, ELISABETTA sē-**rä**-nē, ä-lē-sä-**bät**-tä
f. Bolognese painter, 1638–65

SIRONI, MARIO sē-**rō**-nē, **mä**-rē-ō
m. Italian draughtsman, painter, 1885–1961

SISKIND, AARON **sis**-kind, **a**-rən
m. American photographer, 1903–91

SISLEY, ALFRED sēs-lā, äl-fred or **siz**-lē, **al**-frəd
m. French painter, 1839–99

SKOGLUND, SANDY **skōg**-lənd, **san**-dē
f. American photographer, 1946–

SLEVOGT, MAX **slä**-fòkt, mäks
m. German (b. Bavaria) painter, 1868–1932

SLIGH, CLARISSA slī, kla-**ris**-ə
f. American photographer, 1939–

SLOAN, JOHN slōn, jän
m. American painter, 1871–1951

SLUTER, CLAUS **slue**-tər, klaůs
m. Netherlandish (act. France) sculptor, act. 1379–1406

SLUYTERS, JAN **slœē**-tərs or **slòi**-tərs, yän
m. Dutch painter, 1881–1957

SMET, GUSTAVE DE smet, guə-stäv də
m. Belgian painter, 1877–1943

SMITH, DAVID smith, **dä**-vid
m. American sculptor, 1906–65

SMITH, GRACE COSSINGTON smith, grās **käs**-ing-tən
f. Australian painter, 1892–

SMITH, JAUNE QUICK-TO-SEE smith, zhōn kwik–tü–sē
f. American (Cree/Flathead/Shoshone) painter, 1940–

SMITH, JOHN "WARWICK" smith, jän **wȯr**-ik
m. English painter, 1749–1831

SMITH, KIKI smith, **kē**-kē
f. American (b. Germany) sculptor, draughtsman, 1954–

SMITH, MATTHEW smith, **math**-yü
m. English painter, 1879–1959

SMITH, TONY smith, **tō**-nē
m. American sculptor, 1912–80

SMITH, W. EUGENE smith, yü-**jēn**
m. American photographer, 1918–78

SMITHSON, ROBERT **smith**-sən, **räb**-ərt
m. American sculptor, earthwork artist, 1938–73

SNELSON, KENNETH **snel**-sən, **ken**-əth
m. American sculptor, 1927–

SNYDERS, FRANS **sni**-dərs, fräns
m. Flemish painter, 1579–1657

SODOMA, IL (GIOVANNI ANTONIO BAZZI)
 sō-dō-mä, ēl
 (jō-**vän**-nē än-**tōn**-yō **bät**-sē)
m. Sienese painter, 1477–1549

SOEST, GERARD süst, **kā**-rärt or **gā**-rärt
m. Dutch (act. England) painter, c. 1600–81

SOLANA, JOSÉ GUTIERREZ sō-**lä**-nä, kō-**sā** gü-**tyer**-reth
m. Spanish painter, 1885–1945

SOLARIO, ANDREA sō-**lä**-rē-ō, än-**drā**-ä
m. Milanese painter, c. 1473–1524

SOLIMENA, FRANCESCO sō-lē-**mä**-nä, frän-**ches**-kō
m. Neapolitan painter, 1657–1747

SOLOMATKIN, LEONID sō-lə-**mät**-kēn, lā-ə-**nēd**
m. Russian painter, 1837–83

SØRENSEN, HENRIK **sœ**-rən-sən, **hen**-rik
m. Norwegian (b. Sweden) painter, 1882–1962

SORIANO, RAFAEL sȯr-**yä**-nō, rä-fä-**el**
m. Cuban (act. United States) painter, 1920–

SOROLLA Y BASTIDA, JOAQUÍN sō-**rō**-yä ē bäs-**tē**-t͟hä, k̲wä-**kēn**
m. Spanish painter, 1863–1923

SOTO, JESUS RAFAEL **sō**-tō, k̲ā-**süs** rä-fä-**el**
m. Venezuelan sculptor, 1923–

SOTO, JORGE **sō**-tō, **kȯr**-k̲ā
m. Puerto Rican painter, 1947–

SOULAGES, PIERRE sü-lazh, pyer
m. French painter, printmaker, 1919–

SOUTINE, CHAÏM sü-**tēn**, **kī**-yim
m. French (b. Lithuania) painter, 1893–1943

SOYER, RAPHAEL **sȯi**-ər, **ra**-fē-əl
m. American (b. Russia) printmaker, painter, 1899–1987

SOZA WAR SOLDIER, BILLY **sō**-zə wȯr **sōl**-jər, **bil**-ē
m. American (Cahuilla/Apache) painter, 1949–

SPALLETTI, ETTORE spä-**let**-tē, **āt**-tȯ-rä
m. Italian sculptor, 1940–

SPENCER, LILLY MARTIN **spen**-sər, **lil**-ē **mär**-tin
f. American painter, 1822–1902

SPENCER, STANLEY **spen**-sər, **stan**-lē
m. English painter, 1891–1959

SPERO, NANCY **spe**-rō, **nan**-sē
f. American painter, 1926–

SPINELLO, ARETINO spē-**nel**-lō, ä-rä-**tē**-nō
m. Florentine painter, act. 1373–1410/1

SPITZWEG, KARL **shpits**-vāk, kärl
m. German painter, 1808–85

SPOERRI, DANIEL spō-**er**-rē, dän-yel
m. Swiss (act. France) sculptor, 1930–

SPRANGER, BARTHOLOMAEUS **spräng**-ər, bär-tō-lō-**mä**-ᵿes
m. Flemish painter, printmaker, 1546–1611

SPROUT, FRANCIS — spraůt, **fran**-sis
m. American painter, 1940–

STAËL, NICOLAS DE — stäl, nē-kō-lä də
m. French (b. Russia) painter, 1914–55

STAMOS, THEODOROS — **stäm**-ōs, thē-ə-**dȯr**-əs
m. American painter, 1922–

STANKIEWICZ, RICHARD — **stang**-kē-ə-vich, **rich**-ərd
m. American sculptor, 1922–83

STARN TWINS (MIKE AND DOUG STARN)
stärn, (mīk, dəg)
m. American photographers, 1961–

STEEN, JAN — stān, yän
m. Dutch painter, 1625/6–79

STEENWYCK, HENDRIK VAN, THE ELDER
stān-vīk, **hen**-drik fən
m. Flemish painter, c. 1550–1603

STEER, PHILIP WILSON — stēr, **fil**-əp **wil**-sən
m. English painter, 1860–1942

STEFANO DI GIOVANNI: see SASSETTA

STEICHEN, EDWARD — **stī**-kən, **ed**-wərd
m. American (b. Luxembourg) photographer, 1879–1973

STEINBACH, HAIM — **stīn**-bäk, hīm
m. American (b. Israel) mixed-media artist, 1941–

STEINBERG, SAUL — **stīn**-bərg, sȯl
m. American (b. Rumania) draughtsman, 1914–

STEINER, RALPH — **stī**-nər, ralf
m. American photographer, 1899–1986

STEINERT, OTTO — **shtīn**-ərt, **ȯt**-tō
m. German photographer, 1915–78

STEINHARDT, JAKOB — **shtīn**-härt, **yä**-kȯp
m. Israeli (b. Poland) painter, printmaker, 1887–1968

STEINLEN, THÉOPHILE — stīn-len, tā-ō-**fēl**
m. Swiss draughtsman, painter, printmaker, 1859–1923

STEIR, PAT stēr, pat
f. American painter, printmaker, 1938–

STELLA, FRANK **stel**-ə, frangk
m. American painter, 1936–

STELLA, JOSEPH **stel**-ə, **jō**-zəf
m. American painter, 1877–1946

STEPANOVA, VARVARA FEDOROVNA ste-**pän**-ō-və, vär-**vär**-ə fē-**dō**-rōv-
nə
f. Russian painter, designer, 1894–1958

STEVENS, ALFRED **stē**-vənz, **al**-frəd
m. English sculptor, architect, designer, painter, 1817–75

STEVENS, ALFRED-ÉMILE stā-väns, äl-fred–ā-mēl, or
 stē-vənz **al**-frəd–e-**mēl**
m. Belgian painter, 1823–1906

STIEGLITZ, ALFRED **stēg**-lits, **al**-frəd
m. American photographer, 1864–1946

STILL, CLYFFORD stil, **klif**-ərd
m. American painter, 1904–80

STIMMER, TOBIAS **shtim**-mər, tō-**bē**-äs
m. Swiss painter, printmaker, 1539–84

STONE, WILLARD stōn, **wil**-ərd
m. American (Cherokee) sculptor, 1916–

STORRS, JOHN stȯrz, jän
m. American sculptor, printmaker, painter, 1885–1956

STOSS, VEIT THE ELDER shtȯs, fit
m. German sculptor, painter, printmaker, 1438/47–1533

STRAND, PAUL strand, pȯl
m. American photographer, 1890–1976

STREETON, ARTHUR **strēt**-ən, **är**-thər
m. Australian painter, 1867–1943

STRIGEL, BERNHARD **shtrē**-gəl, **bern**-härt
m. German painter, c. 1460–1528

STROZZI, BERNARDO **strȯt**-sē, ber-**när**-dō
m. Genoese painter, 1581–1664

STUART, GILBERT **stü**-ərt, **gil**-bərt
m. American painter, 1755–1828

STUBBS, GEORGE stəbz, jȯrj
m. English painter, 1724–1806

STUCK, FRANZ VON shtück, fränts fȯn
m. German painter, 1863–1928

SUBLEYRAS, PIERRE süe-blā-rä, pyer
m. French painter, 1699–1749

SUDEK, JOSEF **sü**-dek, **yō**-zef
m. Czech (b. Bohemia) photographer, 1896–1976

SUGAI, KUMI sü-gä-ē, kü-mē
m. Japanese (act. France) painter, 1909–

SULLY, THOMAS **səl**-ē, **täm**-əs
m. American painter, 1783–1872

SULTAN, DONALD **səlt**-ən, **dän**-əld
m. American painter, printmaker, 1951–

SURIKOV, VASILY IVANOVICH **sər**-ē-kȯf, və-**sēl**-ē ē-**vän**-ō-vich
m. Russian painter, 1848–1916

SUTHERLAND, GRAHAM **sə<u>th</u>**-ər-lənd, **grā**-əm
m. English painter, printmaker, 1903–80

SWEERTS, MICHIEL svärts, mē-**kēl**
m. Flemish painter, 1618–64

TÁBARA, ENRIQUE **tä**-vä-rä, en-**rē**-kä
m. Ecuadoran painter, 1930–

TACCA, PIETRO **täk**-kä, **pyä**-trō
m. Florentine sculptor, 1577–1640

TACLA, JORGE **täk**-lä, **kȯr**-ka
m. Chilean (act. United States) painter, 1958–

TADDEO DI BARTOLO täd-**dä**-ō dē **bär**-tō-lō
m. Sienese painter, 1362–1422

TAEUBER-ARP, SOPHIE **tȯi**-bər–ärp, zō-**fē**
f. Swiss painter, collagist, designer, printmaker, 1889–1943

TAKIS (PANAYIOTIS VASSILAKIS TAKIS)
 tä-kēs (pä-nä-**yō**-tēs vä-sē-**lä**-kēs)
m. Greek (act. France) kinetic sculptor, 1925–

TAKUBO, KYOJI tä-kü-bō, kyō-jē
m. Japanese sculptor, 1949–

TALBOT, WILLIAM HENRY FOX: see FOX TALBOT, WILLIAM HENRY

TAMAYO, RUFINO tä-**mä**-yō, rü-**fē**-nō
m. Mexican painter, printmaker, 1899–1991

TANGUMA, LEO täng-**gü**-mä, **lā**-ō
m. American painter, contemporary

TANGUY, YVES tän-gē, ēv
m. American (b. France) painter, 1900–55

TANNER, HENRY OSSAWA **tan**-ər, **hen**-rē **ä**-sə-wə
m. American painter, 1859–1937

TANNING, DOROTHEA **tan**-ing, dȯr-ə-**thē**-ə
f. American painter, printmaker, 1910–

TANSEY, MARK **tan**-zē, märk
m. American painter, 1949–

TÀPIES, ANTONI **täp**-yes, än-**tō**-nē
m. Spanish painter, 1923–

TATLIN, VLADIMIR EVGRAFOVICH **tät**-lēn, vlə-**dē**-mir ev-**grä**-fō-vich
m. Russian painter, 1885–1953

TATSUNO, TOEKO tä-tsü-nō, tō-e-kō
f. Japanese painter, 1950–

TCHELITCHEW, PAUL (PAVEL) **chə**-lē-chef, pȯl (**pä**-vəl)
m. American (b. Russia) painter, 1898–1957

TENIERS, DAVID THE ELDER tə-**nērs**, **dä**-vit
m. Flemish painter, 1582–1649

TENIERS, DAVID THE YOUNGER tə-**nērs**, **dä**-vit
m. Flemish painter, 1610–90

TENNESON, JOYCE **ten**-ə-sən, jȯis
f. American photographer, 1945–

TERAOKA, MASAMI te-rä-ō-kä, mä-sä-mē
m. Japanese (act. United States) painter, 1936–

TER BORCH, GERARD tər **bȯrk**, **kā**-rärt or **gä**-rärt
m. Dutch painter, printmaker, 1617–81

TERBRUGGHEN, HENDRICK tər-**brük**-ən, **hen**-drik
m. Dutch painter, 1588–1629

THAULOW, FRITZ **taú**-lō, frēts
m. Norwegian painter, 1847–1906

THEED, WILLIAM THE YOUNGER thēd, **wil**-yəm
m. English sculptor, 1804–91

THIEBAUD, WAYNE **tē**-bō, wān
m. American painter, printmaker, 1920–

THOMAS, ALMA W. **täm**-əs, **al**-mə
f. American painter, 1891–1978

THOMPSON, BOB **tämp**-sən, bäb
m. American painter, 1937–66

THOMSON, TOM **täm**-sən, täm
m. Canadian painter, 1877–1917

THORN-PRIKKER, JAN tȯrn–**prik**-ər, yän
m. Dutch painter, mosaicist, 1868–1932

THORNE-THOMSEN, RUTH thȯrn–**täm**-sən, rüth
f. American photographer, 1943–

THORVALDSEN, BERTEL **tȯr**-väl-sən, **ber**-təl
m. Danish sculptor, 1768/70–1844

TIBALDI, PELLEGRINO tē-**bäl**-dē, pel-lā-**grē**-nō
m. Roman painter, sculptor, 1527–96

TIEPOLO, GIAMBATTISTA **tyä**-pō-lō or **tye**-pō-lō,
jäm-bät-**tē**-stä
m. Venetian painter, 1696–1770

TIEPOLO, GIANDOMENICO **tyä**-pō-lō or **tye**-pō-lō,
jän-dō-**mä**-nē-kō
m. Venetian painter, 1727–1804

TIGER, JEROME **ti**-gər, jə-**rōm**
m. American (Creek/Seminole) painter, 1941–67

TILLERS, IMANTS **til**-ərz, **i**-mənts
m. Australian painter, 1950–

TINGUELY, JEAN taⁿ-glē, zhäⁿ
m. Swiss sculptor, 1925–92

TINO DI CAMAINO **tē**-nō dē kä-mä-**ē**-nō
m. Sienese sculptor, c. 1285–1337

TINTORETTO (JACOPO ROBUSTI) tēn-tō-**ret**-tō (**yä**-kō-pō rō-**büs**-tē)
m. Venetian painter, 1518–94

TISSOT, JAMES tē-sō, jāmz
m. French painter, printmaker, 1836–1902

TITIAN (TIZIANO VECELLIO) **tish**-ən (tēt-**syä**-nō vā-**chel**-yō)
m. Venetian painter, c. 1485–1576

TOBEY, MARK **tō**-bē, märk
m. American painter, 1890–1976

TOCQUÉ, LOUIS tȯk-kā, lü-ē
m. French painter, 1696–1772

TOLEDO, FRANCISCO tō-**lā**-<u>th</u>ō, frän-**sēs**-kō
m. Mexican painter, 1940–

TOLSÁ, MANUEL tōl-**sä**, män-**wel**
m. Spanish sculptor, 1757–1816

TOMASO DA MODENA tō-**mä**-sō dä **mō**-dā-nä
m. Modenese painter, c. 1325–79

TOMATSU, SHOMEI tō-mä-tsü, shō-me-ē
m. Japanese photographer, 1930–

TOMÉ, NARCISO tō-**mä**, när-**thē**-sō
m. Spanish sculptor, architect, painter, c. 1690–1742

TOMLIN, BRADLEY WALKER **täm**-lin, **brad**-lē **wȯk**-ər
m. American painter, 1899–1953

TOOKER, GEORGE **tu̇k**-ər, jȯrj
m. American painter, 1920–

TOOROP, JAN THEODOOR **tō**-rȯp, yän **tā**-ō-dȯr
m. Dutch painter, 1858–1928

TORRES GARCÍA, JOAQUÍN **tȯr**-res gär-**sē**-ä, <u>k</u>wä-**kēn**
m. Uruguayan painter, 1874–1949

TOULOUSE-LAUTREC, HENRI DE tü-lüz–lō-trek, än-rē də
m. French painter, printmaker, 1864–1901

TOURNIER, NICOLAS tür-nyā, nē-kō-lä
m. French painter, 1590–before 1639

TOVAR Y TOVAR, MARTÍN tō-**vär** ē tō-**vär**, mär-**tēn**
m. Venezuelan painter, 1827–1902

TOWNE, FRANCIS tȧu̇n, **fran**-sis
m. English painter, 1739/40–1816

TOYA, SHIGEO tō-yä, shē-ge-ō
m. Japanese sculptor, 1946–

TOYOTA, YUTAKA tō-yō-tä, yü-tä-kä
m. Brazilian (b. Japan) sculptor, printmaker, 1931–

TRAGER, PHILIP **trā**-gər, **fil**-əp
m. American photographer, 1935–

TRAYLOR, BILL **trā**-lər, bil
m. American draughtsman, 1854–1947

TRESS, ARTHUR tres, **är**-thər
m. American photographer, 1940–

TROCKEL, ROSEMARIE **trók**-əl, **rōz**-mä-rē
f. German sculptor, 1952–

TROOST, CORNELIS trōst, kòr-**nā**-lis
m. Dutch painter, printmaker, 1697–1750

TROOSTWIJCK, WOUTER JOHANNES VAN
trōst-vik, **vaú**-tər yō-**hän**-əs fən
m. Dutch painter, 1782–1810

TROY, JEAN-FRANÇOIS DE trwä, zhän–frän-swä də
m. French (act. Italy) painter, printmaker, 1679–1752

TROYON, CONSTANT trwä-yōⁿ, kōⁿ-stäⁿ
m. French painter, 1810–65

TRUBETSKOY, PAVEL trü-bet-**skói**, **päv**-əl
m. Russian (act. Italy) sculptor, 1866–1938

TRUITT, ANNE **trü**-it, an
f. American sculptor, 1921–

TSAI, WEN-YING tsī, wen–ying
m. American (b. China) sculptor, painter, 1928–

TSINHNAHJINNIE, HULLEAH J. **sin**-hä-jin-nē, hùl-**lē**-ə
f. American (Navajo/Creek/Seminole) photocollagist, contemporary

TSUCHIYA, TILSA tsü-**chē**-yä, **tēl**-sä
f. Peruvian painter, 1932–84

TUFIÑO, RAFAEL tü-**fē**-nyō, rä-fä-**el**
m. Puerto Rican printmaker, 1922–

TURA, COSMÈ (COSIMO) **tü**-rä, kōs-**mä** (**kō**-zē-mō)
m. Ferrarese painter, c. 1430–95

TURNBULL, WILLIAM **tərn**-bùl, **wil**-yəm
m. Scottish sculptor, 1922–

TURNER, JOSEPH MALLORD WILLIAM **tər**-nər, **jō**-zəf **mal**-ərd **wil**-yəm
m. English painter, 1775–1851

TWACHTMAN, JOHN HENRY **twäkt**-mən, jän **hen**-rē
m. American painter, 1853–1902

TWOMBLY, CY **twäm**-blē, sī
m. American painter, 1928–

TWORKOV, JACK **twȯr**-kȯf, jak
m. American (b. Poland) painter, 1900–82

TYNDALL, PETER **tin**-dəl, **pē**-tər
m. Australian painter, 1951–

UCCELLO, PAOLO
ü-**chel**-lō, **paú**-lō
m. Florentine painter, 1397–1475

UDALTSOVA, NADEZHDA ANDREEVNA
yü-dəlt-**sō**-və, nə-dezh-də
ən-**drē**-ev-nə
f. Russian painter, 1886–1961

UECKER, GÜNTHER
ue-kər, **guen**-tər
m. German light/construction artist, 1930–

UELSMANN, JERRY N.
ülz-mən, **jer**-ē
m. American photographer, 1934–

UGO DA CARPI
ü-gō dä **kär**-pē
m. Venetian painter, wood engraver, c. 1480–1532

UHDE, FRITZ VON
ü-də, frits fón
m. German painter, 1848–1911

UNDERWOOD, LEON
ən-dər-wúd, **lē**-än
m. English sculptor, 1890–1975

UTA, UTA (TJANGALA)
ü-tä, ü-tä (chän-gä-lä)
m. Australian (Pintupi) painter, c. 1920–

UTAMARO, KITAGAWA
ü-tä-mä-rō, kē-tä-gä-wä
m. Japanese printmaker, 1753–1806

UTRILLO, MAURICE
ue-trē-yō, mō-rēs
m. French painter, 1883–1955

VALADEZ, JOHN vä-lä-**des**, jän
m. American pastellist, 1951–

VALADON, SUZANNE va-la-dōⁿ, sue-zän
f. French painter, printmaker, 1865/7–1938

VALCIN, GÉRARD val-saⁿ, zhā-rär
m. Haitian painter, 1923–

VALDÉS LEAL, JUAN DE väl-**des** lā-**äl**, k̠wän dā
m. Spanish painter, printmaker, sculptor, 1622–90

VALDEZ, PATSSI väl-**des**, **pat**-sē
f. American painter, collagist, act. 1975–

VALENCIENNES, PIERRE-HENRI DE va-läⁿ-syen, pyer–äⁿ-rē də
m. French painter, 1750–1819

VALENTIN, MOÏSE va-läⁿ-taⁿ, mō-ēs
m. French (act. Rome) painter, c. 1591–1632

VALENTIN DE BOULOGNE, JEAN va-läⁿ-taⁿ də bü-lòn-y', zhäⁿ
m. French painter, 1594–1632

VALLAURI, ALEX vä-**yaủ**-rē, ä-**leks**
m. Brazilian muralist, 1949–87

VALLAYER-COSTER, ANNE väl-lä-yā–kō-stär, än
f. French painter, 1744–1818

VALLOTTON, FÉLIX väl-lòt-tōⁿ, fā-lēks
m. French (b. Switzerland) painter, printmaker, 1865–1925

VALTAT, LOUIS väl-tä, lü-ē
m. French painter, 1869–1952

VAN DER ZEE, JAMES van dər zē, jāmz
m. American photographer, 1886–1983

VAN GOGH, VINCENT: see GOGH, VINCENT VAN

VAN LOO, CARLE vän lō, kärl
m. French painter, 1705–65

VAN LOO, JEAN-BAPTISTE vän lō, zhän–bat-tēst
m. French painter, 1684–1745

VAN NESS, BEATRICE WHITNEY van nes, **bē**-ə-tris **hwit**-nē
f. American painter, 1888–1981

VAN SCHURMAN, ANNA MARIA fän **shùr**-män, **än**-nä mä-**rē**-ä
f. German painter, printmaker, 1607–78

VARGAS, KATHY **vär**-gäs, **kath**-ē
f. American photographer, 1950–

VARLEY, FREDERICK HORSMAN **vär**-lē, **fred**-rik **hòrz**-mən
m. Canadian painter, 1881–1969

VARLEY, JOHN **vär**-lē, jän
m. English painter, 1778–1842

VARO, REMEDIOS **vä**-rō, rā-**mä**-<u>th</u>yōs
f. Mexican (b. Spain) painter, 1908–63

VASARELY, VICTOR vä-zä-rä-lē, vēk-tòr
m. French (b. Hungary) painter, 1908–

VASARI, GIORGIO vä-**zä**-rē, **jòr**-jō
m. Florentine painter, architect, 1511–74

VASNETSOV, APOLLINARI MIKHAILOVICH

 vəs-nyet-**sòf**, ə-pōl-lē-**när**-ē
 mēk-**hil**-ō-vich
m. Russian painter, 1856–1933

VASNETSOV, VIKTOR MIKHAILOVICH vəs-nyet-**sòf**, **vēk**-tòr mēk-**hil**-ō-vich
m. Russian painter, 1848–1926

VASSILIEFF, DANILA və-**sēl**-ē-ef, də-**nē**-lə
m. Australian (b. Russia) painter, sculptor, 1897–1958

VECCHIETTA (LORENZO DI PIETRO) vek-**kyet**-tä (lō-**rent**-sō dē **pyä**-trō)
m. Sienese painter, sculptor, c. 1412–80

VEDOVA, EMILIO vā-**dō**-vä, ā-**mēl**-yō
m. Italian painter, sculptor, printmaker, 1919–

VEGA, JORGE LUIS DE LA **vā**-gä, **kȯr**-kā lü-**ēs** dā lä
m. Argentine painter, 1930–71

VELARDE, PABLITA vā-**lär**-<u>th</u>ā, päv-**lē**-tä
f. American (Pueblo) painter, 1918–

VELASCO, JOSÉ MARIA vā-**läs**-kō, <u>k</u>ō-**sā** mä-**rē**-ä
m. Mexican painter, 1840–1912

VELÁZQUEZ, DIEGO RODRIGUEZ vā-**läth**-keth, **dyä**-gō rȯ-**thrē**-geth
m. Spanish painter, 1599–1660

VELDE, ADRIAEN VAN DE **vel**-də, **ä**-drē-än fən də
m. Dutch painter, printmaker, 1636–72

VELDE, ESAIAS VAN DE **vel**-də, ā-**zä**-yäs fən də
m. Dutch painter, printmaker, 1587–1630

VELDE, HENRY VAN DE vel-d', än-rē vän də
m. Belgian painter, architect, silversmith, 1863–1957

VELDE, WILLEM II VAN DE **vel**-də, **vil**-əm fən də
m. Dutch painter, 1633–1707

VENETSIANOV, ALEKSEI GAVRILOVICH ve-nyet-sē-**än**-ȯf,
 əl-ik-**sä**-ē gəv-**rēl**-ō-vich
m. Russian painter, 1780–1847

VENNE, ADRIAEN PIETERSZ. VAN DE **ven**-nə, **ä**-drē-än **pē**-tərs fən də
m. Dutch painter, 1589–1662

VERESHCHAGIN, VASILY VASILIEVICH ve-rə-**shä**-gin,
 və-**sēl**-ē və-**sēl**-ē-ə-vich
m. Russian painter, 1842–1904

VERMEER, JAN vər-**mär**, yän
m. Dutch painter, 1632–75

VERMEYEN, JAN CORNELISZ. vər-**mi**-ən, yän kȯr-**nä**-lis
m. Dutch painter, c. 1500–59

VERNET, CARLE ver-nā, kärl
m. French painter, printmaker, 1758–1835

VERNET, CLAUDE-JOSEPH ver-nā, klōd–zhō-zef
m. French painter, 1714–89

VERNET, HORACE ver-nā, ȯ-räs
m. French painter, 1789–1863

VERONESE, PAOLO (PAOLO CALIARI) vā-rō-**nā**-zā, **paủ**-lō (käl-**yä**-rē)
m. Venetian painter, c. 1528–88

VERROCCHIO, ANDREA DEL ver-**rȯk**-yō, än-**drā**-ä del
m. Florentine sculptor, painter, 1435–88

VICENTE, ESTEBAN vē-**then**-tā, es-**tā**-vän
m. Spanish painter, 1906–

VICUÑA, CECILIA vē-**kü**-nyä, sā-**sēl**-yä
f. Chilean sculptor, 1948–

VIEN, JOSEPH-MARIE vē-aⁿ, zhō-zef–ma-rē
m. French painter, 1716–1809

VIERA DA SILVA, MARIA ELENA **vyā**-rä dä **sēl**-vä, mä-**rē**-ä ā-**lā**-nä
f. Portuguese (act. France) painter, printmaker, designer, 1908–

VIGAS, OSWALDO **vē**-gäs, ȯs-**väl**-dō
m. Venezuelan painter, 1926–

VIGÉE-LEBRUN, ÉLISABETH vē-zhā–lə-breⁿ, ā-lē-sä-bet
f. French painter, 1755–1842

VIGELAND, GUSTAV **vē**-gə-län, **gủs**-täv
m. Norwegian sculptor, 1869–1943

VIGNON, CLAUDE vē-nyōⁿ, klōd
m. French painter, 1593–c. 1670

VILLA, ESTEBAN **vē**-yä, es-**tā**-vän
m. American painter, 1930–

VILLALPANDO, CRISTOBAL DE vē-yäl-**pän**-dō, krē-**stō**-väl dā
m. Mexican painter, c. 1645–1714

VILLON, JACQUES (GASTON DUCHAMP)
vē-yōⁿ, zhak (gas-tōⁿ due-shäⁿ)
m. French painter, printmaker, 1875–1963

VINCENT, FRANÇOIS ELIE vaⁿ-säⁿ, fräⁿ-swä ā-lē
m. French miniaturist, 1703–90

VINCKEBOONS, DAVID **ving**-kə-bōns, **dä**-vit
m. Dutch painter, 1576–1631/3

VIOLA, BILL vī-**ō**-lä, bil
m. American video artist, 1951–

VISCHER, PETER THE ELDER **fish**-ər, **pā**-tər
m. German sculptor, metalsmith, c. 1460–1529

VISHNIAC, ROMAN **vish**-nē-ak, **rō**-män
m. American (b. Russia) photographer, 1897–1990

VITTORIA, ALESSANDRO vit-**tōr**-yä, ä-les-**sänd**-rō
m. Italian sculptor, 1525–1608

VLAMINCK, MAURICE DE vlä-maⁿk, mō-rēs də
m. French painter, 1876–1958

VLIEGER, SIMON DE **vlē**-kər, **sē**-mȯn də
m. Dutch painter, printmaker, c. 1600–53

VONNOH, BESSIE POTTER **vän**-ō, **bes**-ē **pät**-ər
f. American sculptor, 1872–1955

VONNOH, ROBERT **vän**-ō, **räb**-ərt
m. American painter, 1858–1933

VON WIEGAND, CHARMION vän **wē**-gənd, **shär**-mē-ən
f. American painter, 1896–1985

VOS, CORNELIS DE vōs, kȯr-**nā**-lis də
m. Flemish painter, c. 1584–1651

VOS, MAARTEN DE vōs, **mär**-tən də
m. Flemish painter, 1531/2–1603

VOUET, SIMON vü-ä, sē-mōⁿ
m. French painter, 1590–1649

VREL, JACOBUS vrel, **yä**-kō-bᵤes
m. Dutch painter, act. 1654–62

VRIES, ADRIAEN DE vrēs, **ä**-drē-än də
m. Dutch sculptor, c. 1546–1626

VRUBEL, MIKHAIL **vrü**-bəl, mē-**kil**
m. Russian painter, 1856–1910

VUILLARD, ÉDOUARD vᵤeē-yär or vwē-yär, ä-dwär
m. French painter, printmaker, 1868–1940

WAKABAYASHI, ISAMU — wä-kä-bä-yä-shē, ē-sä-mü
m. Japanese sculptor, 1936–

WAKABAYASHI, KAZUO — wä-kä-bä-yä-shē, kä-zü-ō
m. Japanese (act. Brazil) painter, 1931–

WALDMÜLLER, FERDINAND GEORG — **vält**-muel-lər, **fer**-dē-nänt gä-**ork**
m. Austrian painter, 1793–1865

WALKING-STICK, KAY — **wok**-ing–stik, kā
f. American (Cherokee/Winnebago) painter, 1935–

WARHOL, ANDY — **wor**-hol, **an**-dē
m. American painter, printmaker, filmmaker, 1928?–87

WARING, LAURA WHEELER — **we**-ring, **lo**-rə **hwē**-lər
f. American painter, 1887–1948

WASHINGTON, JAMES W., JR. — **wo**-shing-tən, jāmz
m. American painter, 1911–

WATERHOUSE, JOHN WILLIAM — **wo**-tər-haus, jän **wil**-yəm
m. English painter, 1849–1917

WATKINS, CARLETON E. — **wät**-kinz, **kärl**-tən
m. American photographer, 1829–1916

WATKINS, DICK — **wät**-kinz, dik
m. Australian painter, 1937–

WATSON, JENNY — **wät**-sən, **jen**-ē
f. Australian painter, 1951–

WATTEAU, JEAN-ANTOINE — vät-tō, zhän–än-twän
m. French painter, 1684–1721

WATTS, GEORGE FREDERIC wäts, jòrj **fred**-rik
m. English painter, sculptor, 1817–1904

WEBER, MAX **web**-ər, maks
m. American (b. Russia) painter, printmaker, sculptor, 1881–1961

WEEGEE (ARTHUR FELLIG) **wē**-jē (**är**-thər **fel**-ig)
m. American (b. Poland) photographer, 1899–1968

WEEMS, CARRIE MAE wēmz, **kar**-ē mā
f. American photographer, 1953–

WEENIX, JAN BAPTIST **vā**-niks, yän bäp-**tēst**
m. Dutch painter, printmaker, 1621–1660

WEGMAN, WILLIAM **weg**-mən, **wil**-yəm
m. American photographer, painter, 1943–

WEIR, JULIAN ALDEN wēr, **jü**-lē-ən **òl**-dən
m. American painter, printmaker, 1852–1919

WEISSENBRUCH, JOHANNES HENDRIK
 vī-sən-brük, yō-**hän**-nəs **hen**-drik
m. Dutch painter, printmaker, 1824–1903

WELLS, JAMES LESESNE welz, jāmz lə-**sez**-nē
m. American printmaker, 1902–

WERENSKIOLD, ERIK **vā**-ren-shœld, **ā**-rik
m. Norwegian painter, printmaker, 1855–1938

WERFF, ADRIAEN VAN DER verf, **ä**-drē-än fən dər
m. Dutch painter, 1659–1722

WESSELMANN, TOM **wes**-əl-mən, täm
m. American painter, 1931–

WEST, BENJAMIN west, **ben**-jə-min
m. American (act. England) painter, 1738–1820

WESTON, BRETT **wes**-tən, bret
m. American photographer, 1911–91

WESTON, EDWARD **wes**-tən, **ed**-wərd
m. American photographer, 1886–1958

WEYDEN, ROGIER VAN DER **vī**-dən, **rō**-jer fən dər
m. Flemish painter, 1399/1400–64

WHARTON, MARGARET **hwȯrt**-ən, **mär**-gə-rət
f. American sculptor, 1943–

WHISTLER, JAMES ABBOTT MCNEILL **hwis**-lər, jāmz **ab**-ət mək-**nēl**
m. American (act. England) painter, printmaker, 1834–1903

WHITE, CHARLES hwīt, chärlz
m. American painter, printmaker, 1918–

WHITE, CLARENCE H. hwīt, **kla**-rəns
m. American photographer, 1871–1925

WHITE, MINOR hwīt, **mī**-nər
m. American photographer, 1908–76

WHITELEY, BRETT **hwīt**-lē, bret
m. Australian painter, 1939–92

WHITTREDGE, WORTHINGTON **hwit**-rij, **wər**-thing-tən
m. American painter, 1820–1910

WIERTZ, ANTOINE vērts, än-twän
m. Belgian painter, 1806–65

WIJNANTS, JAN **vī**-nänts, yän
m. Dutch painter, act. 1643

WILDENS, JAN **vil**-dəns, yän
m. Flemish painter, c. 1586–1653

WILKE, HANNAH **wil**-kē, **han**-ə
f. American conceptual artist, 1940–93

WILKIE, DAVID **wil**-kē, **dā**-vid
m. Scottish painter, 1785–1841

WILLIAMS, FREDERICK **wil**-yəmz, **fred**-rik
m. Australian painter, printmaker, 1927–82

WILLIAMS, PAT WARD **wil**-yəmz, pat wȯrd
f. American photographer, 1948–

WILLUMSEN, JENS FERDINAND vil-**lüm**-sen, yens **fer**-dē-nänt
m. Danish painter, sculptor, 1863–1958

WILNOTY (WILNOTA), JOHN JULIUS wil-**nät**-ē, jän **jü**-lē-əs
m. American (Cherokee) sculptor, 1940–

WILSON, DUFFY **wil**-sən, **dəf**-ē
m. American (Tuscarora) sculptor, 1925–

WILSON, ELLIS **wil**-sən, **el**-is
m. American painter, 1899–1977

WILSON, RICHARD **wil**-sən, **rich**-ərd
m. Welsh painter, 1713/4–82

WINOGRAND, GARRY **win**-ō-grand, **ga**-rē
m. American photographer, 1928–84

WINSOR, JACKIE **win**-zər, **jak**-ē
f. Canadian sculptor, 1941–

WINTERHALTER, FRANZ XAVER **vin**-tər-**häl**-tər, fränts ksä-**vär**
m. German sculptor, painter, printmaker, 1806–73

WINTERS, TERRY **win**-tərz, **ter**-ē
m. American painter, 1949–

WIT, JACOB DE vit, **yä**-kòp də
m. Dutch painter, printmaker, 1695–1754

WITKIN, JOEL-PETER **wit**-kin, **jō**-əl–**pē**-tər
m. American photographer, 1939–

WITTE, EMANUEL DE **vit**-tə, ā-**mä**-nü-el də
m. Dutch painter, 1617–92

WITZ, KONRAD vits, **kòn**-rät
m. Swiss painter, c. 1400–44/6

WODICZKO, KRZYSZTOF vò-**dēch**-kō, **shis**-tòf
m. Polish (act. United States) photographer, projection artist, 1943–

WOHLGEMUTH (WOLGEMUT), MICHAEL
vōl-gə-müt, **mik**-ä-el
m. German painter, woodcarver, 1434–1519

WOJNAROWICZ, DAVID vòi-nä-**rō**-vich, **dā**-vid
m. American painter, photographer, installation artist, 1955–92

WÖLFLI, ADOLF **voelf**-lē, **ä**-dòlf
m. Swiss painter, 1864–1930

WOLS (ALFRED OTTO WOLFGANG SCHULZE-BUTTMANN)
vōls (**äl**-fred **òt**-tō **vòlf**-gäng
shùl-tsə–**bùt**-män)
m. German (act. France) painter, photographer, 1913–51

WOOD, GRANT wùd, grant
m. American painter, 1892–1942

WOODRUFF, HALE **wùd**-rəf, hāl
m. American painter, 1900–80

WOOTTON, JOHN **wùt**-ən, jän
m. English painter, c. 1682–1764

WOTRUBA, FRITZ vō-**trü**-bä, frits
m. Austrian sculptor, 1907–75

WOUTERS, RIK **vaù**-tərs, rēk
m. Belgian painter, sculptor, printmaker, 1882–1916

WOUWERMAN, PHILIPS **vaù**-vər-män, **fē**-lips
m. Dutch painter, 1619–68

WRIGHT, JOSEPH (WRIGHT OF DERBY)
rīt, **jō**-zəf (**där**-bē)
m. English painter, 1734–97

WTEWAEL, JOACHIM ANTONISZ. **üt**-väl, **yō**-ä-k̲ēm **än**-tō-nis
m. Dutch painter, 1566–1638

WUNDERLICH, PAUL **vùn**-dər-lik̲, paùl
m. German painter, printmaker, sculptor, 1927–

WYETH, ANDREW **wī**-əth, **an**-drü
m. American painter, 1917–

Xul Solar, Alejandro sül sō-**lär**, ä-lā-**kän**-drō
m. Argentine painter, 1887–1963

YAMPOLSKY, MARIANA
f. Mexican photographer, 1925–

yäm-**pōl**-skē *or* zhäm-**pōl**-skē, mär-**yä**-nä

YÁÑEZ, FERNANDO (DE LA ALMEDINA)
m. Spanish painter, act. 1506–36

yän-yeth, fer-**nän**-dō (dā lä äl-mä-**thē**-nä)

YÁÑEZ, LARRY
m. American mixed-media artist, 1949–

yän-yes, **la**-rē

YARDE, RICHARD
m. American painter, 1939–

yärd, **rich**-ərd

YEATS, JACK BUTLER
m. Irish painter, 1871–1957

yāts, jak **bət**-lər

YOAKUM, JOSEPH E.
m. American draughtsman, painter, 1886–1972

yō-kəm, **jō**-zəf

YOSHIHARA, JIRO
m. Japanese painter, 1905–72

yō-shē-hä-rä, jē-rō

YOSHIMURA, FUMIO
m. Japanese (act. United States) sculptor, draughtsman, 1926–

yō-shē-mü-rä, fü-mē-ō

YOSHITOSHI
m. Japanese printmaker, 1839–82

yō-shē-tō-shē

Z

ZADKINE, OSSIP zäd-**kēn**, ȯ-**sēp**
m. French (b. Russia) sculptor, 1890–1967

ZALCE, ALFREDO **säl**-sā, äl-**frä**-**thō**
m. Mexican printmaker, painter, 1908–

ZAÑARTU, ENRIQUE sä-**nyär**-tü, en-**rē**-kā
m. Chilean (b. Paris) printmaker, 1921–

ZANDOMENEGHI, FEDERICO dzän-dō-mä-**nä**-gē, fä-dā-**rē**-kō
m. Italian painter, 1841–1917

ZARRAGA, ANGEL sär-**rä**-gä, än-**käl**
m. Mexican painter, 1886–1946

ZEITBLOM, BARTHOLOMEUS **tsit**-blōm, bär-tō-lō-**mä**- u̇s
m. German (Ulm) painter, c. 1460–c. 1520

ZEUXIS **zük**-sis
m. Greek painter, late 5th c. BC

ZOFFANY, JOHANN **zäf**-ə-nē, **yō**-hän
m. English (b. Germany) painter, 1733–1810

ZOPPO, MARCO **tsȯp**-pō, **mär**-kō
m. Bolognese painter, c. 1432–78

ZORACH, MARGUERITE THOMPSON **zȯr**-äk, mär-gə-**rēt** **tämp**-sən
m. American (b. Lithuania) painter, 1887–1968

ZORACH, WILLIAM **zȯr**-äk, **wil**-yəm
m. American (b. Lithuania) sculptor, 1887–1966

ZORN, ANDERS LEONARD tsȯrn, **än**-dərs **lā**-ō-närd
m. Swedish painter, printmaker, sculptor, 1860–1920

ZUCCARELLI, FRANCESCO tsü-kä-**rel**-lē, frän-**ches**-kō
m. Italian painter, printmaker, 1702–88

ZUCCARO, FEDERICO tsü-**kär**-rō, fā-dä-**rē**-gō
m. Italian painter, 1540/1–1609

ZÜGEL, HEINRICH JOHANN **tsue**-gəl, **hin**-rik **yō**-hän
m. German painter, 1850–1941

ZULOAGA Y ZABELETA, IGNACIO thü-lō-**ä**-gä ē thä-vä-**lä**-tä,
 ēk-**näth**-yō
m. Spanish painter, 1870–1945

ZÚÑIGA, FRANCISCO **sü**-nyē-gä, frän-**sēs**-kō
m. Mexican (b. Costa Rica) sculptor, 1913–

ZURBARÁN, FRANCISCO thür-bä-**rän**, frän-**thēs**-kō
m. Spanish painter, 1598–1661/4